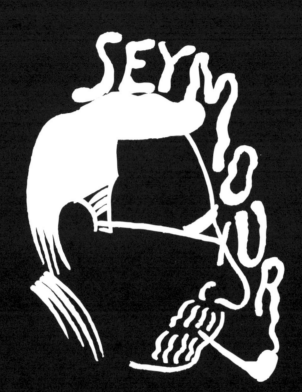

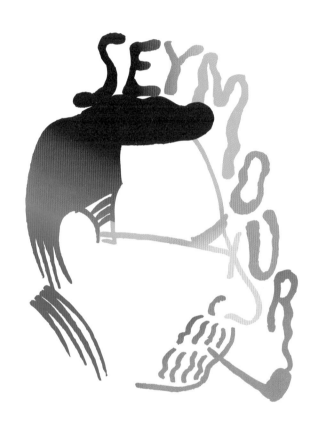

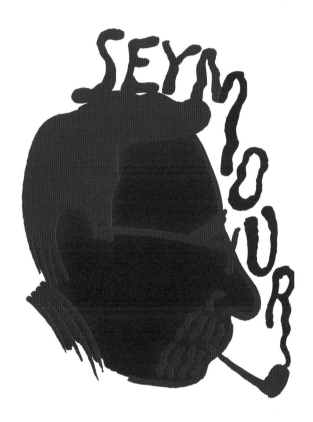

**The Obsessive Images
of Seymour Chwast**

Introduction by Steven Heller

Essay by Paula Scher

CHRONICLE BOOKS
SAN FRANCISCO

Introduction copyright © 2009 by Steven Heller.
Essay copyright © 2009 by Paula Scher.
Interview copyright © 2009 by Seymour Chwast.
Illustrations copyright © 2009 by Seymour Chwast.
All rights reserved. No part of this book may be reproduced
in any form without written permission from the publisher.

Library of Congress Cataloging-in-Publication Data available.

ISBN: 978-0-8118-6546-3

Manufactured in China.

Designer: Seymour Chwast
Associate Designers:
Faith Hutchinson, Brian Ponto
Art Editor: Paula Scher

10 9 8 7 6 5 4 3 2 1

Chronicle Books LLC
680 Second Street
San Francisco, CA 94107

www.chroniclebooks.com

To Paula

Acknowledgments

I have met and worked with many wonderful
people. First I must thank Sandy Choron, my
agent, and Alan Rapp, my editor at Chronicle
Books. Their support and trust in me and my
work made this book happen. My wife, Paula
Scher, full of tough love for my work, who I
learned to listen to because she is right. Steve
Heller, who, despite his unending generosity,
must be bored with writing about me and
Push Pin but doesn't show it.

Here is a list of some of my friends, clients, and
collaborators. I am grateful to the interns and
assistant designers, many whose names I have
forgotten but who helped me get through the
day without major disasters.

Sandra Ruch	Martin Venezky
Kaz Imaeda	R. O. Blechman
Veronique Vienne	Eric Himmel
Paul Tracey	Brian Weaver
Carol Chu	Phyllis Flood
Michi Turner	Anita Kunz
Eric Seidman	Ernestine Miller
Christine Curry	Brian Rea
Max Bode	Steven Guarnaccia
Owen Phillips	Terko Goldinger
Edward Sorel	Maria Peracchio
Cleveland Dobson	Andy Berman
Hans-Georg Pospischil	Stephen Bruce
Ruth Ansel	Chuck Tutaro
Barbara Vaughn-Davis	Mark Heflin
Steve Woods	Jeff Scher
Ted Kleimeyer	Eric Himmel
Leonard Seastone	Silas Rhodes
Richard Wilde	Lanny Sommese
Nicholas Blechman	Kim Keister
Paul Sayre	Frank Rich
Christoph Niemann	Ann Field
Milton Glaser	Eric Baker
Roxanne Slimak	Françoise Mouly
Alan Peckolick	Ilse LeBrecht
Harriet Ziefert	Liz VanDoren
Istvan Banyai	Harry Stendhal
Steven Brower	Maya Stendhal
Deborah Brodie	Paul Davis
Justin Van't Zelfden	James McMullan
Clinton Von Gamert	Ernestine Miller
James Victore	Shigeo Fukuda

Seymour: The Book **07**
Seymour: The Man **12**
Seymour: The Interview **16**

1. **Used Cars** 21

2. **Not Quite Human** 43

3. **Odd Celebs** 55

4. **Brylcreem Man** 69

5. **Monkeys All Over** 79

6. **Unreliable Diagrams & Charts** 91

7. **Fine Food** 103

8. **Mexican Wrestlers** 117

9. **Fab Fashion** 131

10. **War** 155

11. **Fauna and a Little Flora** 173

12. **Ordinary Objects** 191

13. **Body Parts** 207

14. **Around the World** 221

15. **Interior Design** 239

16. **Expressive Expressions** 251

Notes & Credits **269**

Seymour: The Book
By Steven Heller

The Revolutionary Seymour

Seymour Chwast is *not* your typical revolutionary firebrand. His name is a dead giveaway. It is inconceivable that the masses could be moved to frothing frenzy by chanting SEE-MORE, SEE-MORE, SEE-MORE! It just doesn't have the same rousing cadence as CHE, CHE, CHE, or MAO, MAO, MAO, or even BO-NO, BO-NO BO-NO! Nonetheless, Seymour led a major revolution in American illustration and graphic design during the late 1950s and early 1960s, triggering the shift from sentimental realism to comic expressionism, among other radical feats. The illustrations for magazines, posters, advertisements, book jackets, record covers, product packages, and children's books that he created after founding Push Pin Studios with Milton Glaser and Edward Sorel in 1954 directly influenced two generations (statistical fact) and indirectly inspired another two (educated conjecture) of international illustrators and designers to explore an eclectic range of stylistic and conceptual methods. He was very instrumental in wedding illustration to typographic design (a concept that was viewed as passé by orthodox modernists). In addition, Chwast (pronounced "kwast," *not* "shwast") contributed his distinct brand of absurdist wit to twentieth-century applied art and design. And although his methods were unapologetically rooted in vintage-stylish decorative traditions—notably Victorian, art nouveau, and art deco—his work never slavishly *copied* the past. Instead, he synthesized, reinvented, and often parodied it.

Seymour's art was postmodern long before the term was coined. Yet it was resolutely modern in its rejection of the nostalgic and romantic representation, as in the acolytes of Norman Rockwell, that had been popular in mainstream advertising and magazines at the time. Instead of prosaic or melodramatic tableau, Seymour emphasized clever concept.

What makes the very best of his art so arresting, and so identifiable, is the tenacity of his *ideas*—simple, complex, rational, and even absurd *ideas*. Droll humor and conceptual acuity were the foundation on which he built a visual language that advanced editorial illustration beyond pictorial mimicry of a sentence or headline. His images complemented and supplemented the words, gave them additional layers of meaning. What's more, Seymour is master of the visual pun, which enables him to manipulate pictorial concepts as a sculptor shapes soft clay.

He is also skilled at what comedians call the slow burn or double take: using commonplace things as foils for uncommon illusions, he twists imagery into double entendres. Seymour employs one of the most adaptable pictorial lexicons in the world (big claim based on educated conjecture rooted in statistical fact). Yet when he repeats himself, as all artists do, he makes every effort to turn such repetition into something novel. Seymour is nothing if not novel (you can make book on that).

However, concept—the big idea—alone does not make art that shall be called "a Seymour." Although Seymours are rendered in various media and numerous techniques, there are some quintessential graphic traits. Each of his imaginary characters (even portraits of real individuals) have similar facial features—round lips, slits for eyes, bulbous noses. They never scowl, yet they are not cute. What's more, his animals and humans share a curious innocence, not in the free-of-guilt sense—but in a kind of Peter-Sellers-as-Chance-in-*Being-There* sense—of acceptance cut with a kind of comic humility. A Seymour can be a simple vignette or a large tableau, but in whichever form the look is unmistakable. His ideas are routinely framed by means of playful stylistic conceits that, although varied, express his singular personality. Virtuosic drawing underpins almost everything he touches, but the results are never slick. His

finishes are often unfinished looking and not tethered to one particular method; instead his illustration ranges from gnarly to precise, from naive to sophisticated. He is versatile with media, including monoprint, woodcut, collage, and montage; paint, ink, and charcoal; pencil, burin, and graver. Few are as flexible yet so consistent. Decades ago he may have ended the brief revolutionary phase of his career (even Mao knew one cannot be a revolutionary forever), but judging from his output, we see that Seymour is resilient, and endures as restlessly motivated as ever.

The Life of Seymour

Born to Polish immigrant parents in 1931 in the Bronx, New York, Seymour was, like so many first-generation Jewish children, given an aristocratic English surname as a first name (e.g., Milton, Murray, and Morris) and an unusual last name (that means "weed" in Polish). He was an only child, bright and inquisitive but painfully shy—he had few close friends, so by way of compensation drawing entered his life at the age of seven. He attended WPA-sponsored art classes, which made him appreciative of the difference between "museum" and commercial art; he instinctively preferred billboards and advertisements to Picassos and Mondrians. Also influenced by Walt Disney, the Sunday comics, and serial movies, he developed a repertory of his own cartoon heroes, including "Jim Lightning" and "Lucky Day," filling up various lined notebooks with their exploits. His mother and father (who were divorced when Seymour was fifteen years old) moved to Coney Island in the late '40s, and he was enrolled in Abraham Lincoln High School. What outwardly was a drab New York City public school for low- and lower-middle-class children was actually a pulsating heart of art and design. This school and its art teacher changed Seymour's life.

At Lincoln he was accepted as a member of the elite "Art Squad," a roving band of sign and poster artists. It was a spin-off of a graphic design class taught by Leon Friend, the pioneering art educator of such graphic design notables as Gene Federico, Alex Steinweiss, and Bill Taubin. Seymour learned to design typography, make stark graphic images, and tap the potential of commercial art as an expressive medium. Friend, who coauthored a book titled *Graphic Design*, which wed practice to heretofore ignored history, believed that there was no greater glory for a young artist than to have his work published in any visible venue, and demanded that all his students enter every current design competition. Seymour was a prodigious submitter, and at sixteen his first illustration was published in the reader's column in *Seventeen* magazine (art directed by Cipe Pineles). Having tasted printer's ink, he took to it like a baby to mother's milk, or a vampire to fresh blood.

Early indoctrination into commercial art was total and unalterable. And in 1948 (just as the cold war was getting hotter) he began the next stage of his education at New York's prestigious Cooper Union, along with Edward Sorel and Milton Glaser, whom he later joined to found Push Pin Studios. During those stimulating Cooper years, Seymour was profoundly inspired by the political graphics of Ben Shahn, Georg Grosz, Georges Rouault, and Honoré Daumier. The conceptual strength of these stylistically dissimilar but spiritually kindred critical commentators was reflected in his own penchant for expressive woodcuts. He was antibomb, antimilitary, and pro-peace, and one of his earliest (still timely) pieces was *The Book of Battles*, a hand-printed, hand-bound, and hand-colored illustrated antiwar manifesto. For Seymour, a member of SANE (the organization for sane nuclear policy), social commitment was a recurring concern telegraphed through comedy. As for this comic bent, his most direct antecedents were the masters

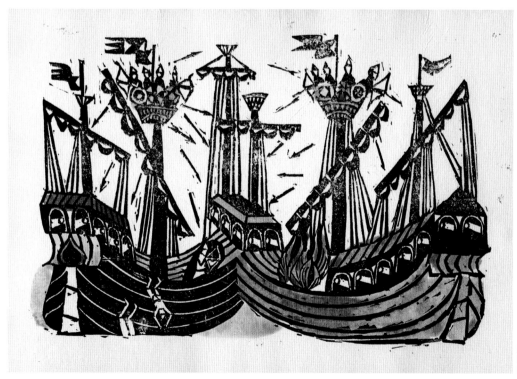

BATTLE OF VONCHIO,
HAND-COLORED LINOCUT.
FROM *THE BOOK OF BATTLES,* 1957

of paradox and irony André François and Saul Steinberg. Seymour is nothing if not a connoisseur of irony.

Ironically, Cooper Union was tied to the fashionable abstract expressionist art canon at the time Seymour and his classmates were developing their visual personas. His education was, therefore, rooted as much in the rejection of these abstract tendencies as in the embrace of alternatives. Realizing that he couldn't (or wouldn't) paint in the prescribed manner pushed him into more comedic artistic realms and to step up to commercial art. In their sophomore year, Seymour, Glaser, and another classmate, Reynold Ruffins, formed a small studio called Design Plus. However, after completing three jobs together (a flier for a theatrical event, silk-screened placemats, and a children's book), they summarily closed shop.

It was impossible to predict the eventual fruits of this ill-fated Design Plus collaboration; likewise it was hard to fathom why in the world Seymour would continue in graphic design given the outcomes of his first five jobs. After graduating from Cooper Union, he worked for a year in the *New York Times* promotion department where, under the tutelage of art director George Krikorian, he learned the principles of classical typography and was given some visible design and illustration assignments. Yet one year as boardman was just about enough time to stay in the *Times* bullpen, so he left for greener pastures, bluer skies, and whiter whites (too bad he didn't know how good he had it). As it turned out, his subsequent jobs amounted to a string of failures beginning with a layout job at *Esquire* magazine; one with pioneering designer and typographer Herb Lubalin, who fired him (because he was unable to do good comps); and ending with a dead-end stint in Condé Nast's art department.

In desperation (although Seymour effectively conceals such emotions) he turned to freelancing. Together with Ruffins and Sorel he produced a promotional publication designed to show prospective clients that ideas were as central to design and illustration as was emphasis on technique or other modernist orthodoxies. The result turned into a semiregular mailer they called the *Push Pin Almanack*, inspired by the old *Farmers' Almanac*. Each issue included drawings, texts, and bits of trivia on specific themes. At the time there were a few other "continuity" promotions, but none so ambitious or inventive as the *Almanack*, which brought in enough freelance work that Seymour, Sorel, and Glaser (who had recently returned from studies in Italy) decided to form a studio, which they christened Push Pin. Seymour credits Glaser for realizing that a full-fledged studio had greater business and creative potential than going their individual ways.

The Historical Seymour
Starting a design studio in 1954 was about as easy as printing a business card and renting office space. Push Pin's rent was low, and a pay phone served all its telecommunications needs. Illustration assignments for educational slide shows and renderings for package design proposals provided respectable cash flow. After salaries were paid to the assistant and secretary, the bosses earned a whopping $25 a week.

Push Pin fostered an adventurously eclectic aesthetic that revived Victorian, art nouveau, and art deco (what Seymour dubbed his "Roxy Style") and may have, at least in part,

contributed to the demise of orthodox modernism. The studio certainly created contemporary contexts for older graphic methods foreshadowing the postmodernism of the '80s. Seymour collected styles, drawing nourishment and then discarding them as necessary. He said he gave up woodcuts in the '60s because the German expressionist manner had lost its vigor. What's more, with the studio's sampler of Push Pin styles, clients were asking for certain looks and moods, and Seymour tried to fulfill this need while tapping his own inclinations. What became known as the Push Pin Style—an eclectic mélange of illustration and design—derived, according to Seymour, not from forced imposition of a "look" but from the requisites of each assignment. It was his goal to state a client's message in as personal yet as public and engaging a vocabulary as possible. Although Seymour explains that he and the studio as a whole were swept along with the "pop art thing" of the '60s—bright colors and stylized outline drawings—such a statement should not diminish the significance of his own innovations.

Push Pin was on the cutting edge of popular art. This was manifest in highly visible, mass-media jobs, including book jackets, record covers, posters, advertisements, and magazine covers. During the '60s and '70s it was impossible not to see Push Pin's work (and those it influenced). Push Pin was so popular, its output predictably fostered opposition among those who saw the studio's style as too dominant.

Owing to Push Pin's dexterity for self-promotion, its eclectic revivals were enthusiastically accepted by publishing and entertainment industry clients. Likeminded designers who objected to stylistic rigidity also turned to the "big closet" of historical precedents for inspiration. While some used these artifacts as a springboard to achieve unprecedented work, others flagrantly stole fully realized ideas—Seymour has had his share of imitators and followers in a generation or two that came later. Steven Guarnaccia, one of the latter, admits that Seymour's simplicity was integral to his style and his use of "toothpaste" green influenced his color palette. Yet despite intense visibility, Push Pin was more influential than it was wealthy. Unlike major corporate design firms, such as Landor and Unimark, servicing ongoing and lucrative identity programs, Push Pin was more or less working on an assignment-to-assignment basis. One reason was that the pop-cult nature of its collective work went contrary to accepted rules of corporate image. Seymour worked best without the tight corporate constraints, anyway; he was what Jean-Jacques Rousseau referred to in a different context as the "noble savage," which is to say, as client-focused as Seymour wanted to be, he followed his own very quirky path, which sometimes cost him the more lucrative assignments.

A historic exhibition in 1970 at the Louvre's Musée des Arts Décoratifs underscored the inevitable canonization of Push Pin and Seymour's accession into the pantheon. It was the first time an American design studio was honored by such a prestigious (and foreign) cultural center. French critics applauded Push Pin for its nonconformity, and some even voiced surprise that such work would be supported by a capitalist system. The show traveled throughout Europe and to Brazil and Japan and cemented the Push Pin Style, which

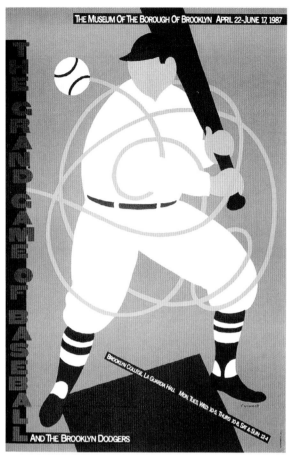

Within the poster image:
THE MUSEUM OF THE BOROUGH OF BROOKLYN APRIL 22-JUNE 17, 1987
THE GRAND GAME OF BASEBALL
AND THE BROOKLYN DODGERS
BROOKLYN COLLEGE LA GUARDIA HALL MON. TUES. WED. 10-5. THURS. 10-8. SAT. & SUN. 12-4

THE GRAND GAME OF BASEBALL, EXHIBITION POSTER, OFFSET, 1987

was increasingly spreading its notions of humor, play, and surprise around the world. And Seymour's work had more visibility than ever.

Seymour was a willing collaborator with others, yet it is fairly easy, even for the untrained eye, to pick out his contribution among the studio's output from the '60s and early '70s. Seymour's approach—regardless of media—relied so much on humor, bawdy at times, but never crass. His talent has always been demonstrated in his ability to wed sophistication to pop and pop to old and new vernaculars. Glaser's work was, given his studies in Italy, more rooted in the classical line and form, although no less contemporary in style.

Glaser left Push Pin in 1975 to explore different media and métiers, ending their twenty-year collaboration. But Seymour felt no need to abandon the studio. He continued as Push Pin's director, and he became an early proponent of design entrepreneurialism. He formed a company to develop and market a line of candies called "Pushpinoff." It was a way to generate work when the phone didn't ring and it "fit with my '30s depression mentality." He also continued publishing on a regular basis the highly popular, though occasional, *Push Pin Graphic*, which evolved directly from the *Push Pin Almanack* and *Monthly Graphic* into a thematic showcase of Push Pin's art and ideas. Thematic issues, including "Mothers," "the Condensed History of the World," "Food and Violence," "New Jersey," and "the Chicken," served as an outlet for Seymour's creative obsessions as well as a showcase for other members of the new Push Pin Studios. More than a decade after the *Graphic* folded, Seymour started the *Nose*, a twice-yearly festschrift devoted to ideas on politics, society, and culture. Seymour also began something of a poster renaissance with projects for *Forbes* magazine and Mobil. During this time *Push Pin Press* was founded as a means to package books that appealed to his sense of playfulness. In fact, the second stage of Seymour's career as a solo act, so to speak, was consumed with an insatiable desire to play . . . and so he did.

What Makes Seymour Run

Seymour seems laid-back to a fault, a deception he has successfully cultivated as part of his mild-mannered absent-minded image. In fact, he is a tireless worker and a ceaseless producer of quantity and quality. To understand the disparate but distinctly "Seymourian" art and design selected for this book and to appreciate what makes Seymour run, it is useful to reference the comic strips, comic books, and animated films that made such a strong impression on him. In addition to his formal art and design education, he learned some key lessons from the likes of *Mutt and Jeff* and *Bringing Up Father*, *Krazy Kat* and *Dick Tracy*, among others. These strips taught him gesture, expression, and timing. These are traits that Seymour controls with exceptional facility yet with minimalist means. It is therefore not surprising that his current drawings (and particularly his metal sculptures) have what he calls "traces of comic-strip iconography." He reflexively borrows from the comic to tell narrative stories that cannot be told in one image. "Single image illustrations can tell stories, too, but in a different way," he says. "My work usually combines metaphorical messages using the visual language. A strip can tell more with its possibility of a beginning and end or before and after." Still, he is not a comic strip artist per se, although

he has created over thirty children's books that are narrative and sequential and allowed him to address a wide range of ideas.

Seymour's art is so resolutely individual that it can be branded by simply using his first name. All the works in this book are "Seymours," not in the possessive sense, but as nouns, as objects. What's more, his name may not be a revolutionary's rallying cry, but it denotes a timeless attitude toward art and design. He is of the moment, but beyond fashion. So, what actually makes something a Seymour? One case study in the book best illustrates his method and madness.

In the early '60s, "A little dab'll do ya" was the recurring tagline for Brylcreem, the glutinous white substance that ensured a greaseless, well-managed coif and promised that women would "love to run their fingers through your hair." Problem was, Brylcreem *did* leave an oily residue on the hands of both the user and the fingerer, making romance a rather sticky proposition. This was in Seymour's mind when in 1997 he appropriated the vintage "Brylcreem man" trademark character, which he had enlarged and reproduced in an edition of two hundred 25-by-36-inch silk-screen prints (with a solid red background behind each). His goal was to deface each one of these prints and make them into a series of conceptual portraits, later exhibited at a major retrospective of his work held at the School of Visual Arts. For Seymour, this symbolized the "ideal white man," the epitome of pure American culture, and such epitomes just call out to be maliciously marred.

Seymour used every stylistic and technical trick at his disposal—painting, collage, tearing, burning, scratching, stomping, and more—to transform this emotionless portrait of perfection into slapstick comedy. As it turned out, the first fifty or so concepts went fairly fast in a stream of consciousness. Intuitively, he transformed Mr. Brylcreem into Abe Lincoln, Adolf Hitler, Johann Sebastian Bach, and Groucho Marx, as well as a clown, a cowboy, a skeleton, and even a brick wall. Mr. Brylcreem was the perfect tabula rasa. However, around the fifty-third portrait, Seymour ran out of steam. Was this pictorial vandalism really revenge on Brylcreem for a bad-hair day in his past? Maybe and maybe not: the question lingers like pomade on the fingers. But what this project does show is how Seymour can take the most commonplace object and inject it with his renegade's chi.

Testing Seymour's Metal

Seymour is a peripatetic stylist, moving from one pictorial locale to another when either the mood or manuscript requires it. He has likewise mastered various media as an actor inhabits different roles. Metal has become his favored ersatz canvas. Cutting, sculpting, and painting on sheet metal (which he buys in bulk from Lindell's Hardware in Canaan, Connecticut) allows him the physicality and scale that bring his two-dimensional ideas to three-dimensional life. What started out with replicating his favorite toys—including tin cars and motorcycles—by cutting and bolting galvanized metal, grew into an obsessive, if also dangerous (inducing many cuts), métier. As this book so vividly reveals, Seymour transcends the commonplace with his series on cars (page 20), robots (page 42), fine food (page 102), Mexican wrestlers (page 116), ordinary objects (page 190), expressions (page 250), and much more. Metal is versatile. And there is little Seymour cannot cut out of it, from savory bowtie pasta (page 105) to fish climbing an evolutionary ladder (page 189) to torturous brassieres (page 147).

Metal was once what separated his muse-inspired art from his commercial endeavors, but over time the boundaries blurred. His metallic machinations and his illustrations are interchangeable—both can hang in a white box room or be reproduced on an ink-saturated page. For Seymour, his work can be large or small, colorful or monochromatic, but metal is just another means to affect illusion.

For the past two years he's been painting battle scenes, which more accurately should be called "battle patterns," on 8-by-9-foot canvases (page 154), each a pattern or jumble of tanks, soldiers, planes, and other materiel. He chose models for this cannon fodder from early twentieth-century tin toys that doubtless celebrated warfare and were ubiquitous in most young boys' toy boxes. The paintings, rendered in an obsessively naive manner, suggest the faceless, mechanistic inhumanity of war; akin to wallpaper, they comment on how dangerous it is that in many quarters war has become little more than a casual backdrop.

Seymour: The Legacy

For almost six decades, Seymour has unpretentiously contributed to the visual culture of his epoch. Unpretentiously because anyone who knows him will attest that he just tirelessly does his "jobs" with no other ambition than to do them. Sometimes they are just fine, but sometimes they are masterpieces of visual erudition. His *End Bad Breath* poster of 1968 (page 14) was, for example, as vivid a symbol of the antiwar '60s as his *Nicholas Nickleby* poster of 1984 was iconic of the cultural '80s, and the list of key images continues. In this book are a few iconic testimonies to contemporary life, including *Hi-Rise Hell* (page 94), *Coitus Topographicus* (page 97), and my favorite (because he did it for me at the *New York Times Book Review*), *The Kama Sutra of Reading* (page 96). Some illustrators and designers continue to work only as long as their styles are popular, but Seymour has not suffered the vicissitudes of the marketplace in large part because he was never merely a stylist. When his monograph *Seymour Chwast: The Left-Handed Designer* (Harry N. Abrams) was published in 1985, it might have marked the pinnacle of his career. But in the years since its publication, Seymour has filled another volume and could easily fill one more.

It may seem trite to call Seymour a consummate artist. Yet he is consumed by art. Seymour is his art; he is what he makes. His hands are always covered with ink; his clothes are stained with paint; his hair is speckled with pigment. There isn't a day when he doesn't create something. His collected physical work would easily fill a sizable warehouse (or cruise ship); children's book and editorial illustrations (before digital files) alone number in the thousands. And after all this he continues to generate witty, beautiful, and more often than not, smart work. In the pantheon of American (nay, world) illustration, he stands, albeit slightly shorter and a little more rumpled, beside N. C. Wyeth, J. C. Leyendecker, and Norman Rockwell—and he's not through yet.

Years ago, when my parents first met my husband, Seymour, he and I were looking for a new apartment to live in in Manhattan. Seymour wanted to find an apartment close to his studio, maybe even next door to it, or in the same building. My parents thought that was odd and backward, equating it with the immigrant experience of the toiling shopkeeper. My father said, "That's like the pharmacist living above the candy store." Seymour replied, "You never know when someone might need a drawing in the middle of the night."

If someone ever did need a drawing in the middle of the night, Seymour would be the one to get up and draw it. For more than fifty-five years, he has gone into his studio every morning between 7:00 and 7:30 a.m. and stayed until at least 6:30 p.m., for the sole purpose of making drawings. He makes them all day, or talks to clients about making them, or makes revisions to ones he's already made, or totally redoes them, which is just like making new ones.

If there is a day that he doesn't have any drawings to make, he comes up with ideas for things that will demand that he make more drawings anyway. He comes up with ideas for children's books or novelty books, op art pieces for the *New York Times*, product ideas, licensing ideas—any idea that has a drawing at its heart to make the idea come to life.

His biggest drawing enforcer is his own publication, the *Nose*. The *Nose* comes out twice a year. The editorial content, decided on by Seymour with the help of Steven Heller, ranges from the serious, socially conscious, and political to completely useless, trivial fluff. But regardless of the subject matter, Seymour has determined that each thought or piece of writing requires one of his drawings to make its specific point. Then, the drawings for the *Nose* can become assignments to be resolved at the studio each day from 7:00 or 7:30 a.m. to 6:30 p.m.

Seymour's process of creating ideas that will result in his need to make a drawing is continual and can happen anywhere. They happen when he wakes up in the morning, walks the dogs, and stands at an ATM, on a car trip and often on vacations. Once Seymour accompanied me to a Pentagram partners' meeting that took place at the Round Hill resort in Jamaica. He spent his day on the beach with the other partners' wives, while I was in an all-day meeting. He used the day to create what became *The Bra Book: Bra Designs by Stephanie*. The book was composed of silly drawings of bathing suit tops. The bras were illustrations of puns (see page 130). When I joined him on the beach after the meeting, I was enlisted to come up with more bra puns. All of the puns were carefully reviewed to determine whether or not they would make "good" drawings, and then they were recorded in his sketchbook. The sketchbook flew home to New York City with Seymour, and the bra sketches became drawings that were completed between 7:00 a.m. and 6:30 p.m. in the course of another working business day.

Much has been written about the ideas contained in Seymour's work. But I don't know if his work is really about ideas. I think "the idea" is a convenient excuse he uses to force himself to make another drawing. A great idea doesn't always necessarily provoke a great drawing. Some of my favorite drawings and paintings Seymour has made have been less about ideas and more about personal obsessions. But as a working illustrator, Seymour relies on ideas, and that ability has made him desirable as an illustrator and forced him to go into the studio each day to make more drawings.

Seymour is the consummate professional illustrator; ever ready, responsible, reliable, and elastic. He is capable of working in a myriad of styles and media, and best of all, he is capable of solving any difficult problem, at any given moment, and delivering the solution to a client on time. Imagine that you

are an art director of a publication featuring a boring, lengthy article about levels of cholesterol in the middle-aged man. No problem! Call Seymour! He'll pull something out of a hat. This has made him ever popular, ubiquitous, and at seventy-seven probably busier than most working illustrators half his age. It's not because he is famous (that probably hurts him). It's because he has to be busy. He has to be busy, because he needs to get up and go to the studio between 7:00 and 7:30 a.m. and make drawings until 6:30 p.m. He has to be busy because the act of making drawings is so ingrained in his being it has become equivalent to breathing, and if he doesn't do it he will die.

On the weekends, Seymour breaks from this routine by going to our weekend house in Salisbury, Connecticut, where he has a large studio in the attic. Here he makes sculptures and paintings that are not framed by editorial content, but exist thematically, expressing various bizarre personal obsessions.

In the '70s, Seymour painted peep shows and other girlie burlesque situations. They were small tempera paintings on chipboard that were delicately rendered, in glowing colors, in the spirit of Persian miniatures.

Later, in the '80s, he painted an endless stream of absurd television sets. Seymour paints with a background of noise continually blaring from a loud television. The television is really like a radio or iPod to Seymour; he listens to TV, rather than watches it. He listens to political talking heads and news reports; black-and-white movies on Turner Classic Movies, where he likes noir films the best, or anything done by Billy Wilder; or he listens to indie movies on the Independant Film Channel. (For a while, he reported to me extensively on every movie featuring Steve Buscemi. There are a million of them.) He never listens to sports, soaps, or Oprah-type shows, which seems odd when you consider that those types of programs were all originally designed for radio. He watches Bill Maher and Jon Stewart and George Carlin reruns at night. He watches them but never paints to them.

The series of TV paintings Seymour made never had anything to do with what was on TV. The paintings were all about the form of the television—the TV as architecture, the TV as object, the TV in still life, the TV in a landscape, the landscape in a TV, the TV reflecting different styles of art. They were a catalog of "Seymourisms," a kit of all his stylistic obsessions, realized as television sets.

After the TVs, he began creating bent-metal painted sculptures by cutting sheet metal into various shapes and sometimes bending them. He made funny heads, household objects, cars, coffee cups, bowls of soup, and food on platters. Then, he moved on to wrestling masks. He claimed he liked painting the principal subject on the bent sheet metal and cutting it out, because that way he didn't have to paint backgrounds.

With each subject his work would follow the same pattern. He would identify the object of obsession. He would discover a way to render that obsession. Not satisfied, he would render it in different scales, colors, and textures, each time changing the narrative as if he were creating an assignment for himself with a deadline. He would play it out as long as possible and

then suddenly be done with it, as if he were abandoning a boring lover. Then he'd move on to the next obsession.

After the food and wrestling masks came paintings of the talking heads. Seymour had gotten tired of cutting out the sheet metal and began to make paintings on the big flat sheets. The talking heads emerged when he used to watch the now canceled *McLaughlin Report*. This series of paintings depicted very square white men, bedecked in pastel golf shirts, conversing and laughing. The laughing white men looked like a combination of Dick Cheney, E. G. Marshall, and Warren Buffett all rolled up into one Waspy, middle-aged, middle-American man. You know what their laugh sounds like just by looking at the paintings.

Then, Seymour moved on to battle scenes from World War II. It was as if he had moved directly from the men who made war into the war itself. Here planes and parachutes create patterns of war. The planes are from World War II, but the soldiers are from World War I. The planes, tanks, and soldiers are reminiscent of metal or plastic battle toys. At first glance, the war patterns are pretty, like flowery wallpaper. At a second look, we discover the piles of dead bodies, smashed planes, and explosions behind the pattern and texture. The World War II paintings are Seymour's most recent work, and I think they are among his best.

The design writer Karrie Jacobs once commented that all graphic designers need to return to the styles they saw during their childhood, so they can correct the mistakes. This has resulted in a series of design revivals, styles from the '30s through the '80s, that have occurred over the past several decades. Each revival is tied to the prevailing age of the generation responsible for the revival. I'm not sure if this theory holds true for illustrators, but I see it reflected unconsciously in Seymour's drawings.

In the '60s, Push Pin designers and illustrators worked in a wide variety of historic styles, Victoriana, Jugendstil, art nouveau, and art deco among them. They used the styles as a tool to convey an idea or a specific spirit. As a designer-illustrator, Seymour has always been a master of this technique. In his work for the *Frankfurter Allgemeine Magazin*, he would identify some dumb premise, like cars of famous artists, and then render them in the style or period of the artists, demonstrating the absolute broadest range of style possible. He used a similar technique in the execution of his silk-screen series *Brylcreem Man*, though the point here is more ambiguous and the styles he employs less easy to identify.

However, Seymour's unconscious drawing style is definitely rooted in the '30s and early '40s, the years of his childhood. His cars are always extremely rounded, with small windows, even when the cars are supposed to be contemporary. Inanimate objects are also usually rotund and bulbous, resembling porky refrigerators. Buildings have lots of windowpanes and decorations usually rooted in deco. Even cats and dogs have bulky refrigerator-like body frames. They often have body types that are closer to old radios than to animal anatomy.

Seymour's drawn women wear a lot of hats and floral dresses. Their shoes are usually platformlike, looking as if they came from the '40s. Women's hairdos have permanent waves.

younger women sometimes look like me. Somehow everyone, including cats, dogs, and other animals, will look vaguely Jewish, vaguely Jewish and from the '40s.

Seymour draws with his left hand. The line of his drawings, as well as his handwriting, is off and awkward but amazingly distinctive. The awkwardness of line is always totally consistent, regardless of whether he is depicting something simple, like the outline of a flower vase, or complicated, like a hand. The consistency makes the awkwardness fluid.

Great drawing is pure confidence in one's own awkwardness to ensure consistency. Seymour's drawing is great. The specific consistent awkwardness is what makes Seymour's so recognizable. He is recognizable regardless of the media he chooses to use, which ranges from Pentel to colored pencil, to ballpoint pen, to acrylic painting on sheet metal to painting on canvas, to tempera on chipboard to drawing mixed with collage. He is recognizable regardless of the subject matter and regardless of the size of the drawing. In all media, and in all ways, he is always utterly, unmistakably Seymour.

Seymour's drawings have two full generations of imitators. Some of the contemporary imitators imitate the first generation of imitators. Student illustrators often imitate the imitators imitating imitators and often don't know that at the very root of it, there is Seymour. But if and when the imitators discover their own obsessions and are consistent in their own awkwardness, they cease to imitate Seymour, and they invent their own style. Generally, when they find that level of self-confidence, they have learned enough about illustration to understand how much Seymour has influenced them.

Seymour was world famous when I first met him in 1970. I was a senior in art school, and he was my hero. He was thirty-eight years old. Push Pin was referred to as "legendary." Seymour and his partner, Milton Glaser, were having Push Pin retrospectives at the Louvre in Paris, in Japan, and in South America. They had shows all over the world and they continued to have them together and individually. They still do.

It's funny remembering it now. Consider having a retrospective show when you are thirty-six or thirty-eight years old. It doesn't leave you much to look forward to. The book *The Push Pin Style* was published in 1969 when Seymour was thirty-eight. It influenced a whole generation of designers. In 1985 *The Left-Handed Designer* was published, Seymour's career monograph up to that point. That book influenced the next generation of illustrators and designers. *The Push Pin Graphic Book* was published in 2004, which introduced a still newer generation of illustrators and designers to the work of Push Pin.

Seymour's work from the early Push Pin days and later has also been endlessly recorded in every national and international design survey book regardless of its editorial slant. His most published piece of work is his 1968 antiwar poster, *End Bad Breath*. In the survey books, *End Bad Breath* is usually coupled with another antiwar poster, or an original alphabet Seymour designed, or a *Mobil Masterpiece Theatre* poster from the '80s, or something from the *Push Pin Graphic*, or something from his current publication, the *Nose*. But in these survey books he is locked in time, Seymour Chwast: Push Pin Studios, 1960s.

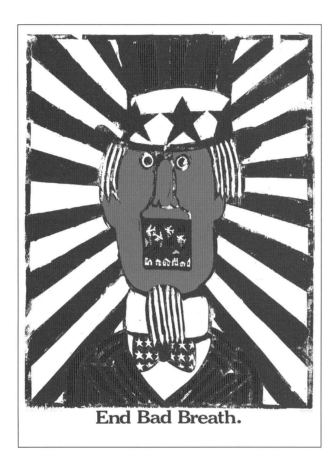

END BAD BREATH, OFFSET POSTER, WOODCUT WITH COLOR ADDED, 1968

Many of the women have hairdos and outfits like Barbara Stanwyck's in *Double Indemnity*. Men wear hats, even though hats went out with the Kennedy administration. Seymour loves drawing hats. Even when Seymour is conforming to a specific assignment to demonstrate contemporary fashion, it always looks a little off and the '40s slip in. It's as if the fashion is being commented on from a distanced perspective. Fashion, technology, and animate objects are never purely depicted in a straight way. It's unconscious, nondeliberate; when he is genuinely trying to be serious and accurate, the obsessions of the '30s and '40s seep through. These obsessions are Seymour's default mode. Also in Seymour's default mode are these specifics: women will look like his mother, telephones will be rotary, electrical appliances will have rounded corners, laughing businessmen will look like Milton Glaser, and

I am amazed at how many of these books have been produced since Philip Meggs's *A History of Graphic Design* (a compendium no one has yet improved upon). Most of these books serve as a historical overview of style or merely a catalogue of famous designers. When they discuss an individual designer, they trivialize the designer's work by reducing it to a snapshot with a date. They are also a somewhat depressing experience for the person catalogued (I write here from my own experience with it), because you are written about as if you are already dead. There is no possible way for the reader to have any feeling for or understanding of the individual who created the work, nor is there a sense that the making of the work is an ongoing process. Instead, the snapshot of work becomes iconic through its repetition in every survey book.

Iconic works by a broad variety of artists, designers in these instances, become roughly equivalent, and the artists by their inclusion also become equalized, regardless of their individual bodies of work. This either trivializes their work or elevates people who do not have significant bodies of work. But the worst aspect of the survey books for a working artist is that it makes you appear to be a dead legend. That type of star status is no honor.

Yet Seymour has always managed to work outside his reputation, his legend, his towering historical position, or even the area in which he's been pigeonholed. He lives far away from the survey books, the annuals, the awards, the blogs, and every other part of our profession that serves as a measuring device. Seymour is fairly oblivious to design buzz topics, gossip, who's hot and who's not. He had never Googled himself, so I showed him his Google posts; he looked at a few entries and said, "Look at all this stuff." Then he decided it was boring and went off to make another drawing and listen to TV.

Seymour can't absorb or remember industry gossip. I find this very frustrating, because I love to gossip. He confuses people, doesn't get the story straight, and generally has no apparent interest in it. I've often wondered if this is a defense mechanism that keeps him capable of working, totally absorbed and without distraction, or if it's that he simply works naturally without distraction, because his only interest is in making the drawing, and therefore he doesn't care about anything outside his work. Either way, it's amazing and unbelievable.

For me, the most inspiring part of living with Seymour is seeing firsthand his ability to keep working evenly, steadily, year after year, always making discoveries, always excited by the next project, ever ready to make the next drawing regardless of changing styles, changing economies, changing technologies, and the changing cast of characters in our industry. No success for Seymour has been so monumental as to turn Seymour's head from the daily occupation at hand. There has been no rejection, no failure so overwhelming that it would halt the daily output. In fact, often Seymour's failures are turned into his advantage. If a job is rejected, he will make another drawing, and if he has no work at all, he will make some up. Either way, no matter what else is going on, he will have to go to the studio between 7:00 and 7:30 a.m. and stay until 6:30 p.m. to be sure and make another drawing. How bad is that?

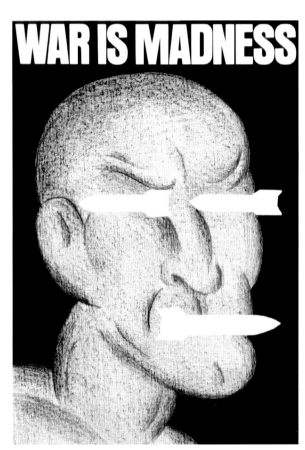

WAR IS MADNESS, OFFSET POSTER, CRAYON ON CANVAS, 1986

Seymour: The Interview
By the Author

S.C.: *Tell us something of your background.*
Chwast: I was a child of working-class immigrants. We lived a few blocks from the zoo in the Bronx, the way station between Harlem and Queens. While we had a Pekinese/Pomeranian dog named Queenie, I had no room of my own until I was twelve. My physical activity was limited by choice to tossing baseball cards, while comic books were my passion (I was around for the birth of Superman). By age ten I drew black-and-white comics with my own characters.

S.C.: *Do those books still exist?*
Chwast: They are lost; we moved a lot.

S.C.: *Did you see your future as a comic book artist?*
Chwast: Milton Glaser has described how early comics and Walt Disney affected his work. No one of our generation could get away from these persuasive influences. I learned how to exaggerate perspective, how to express emotions of my characters with simple clues, and how to draw living rooms. My cars still tend to have fenders, which disappeared from all models in 1955. I didn't learn how to draw hands from the comics. That came years later.

I did expect to be an animator and work for Walt Disney. That goal was abandoned when I found myself in a Brooklyn high school where I attended a class actually called Graphic Design. My teacher, Leon Friend, exposed us to great design by insisting on excellence. His students were pitted against each other to create the best poster or whatever. I learned that there is a lot of play in design—intellectual and visual manipulation, puns, tricks, parody, irony, and incongruity. I also learned the principals of design that I find hard to get away from in these freewheeling anarchic times.

S.C.: *Was your social consciousness aroused then?*
Chwast: I absorbed the political messages of Honoré Daumier, Georg Grosz, and Ben Shahn while I hung out with the left-wing kids of Coney Island where I lived. Later in my career my pacifist leanings prevented me from attending a party on the aircraft carrier *Intrepid*, permanently parked in a Manhattan pier (no great sacrifice). I never joined the Society of Illustrators, because it has a standing arrangement with the U.S. Air Force to glorify our airborne military through illustration by its members.

In the '60s I picketed a Woolworth store in New York in solidarity with those who wanted blacks to be able to sit at lunch counters in Woolworth's in the South. I marched in New York and Washington against the war in Vietnam. These efforts consoled my conscience while having little effect otherwise. Two of my antiwar posters, *End Bad Breath* and *War Is Good Business/Invest Your Son* were sold in poster shops, along with psychedelic rock posters. It probably would not surprise you to learn that war is still with us.

S.C.: *When did you get interested in typography?*
Chwast: My tenure at Cooper Union expanded my view of art as well as life. I drew, painted, and learned something of the craft of typography. *Old-Fashioned Phillip's Type Book*, with decorative and vigorous examples of Victorian styles, inspired me while I admired the latest modernist designs.

Cooper Union was the source of my art education and association with creative classmates. My twenty-year partnership with Glaser affected my life and work to a great and estimable degree. It was impossible to keep up with his immense talent.

From my days as a teenager through my twenties, I visited my cousin Dachine Rainer and her husband, Holly Cantine, in their cabin in Woodstock, New York. They had a print shop among the goats and chickens they tended, where they hand-set and printed an anarchist journal, *Retort*. Their letterpress was not much more modern than the one used by Gutenburg. With

his no-electricity cabin and print shop, Holly would have been more comfortable in the nineteenth century. Dachine wrote the introduction to my self-printed *Book of Battles*, comprising my hand-set type and hand-colored linocuts.

S.C.: Illustrators are concerned more and more about the present state of the field as well as the future. Actually, is there a future?
Chwast: The cliché tells us how much a picture is worth. But it seems to be worth less and less. I don't know how most illustrators earn a living since many markets have dried up and stock illustration, photography, and computer manipulation compete with current work and trivialize its value. Narrative illustration in graphic novels is flourishing, however, as well as computerized animation from the feature-film mill. Illustration has a glorious past and will have a glorious future with changes in methods, style, media, and markets.

S.C.: You've been at this for a long time. What changes have you seen since you started?
Chwast: The prevailing graphic styles inform illustration as well as design, the other applied arts, architecture, and fine art. I benefited from the work of Toulouse-Lautrec, A. M. Cassandre, Winsor McCay, Paul Rand, and Roland Topor, among others. I watched Victorian art turn to art nouveau, art deco through modernism and all the variations. I learned to hate the boring mass-magazine style of the '30s, '40s, and '50s (I have since gained a grudging appreciation for Norman Rockwell). I watched the development of psychologically based work to counter the sentimental and melodramatic illustration in advertising and magazines that persisted during that period. Design, abstraction, stylization, and painterly sensibilities imposed themselves. My woodcut style, after the German expressionists, fit very nicely. This new kind of illustration could be seen in the work of Robert Weaver, Jack Potter, Harvey Schmidt,

THE PUSHPIN ALMANACK, 1955
LEFT: COVER, ILLUSTRATION BY REYNOLD RUFFINS
RIGHT: LINOCUT

and others. The '70s saw the rise of "conceptual" work inspired by René Magritte and the surrealists.

Much of today's work in publications is cooler, cerebral, and diagrammatic. Advertisers seem to have discovered design, which for a long time was an anathema to them. (See iPod, Nike, and Target.)

While I'm not sure where work will take me, the possibility of conceiving something new is exciting and still gets the juices flowing. Among my techniques I have no preferences— woodcut, acrylic painting, colored pencil, flat color in an outline drawing. I swore off airbrush in high school when my classmate Jay Maisel (now a world-renowned photographer) won the first prize in a cancer poster contest we both entered. His airbrush work was better than mine. And now airbrush is obsolete anyway.

S.C.: How important has your painting become in your life?
Chwast: Very. At Cooper Union, where I gained a formal art education, my large canvas of a funny cow did not go over very well in my painting class. Since then I created papier-mâché sculpture and painted nudes, TV sets, and old toys on canvas. In 1990 I started to cut out and paint on sheet metal. Samples of these from series in food, Mexican wrestlers, and ordinary objects appear in their own sections in this book.

I half-seriously told myself that I started doing cutouts to avoid having to consider the backgrounds of paintings on stretched canvas. As with cutting wood or linoleum, the physical act of cutting the shape of the metal is a way of intimately bonding me to the work. I turned back to painting on canvas for the bigger dimensions to play with.

Few practicing illustrators have succeeded as "fine artists." Andy Warhol is probably the most famous artist who came from illustration (some people think he was always an illustrator). In any event, it is a curse to be an illustrator if one wants to be considered seriously by the art establishment. Saul Steinberg and Andrew Wyeth were victimized by the critics.

S.C.: Is there a real difference?
Chwast: Haven't we considered this question many times before? Fine art is supposed to rise above storytelling to have some sort of universal expression. When I paint for myself I've had to work against my instinct to "solve a problem," or relate to literary material, which is what I've had to do for my whole career. As we know, the line between the two disciplines has blurred since the '60s. Warhol, Steinberg, James Rosenquist, and others helped to make the distinction irrelevant. But there is a difference between the disciplines, and it should be pointed out to students. I've interviewed painting students who mistakenly thought their education could result in illustration assignments. Style and the visual language, however, necessary in illustration, are often foreign to painters.

I've become involved in a series of large paintings depicting battle scenes, not unlike the ones I drew as a preteen during World War II. Planes vs. tanks vs. planes vs. tanks of undetermined nationalities totally filling the canvasses. At first glance they suggest pretty wallpaper, while with closer investigation I hope to reveal the stupidity of war.

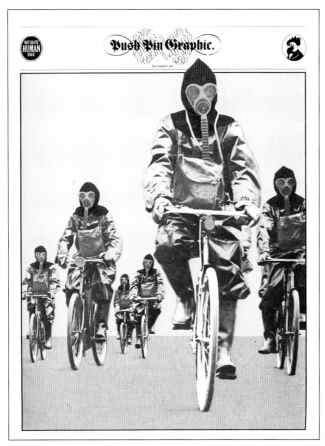

THE PUSH PIN GRAPHIC, COVER, HAND-COLORED PHOTOGRAPH, 1980

S.C.: Why do you continue to produce those minipublications?
Chwast: It started with Edward Sorel and Reynold Ruffins with a promotion piece we conceived, sending it to advertising art directors to attract freelance work while we had day jobs. It was a quaint four- to sixteen-page bimonthly. We called it the *Push Pin Almanack* to reflect our interest in anything old. Glaser, Reynold Ruffins, and other Cooper Union classmates joined us, and it was found to be successful.

After Glaser, Sorel, and I formed Push Pin Studios, we wanted a more flexible vehicle for promotion and expression. The *Monthly Graphic* (soon to be called *Push Pin Graphic*) satisfied our need for a freewheeling size and subject matter. All Push Pin artists, including Ruffins, Paul Davis, James McMullen, and Isadore Seltzer, contributed work. I was the sole remaining partner in 1982 when I shut down the labor-intensive and costly *Graphic*. At that time it had a conventional magazine format.

A publication series designed for promotion develops an identity and does not have to be totally reinvented for each issue. Work is created expressly for each issue, and editorial material is used to give meaning to the specific theme and create context for the art. For the last twelve years I've produced the *Nose*, a modest semiannual version of the *Graphic*, serving the same goal.

S.C.: Didn't you do a series of brochures for Mohawk Paper?
Chwast: Yes. Steven Heller and I produced elaborate pieces promoting the mill's paper and directed to designers. Each brochure explored a different graphic style: Jugendstil, art deco, de Stijl, futurism, Bauhaus, streamline, and surrealism. We used examples of each style from Steve's amazing collection and combined them with his equally amazing knowledge and insight of design history.

S.C.: You design, illustrate, and paint. What do you call yourself?
Chwast: An artist.

S.C.: What were the major influences in your work?
Chwast: Posters in history have been a huge source of inspiration for me. I studied their concepts and compositions along with scale, color, and form. They evoke drama, mystery, humor, and elements of poetry.

I've noted that one decade is often felt in my work: I intimately relate to the visual landscape of the 1930s. The movies, cars, art, and comics convey not a small amount of appreciative nostalgia.

S.C.: Do you have a philosophy?
Chwast: No. But there is conflict and contradiction. My design side looks for order within creative concepts, easy interpretation, and adhering to design principles. Illustration may relate stylistically to design and typography. My expressive side tends to ignore intellectual solutions, allow for a more individual personality, and be less gridded. It may be drawn from emotion whether authentic or applied as a technique or style.

I've been envious of media artists who find their style vision early and stick to it. I call myself a generalist, but it's another way of saying "a master of none." My lack of focus, however, allows me to explore a wide range of design idea possibilities executed the best way.

When I get an idea I ask myself three questions: "Is it beautiful, is it smart, and does it meet the goal of the end user and person who pays my bills?" For example, the iPod posters satisfy these criteria: they look great, I relate to the campaign, and they helped market iPods to the multitude. And they spawned many rip-offs.

S.C.: What are your obsessions?
Chwast: Well, if you mean repeated metaphoric symbols from the visual language, I can tell you a story. Some years ago I illustrated a story about gambling for a magazine. I drew a hand holding a pair of dice. I forgot that drawing a year later when I was asked to illustrate a similar article. My solution was an unconscious exact replica of the art of the year before. It was unsettling, and I was concerned that if ideas are retrieved from tracks in my brain it means that my work is in a rut.

My pervasive insecurity has been a boon. My fear of failure persuades me to work overtime to improve the work. I got my ideas from a barrel full of fish when I started working a half century ago. There are fewer fish these days. When I think I'll never do anything of merit again, I just slug it out until something appears that I like.

In order for messages to be understood by a wide audience, stereotypical images are used to convey the message. They often become clichés, especially in my case, with the many

Statues of Liberty that I've been forced to use to represent New York. Outside the Empire State Building and yellow taxis, there isn't much else to pick from. Feet and hands have appeared in my work too many times, but faces can never be overdone. Faces, faces, faces surreal, expressive, funny, tragic, steely faces. I've had at least two one-man shows exhibiting work where a head was the major graphic element.

S.C.: Any last words?
Chwast: Since I have the perspective of a person who has worked and observed over a half century, I've seen how the digital revolution has enlarged the creative possibilities for print as well as motion graphics. It seems that technology has advanced so that anything that can be imagined can be done. To produce great work, it takes the inspired mind of the artist to direct his or her talent to the technical mind on the other end. However, we should not use bells when only whistles are required.

My wife, Paula Scher, is responsible for the concept and the direction of the design. Her talent, persuasive power, creative energy, and matchless instincts know no bounds. We did not exhaust the choice of pieces we could have made for inclusion. Left out was work that was dated, clichéd, and bad, while some good pieces did not make the cut because they did not fit into any of the sections. I hope that those that did are worthy of your interest.

THE NOSE, COVER, INK ON PAPER, HAND LETTERING, 2000

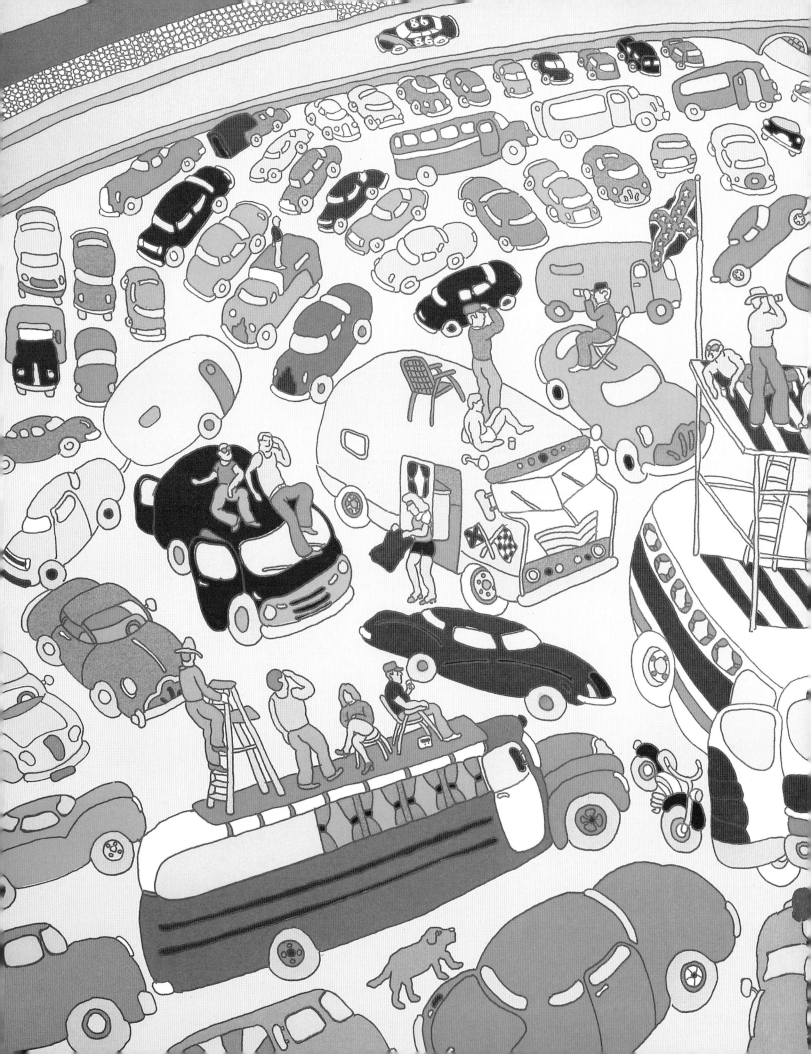

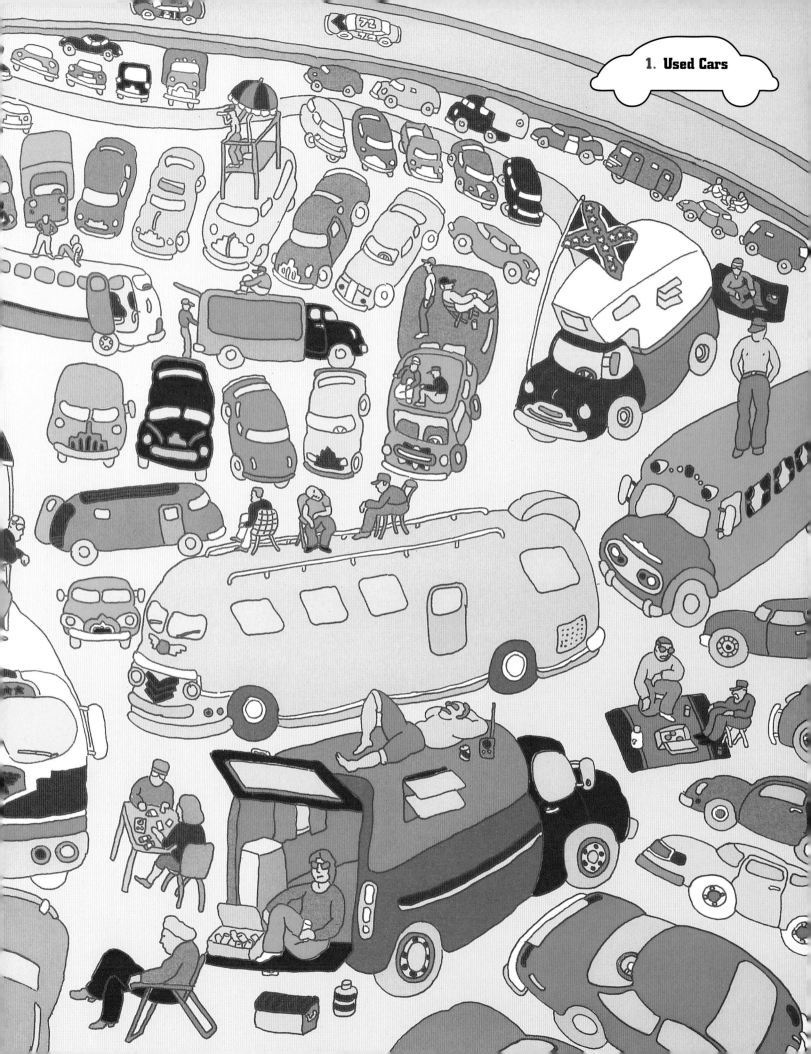

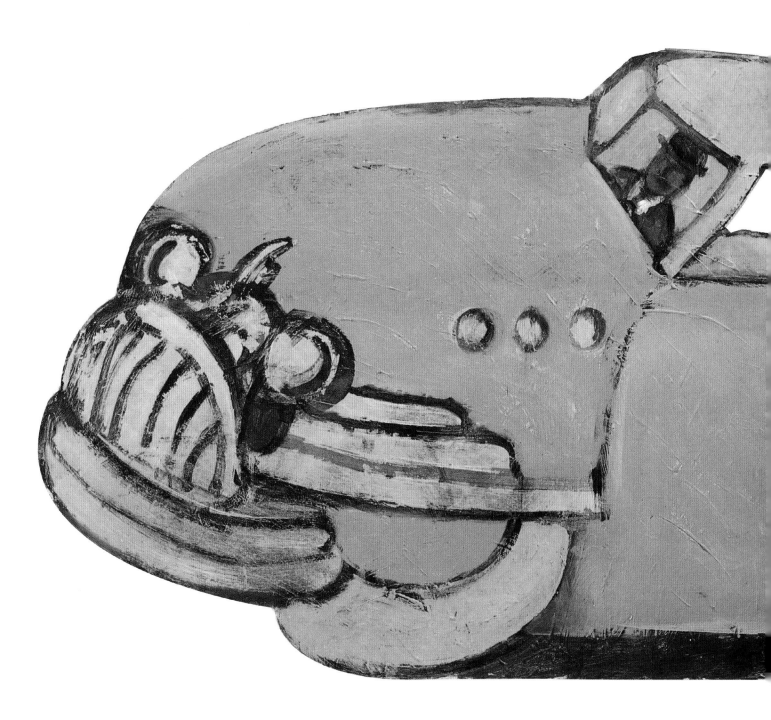

PREVIOUS SPREAD: *DAYTONA*, SILK SCREEN, 1972
GREEN AND PINK, ACRYLIC ON CUTOUT SHEET METAL, 1996
TOP: *DECOCAR*, PEN AND INK WITH DIGITAL COLOR ON PAPER, N.D.

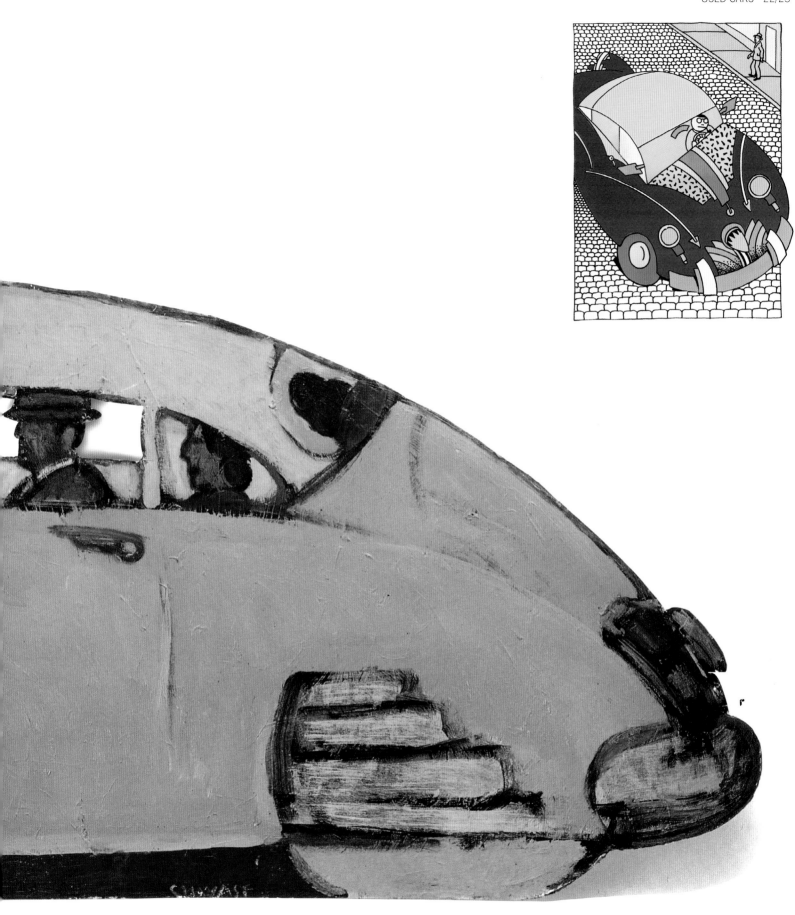

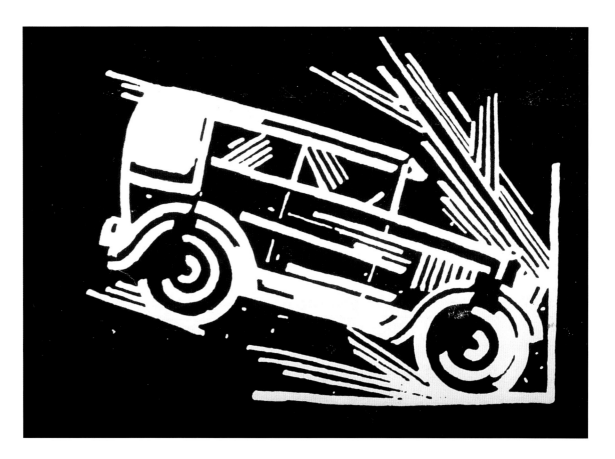

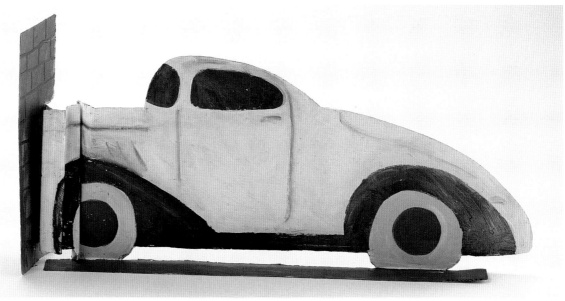

TOP: *LYONEL FEININGER'S CAR*, WOODCUT, 1988
COUPE DE GRAS, ACRYLIC ON CUTOUT SHEET METAL, 1994
RIGHT: COLLAGE, PEN AND INK, 1974

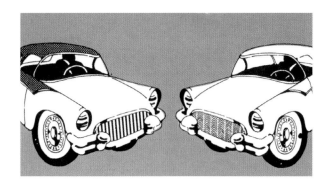

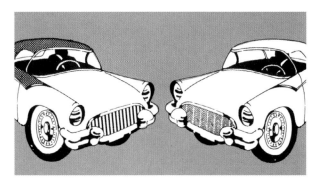

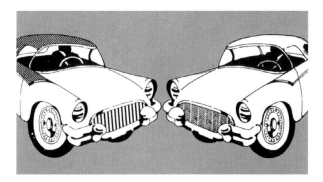

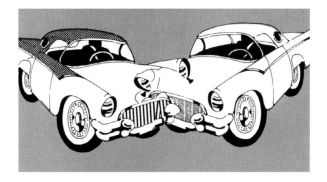

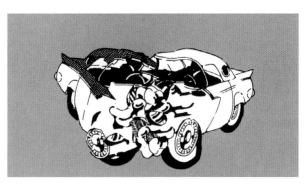

CUBICAR, PEN, INK, AND ACRYLIC ON PAPER, 1995

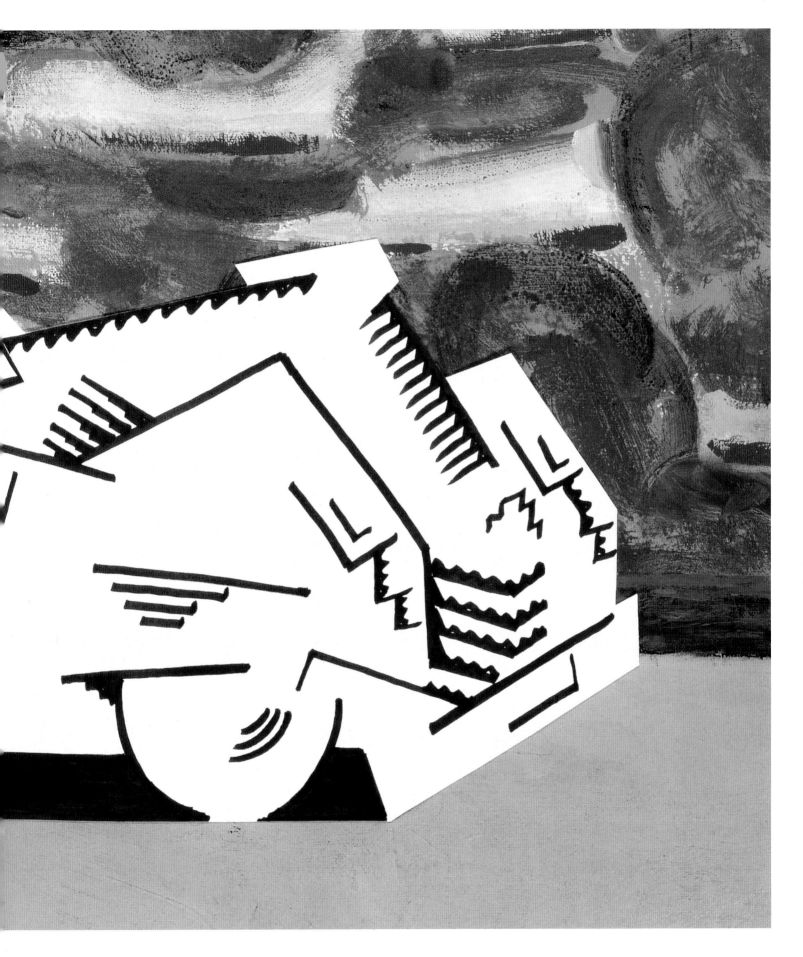

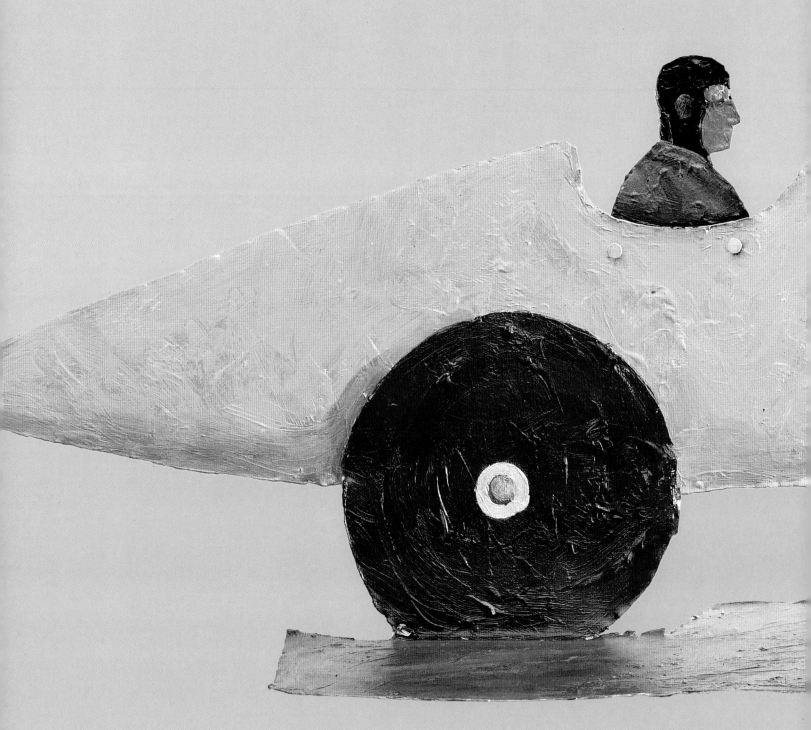

YELLOW RACER, ACRYLIC AND SCREWS ON CUTOUT SHEET METAL, 1992

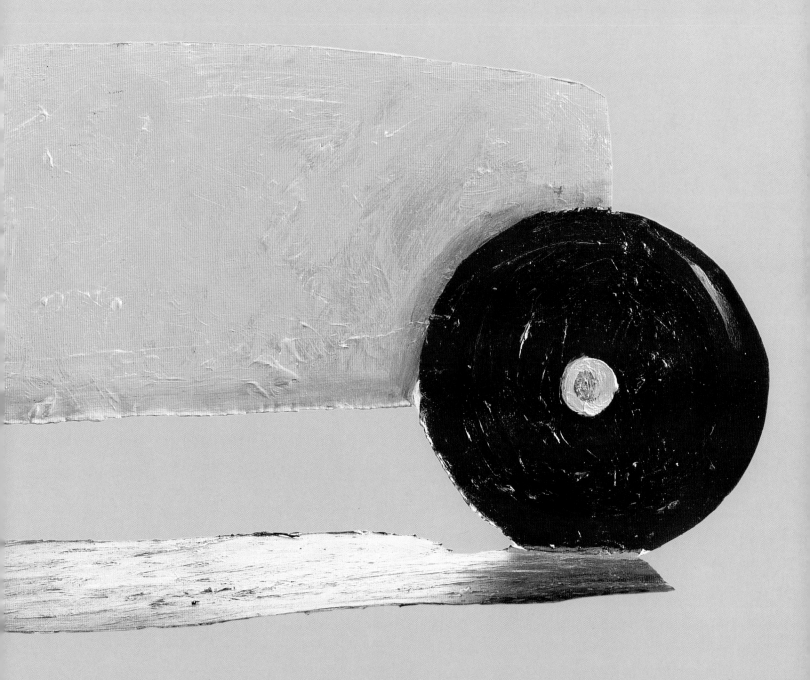

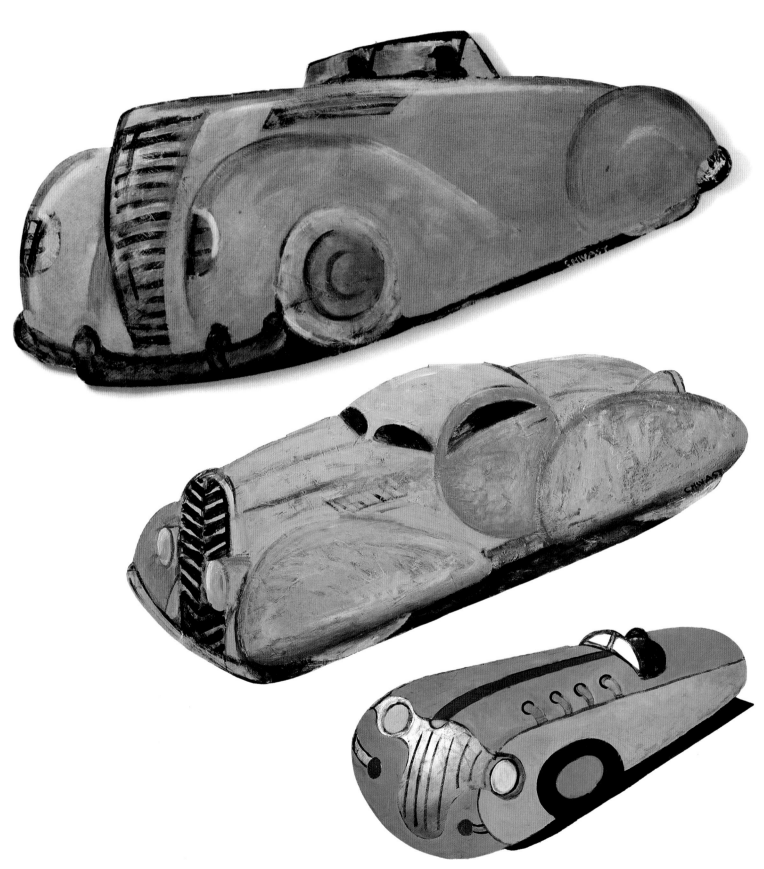

A CONVERTIBLE, A COUPE, AND A RACING CAR, ACRYLIC ON CUTOUT SHEET METAL, 1992

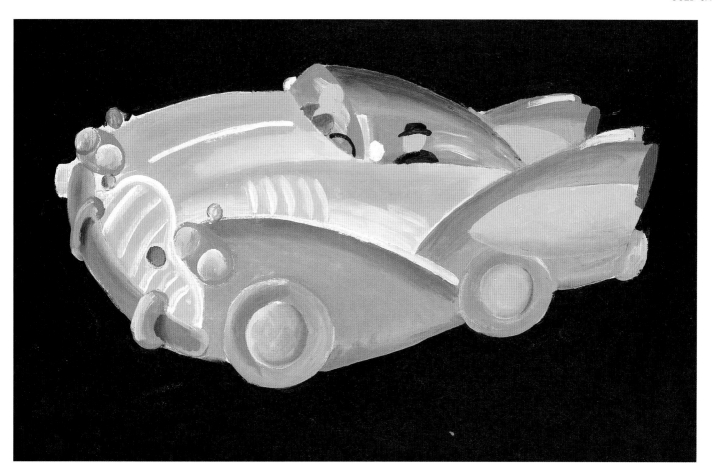

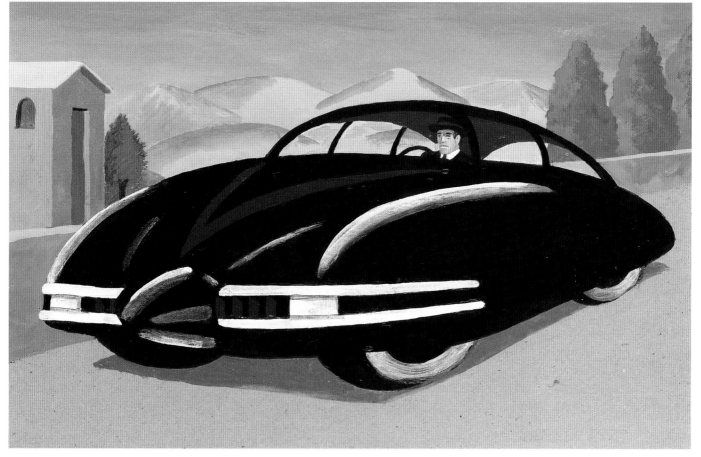

TOP: *FINS,* AND ABOVE: *DRIVING IN ITALY.* BOTH ACRYLIC ON PAPER, 1994

THE 10 COMMANDMENTS TRUMP THE 7 DEADLY SINS, COLLAGE, 1995

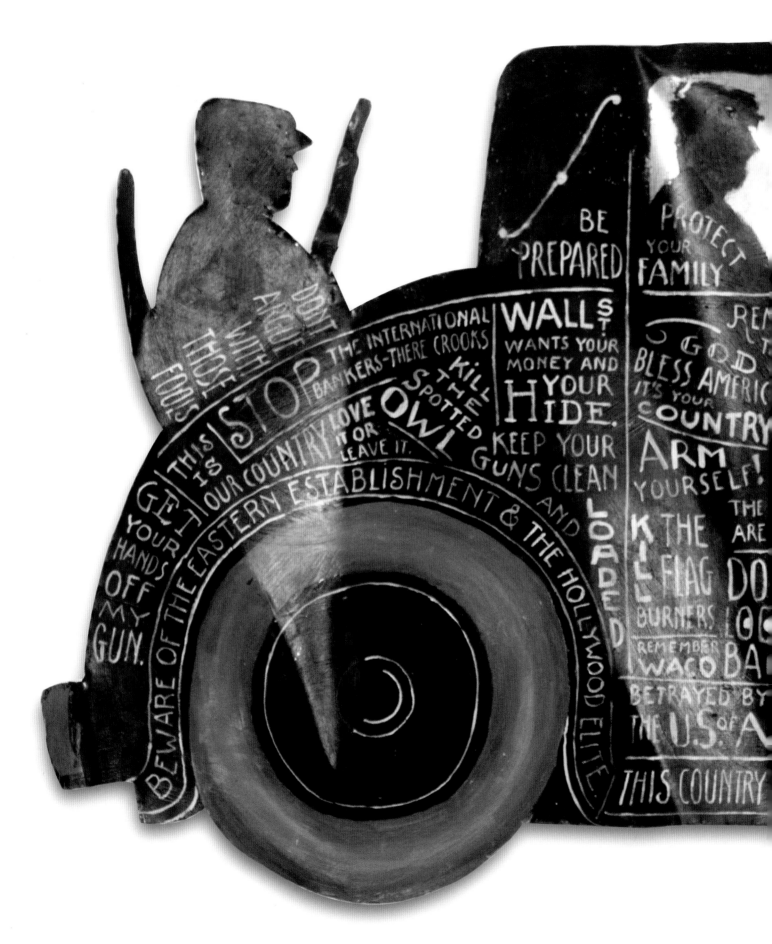

MILITIA CAR, ACRYLIC ON CUTOUT SHEET METAL, 1990

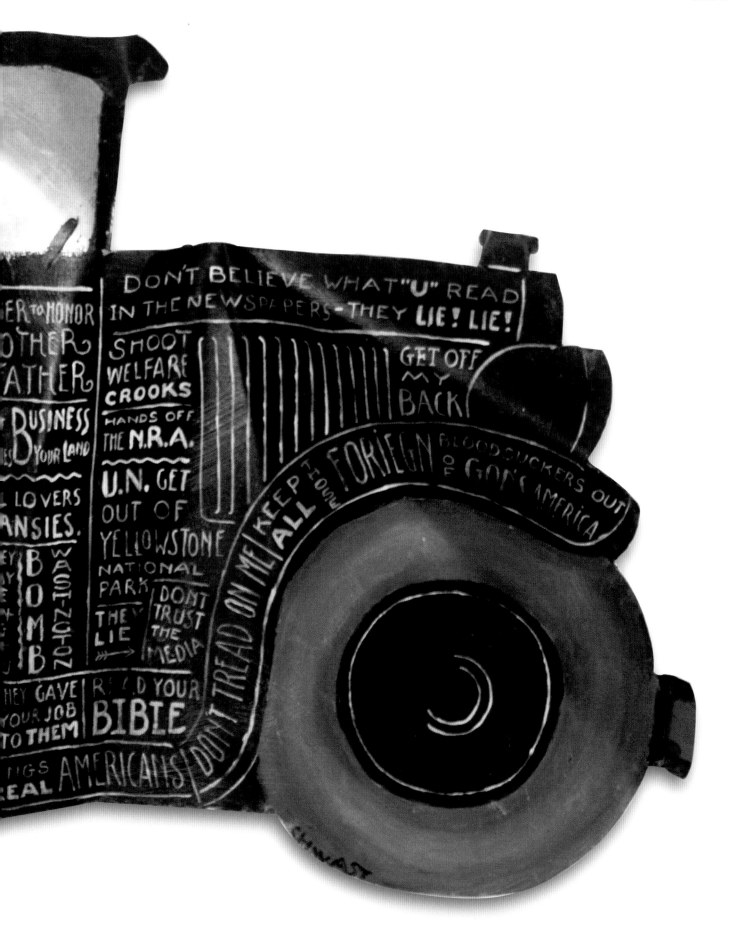

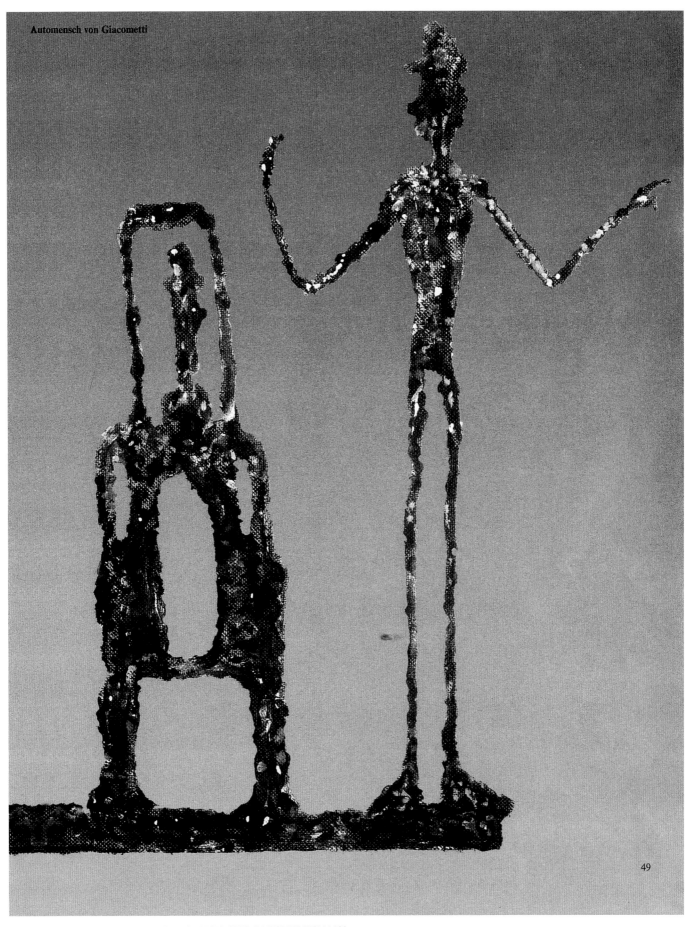

Automensch von Giacometti

49

THIS AND THE FOLLOWING SPREAD: *IMAGINING ARTISTS' CARS*, ALL WORK IS FROM 1988
ALBERTO GIACOMETTI'S CAR, MIXED MEDIA

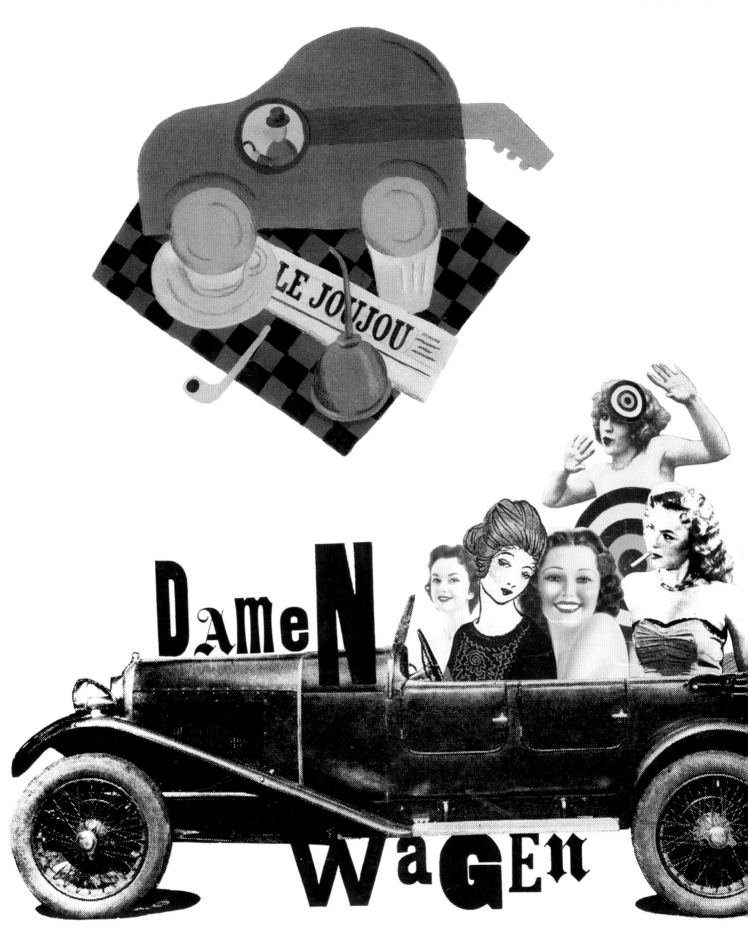

TOP: *JUAN GRIS'S CAR*, ACRYLIC ON PAPER
KURT SCHWITTERS'S CAR, COLLAGE

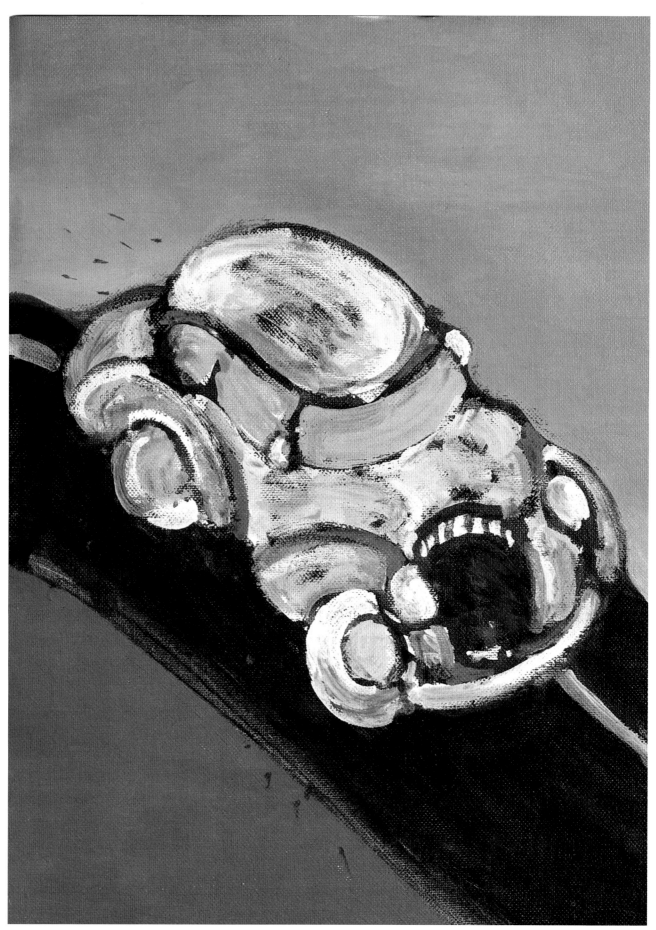

FRANCIS BACON'S CAR, ACRYLIC ON CANVAS

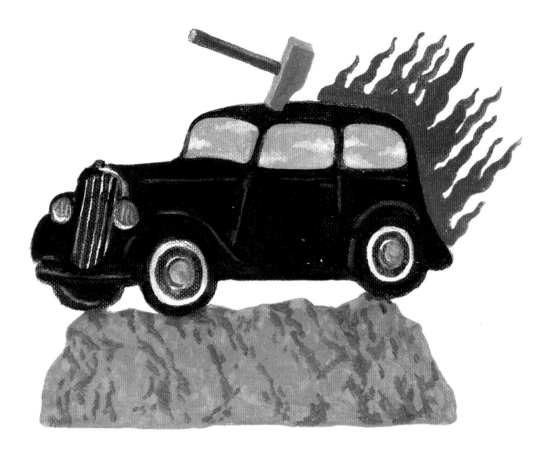

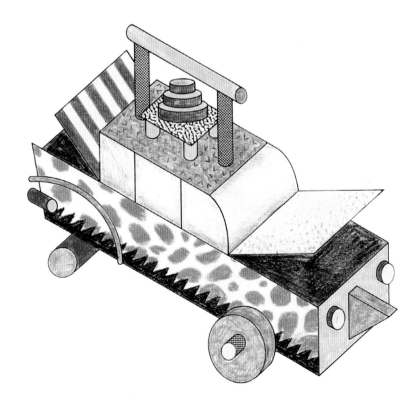

TOP: *RENÉ MAGRITTE'S CAR*, ACRYLIC ON PAPER
ABOVE: *ETTORE SOTTSASS'S CAR*, PEN, INK, AND COLORED PENCIL ON PAPER

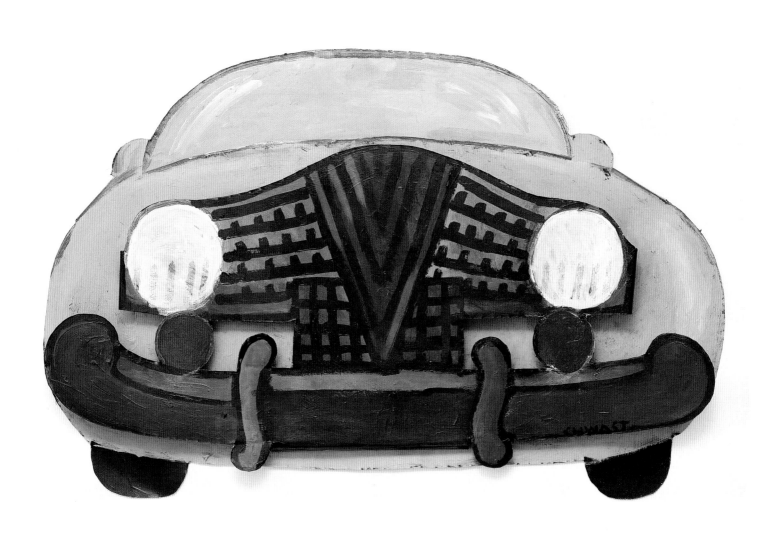

SEDAN, ACRYLIC ON MULTILAYERED CUTOUT SHEET METAL, 1994
RIGHT: *BETTER BUGATTI*, ACRYLIC ON CUTOUT SHEET METAL, 1994

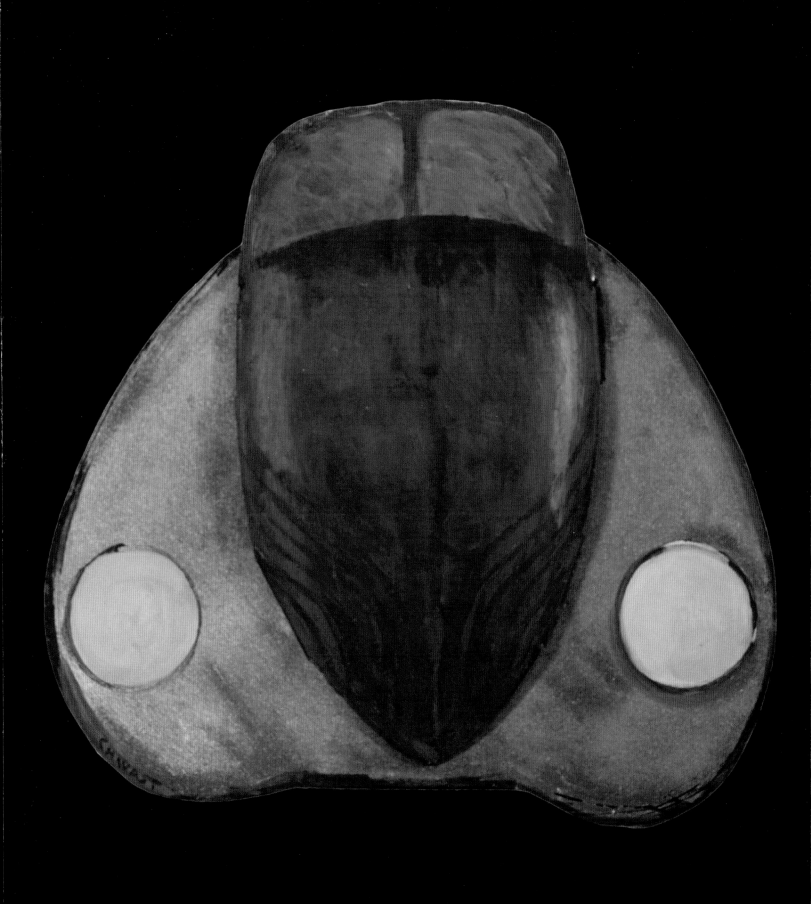

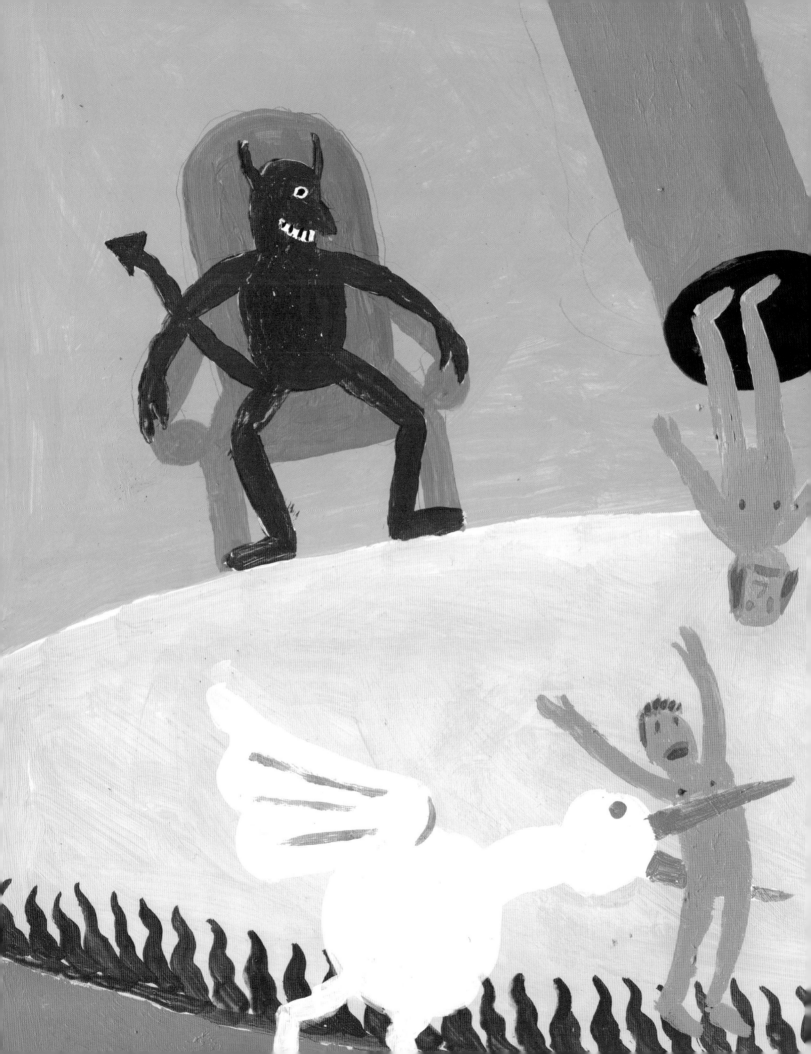

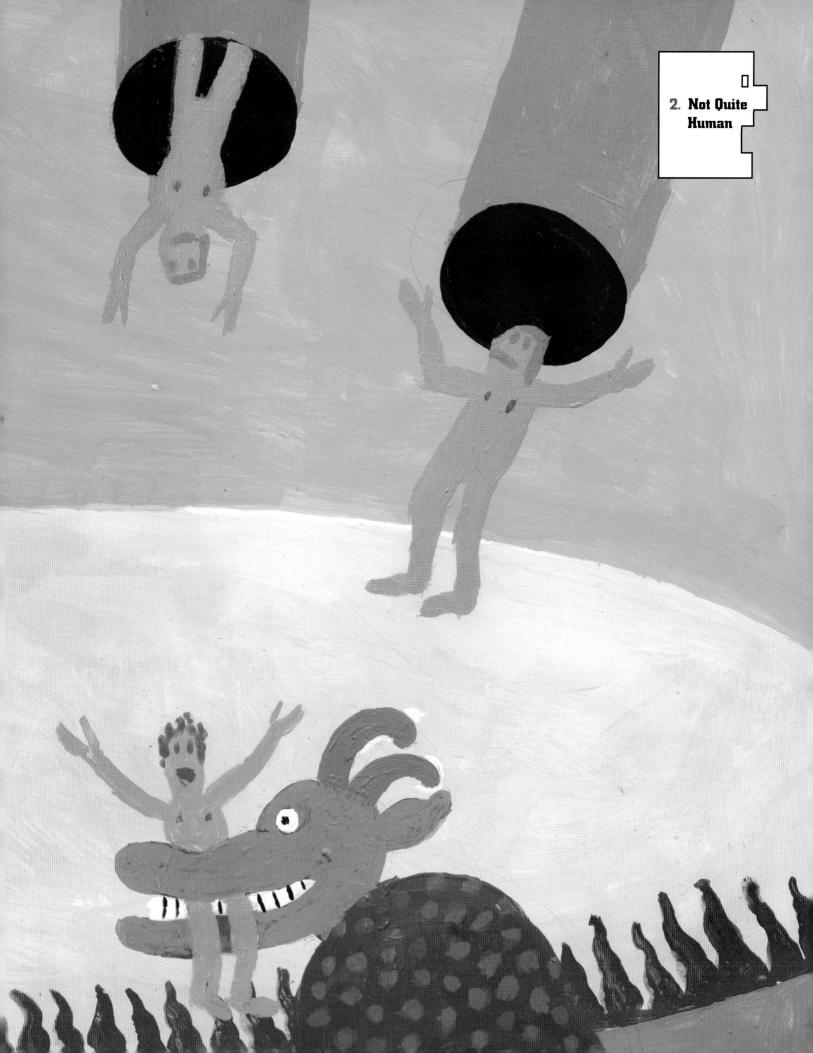

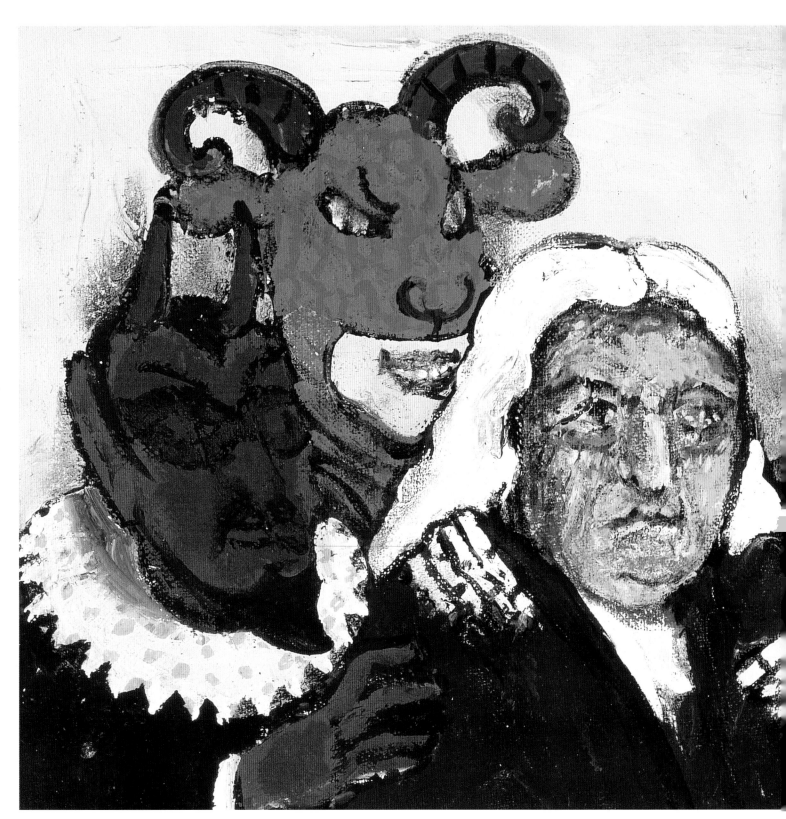

PREVIOUS SPREAD: *HELL, REALLY*. ACRYLIC ON BOARD, FOR THE *NOSE*, 2004
THE DEATH OF BACH, ACRYLIC ON BOARD, 2004

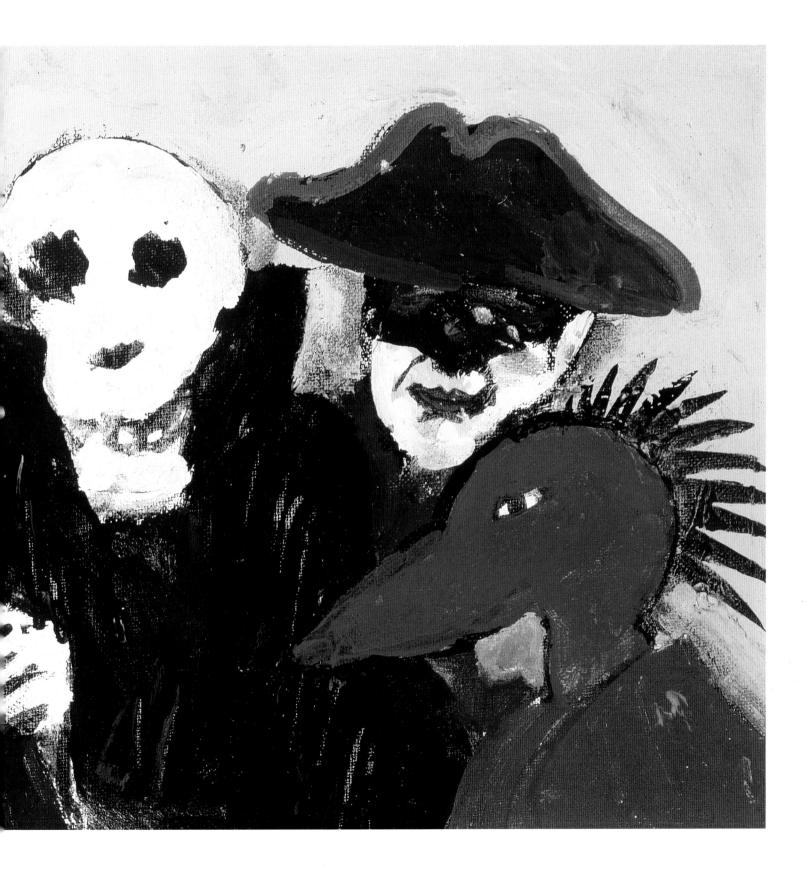

OPPOSITE AND ABOVE: MAGAZINE ILLUSTRATIONS, MONOPRINTS, C. 1968.

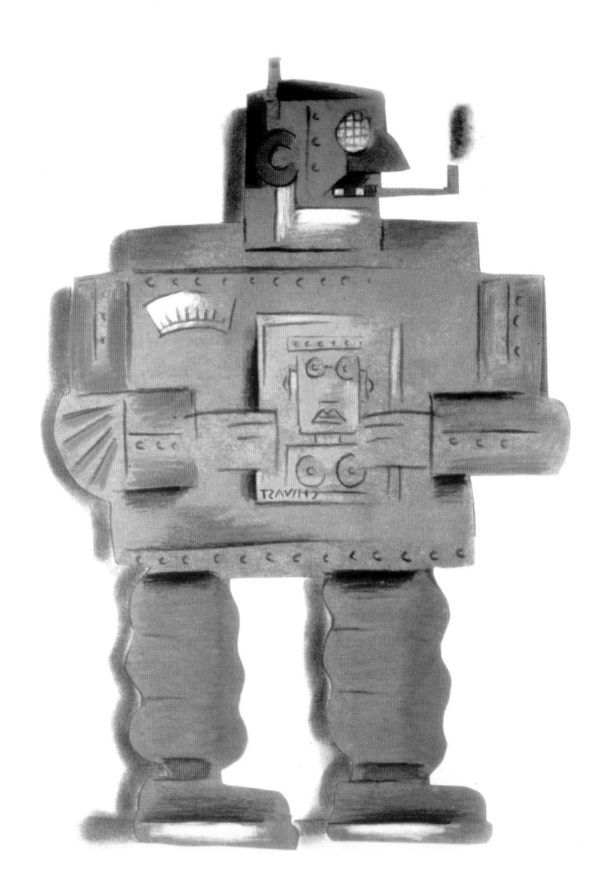

ART FOR AN EXHIBITION POSTER, PEN, INK, AND COLORED PENCIL, 1997

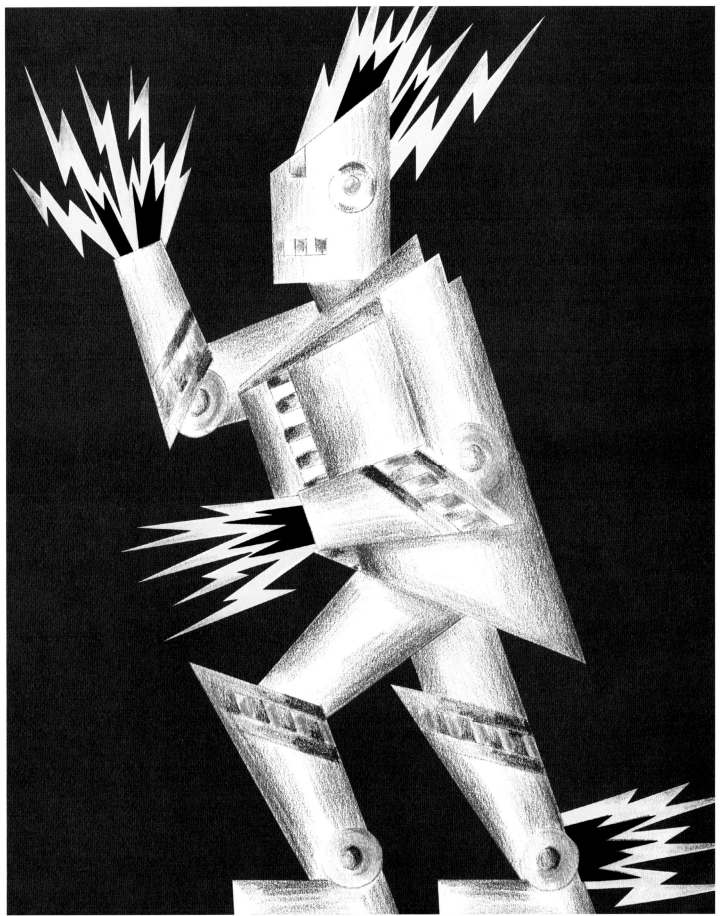

FUTURISM, COLORED PENCIL, DIGITAL COLOR, AND GLOSS STAMPING, 1990

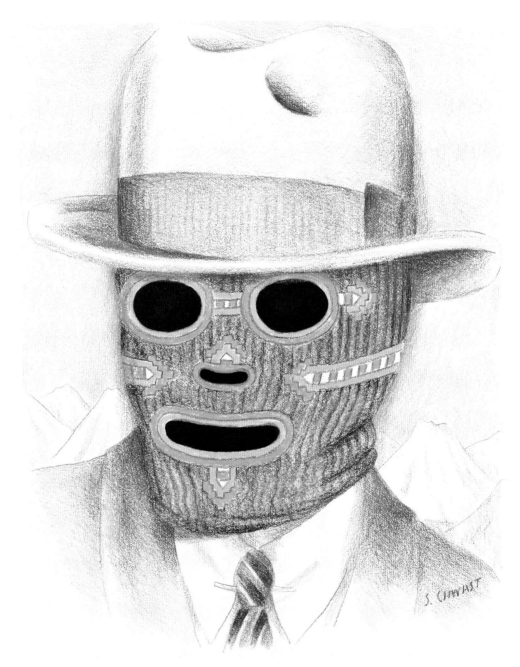

SKIER IN BUSINESS, COLORED PENCIL ON BOARD, 1995
OPPOSITE: *EUROPEAN TERRORIST*, PEN, INK, AND COLOR FILM, N.D.

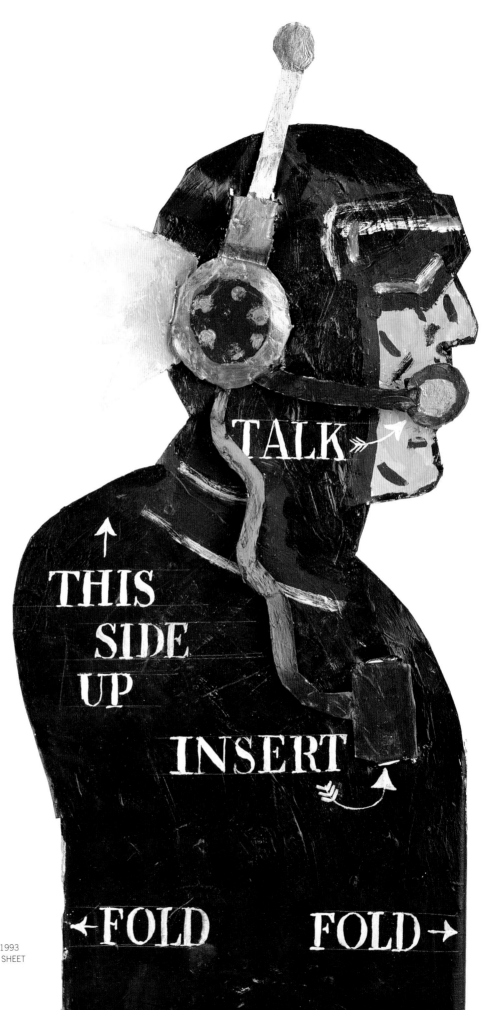

MODERN TIMES, ACRYLIC ON CUTOUT SHEET METAL, 1993
OPPOSITE: *CATCHING THE 5:23*, ACRYLIC ON CUTOUT SHEET
METAL, 1992

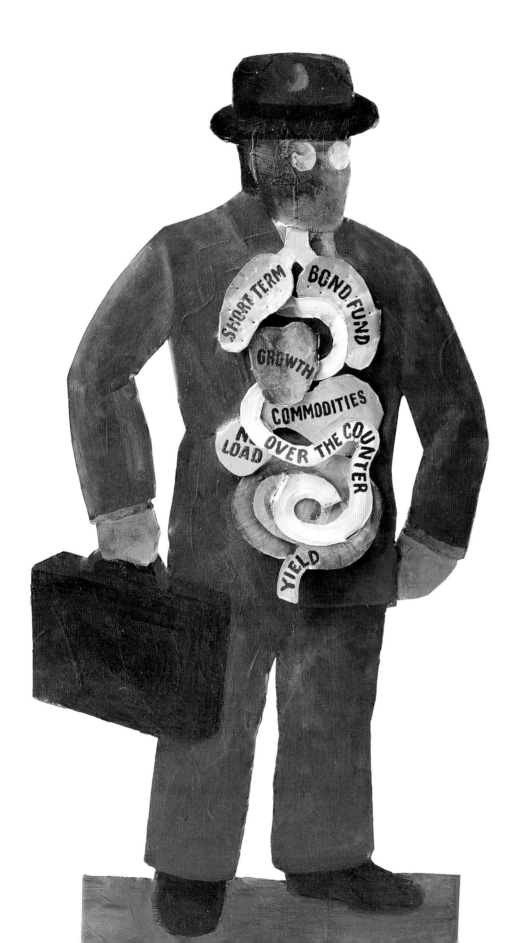

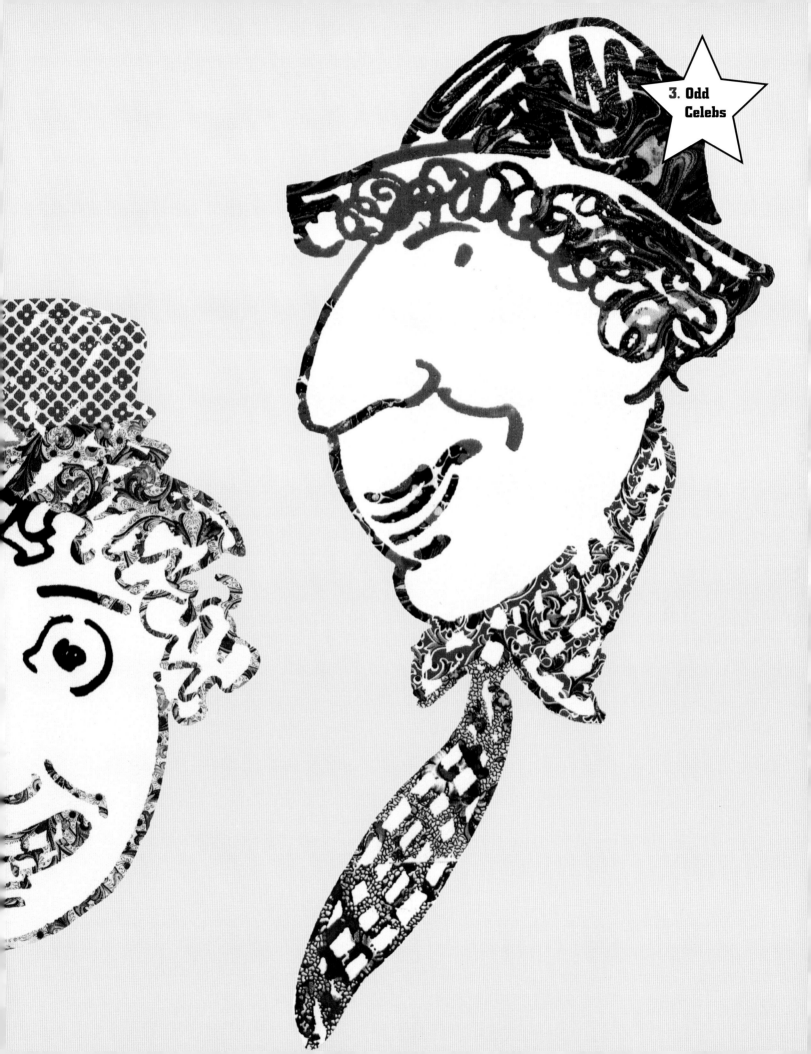

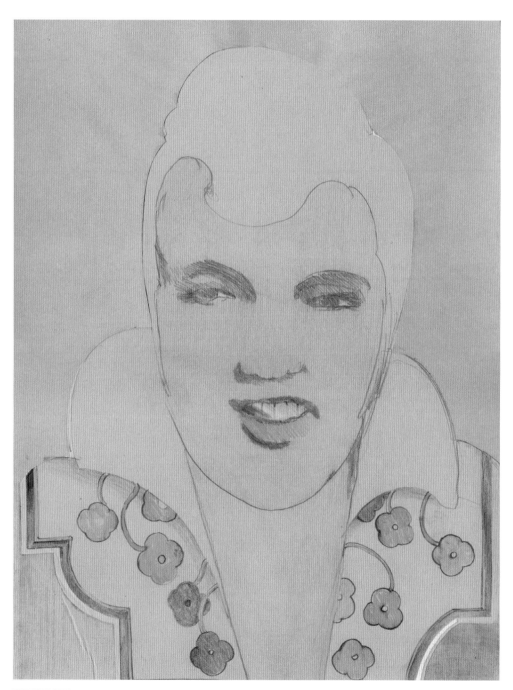

PREVIOUS SPREAD: *THE MERRY MARX BROTHERS*, MIXED MEDIA, 1990
THE KING, GRAPHITE AND COLORED PENCIL ON COLORED PAPER, 1971

ELVIS AND FRIENDS, COLLAGE, 1985

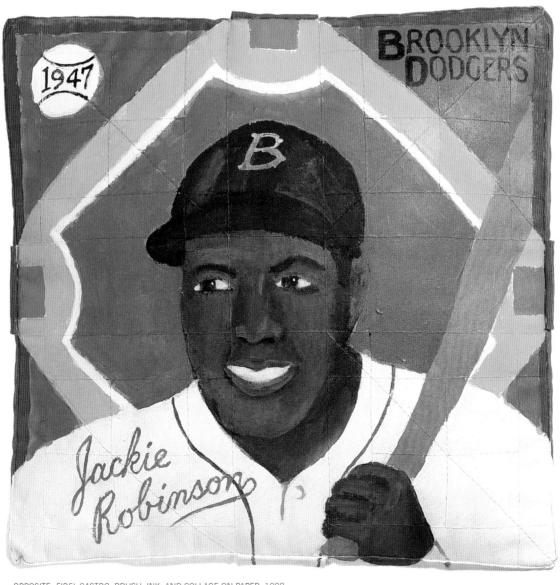

OPPOSITE: *FIDEL CASTRO*, BRUSH, INK, AND COLLAGE ON PAPER, 1998
JACKIE ROBINSON, ACRYLIC ON HOME PLATE, C. 1989

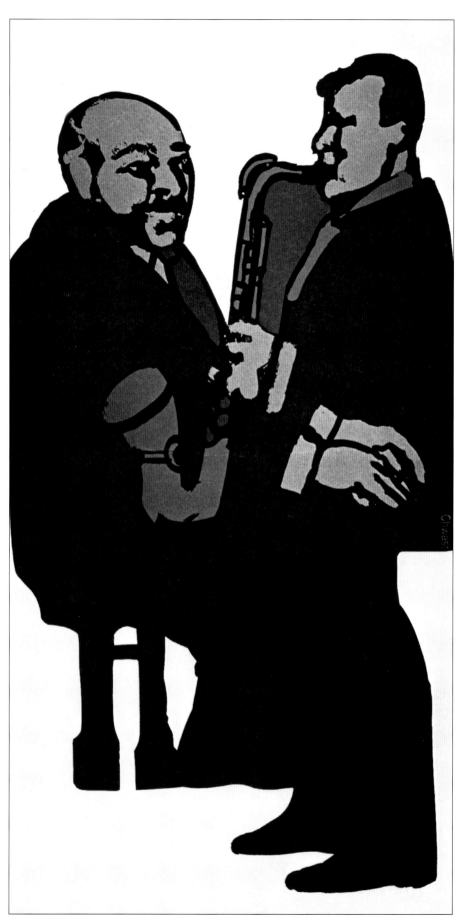

BASIE AND GETZ, CONCERT ANNOUNCEMENT, BRUSH, INK, AND COLOR FILM, 1964

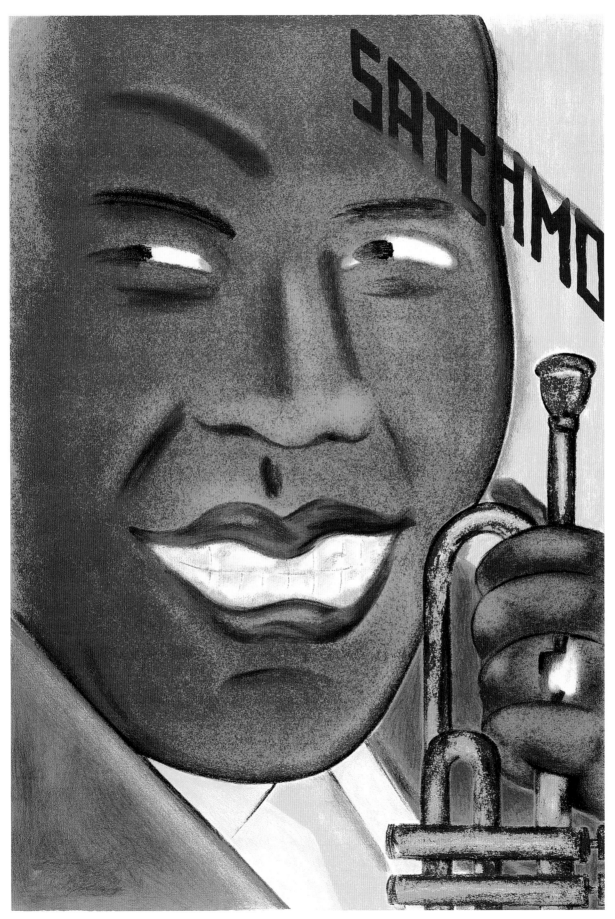

SATCHMO, SILK SCREEN, 1989

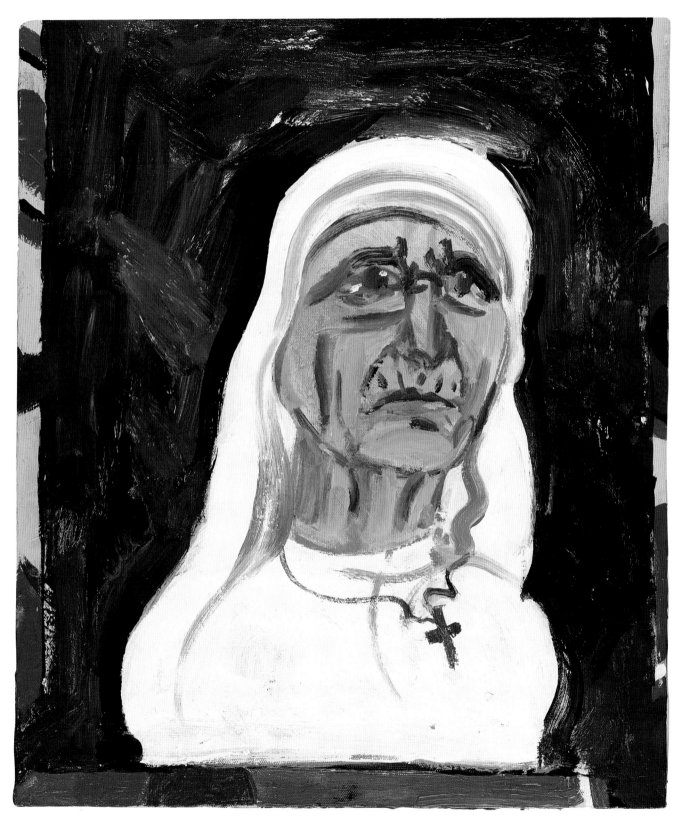

OPPOSITE: ILLUSTRATION FOR POEM, PEN AND INK, 2006
MOTHER TERESA, ACRYLIC ON CANVAS, 1997

CARUSO, MIXED MEDIA, 1997
OPPOSITE: ALBERT EINSTEIN, PEN, INK, AND COLORED PENCIL, 1997

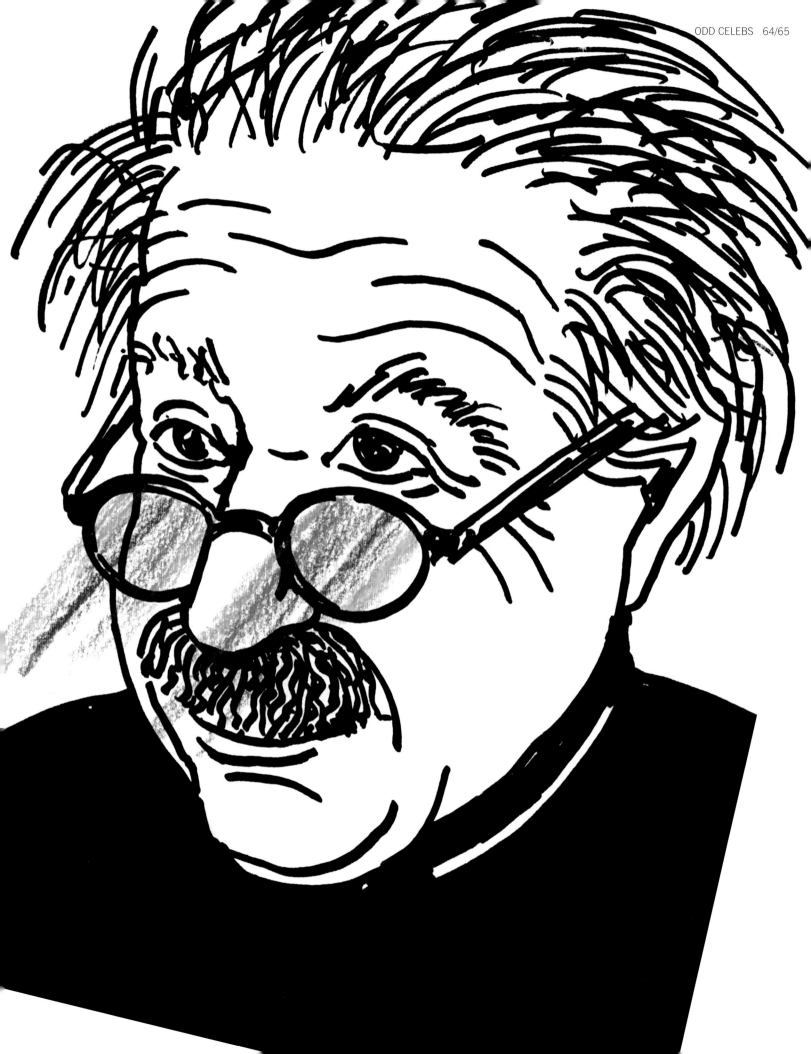

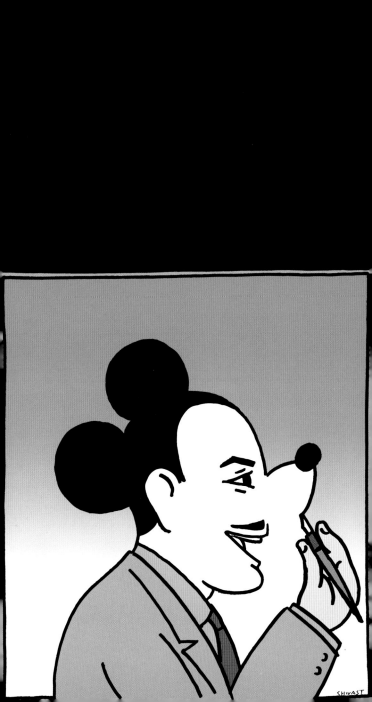

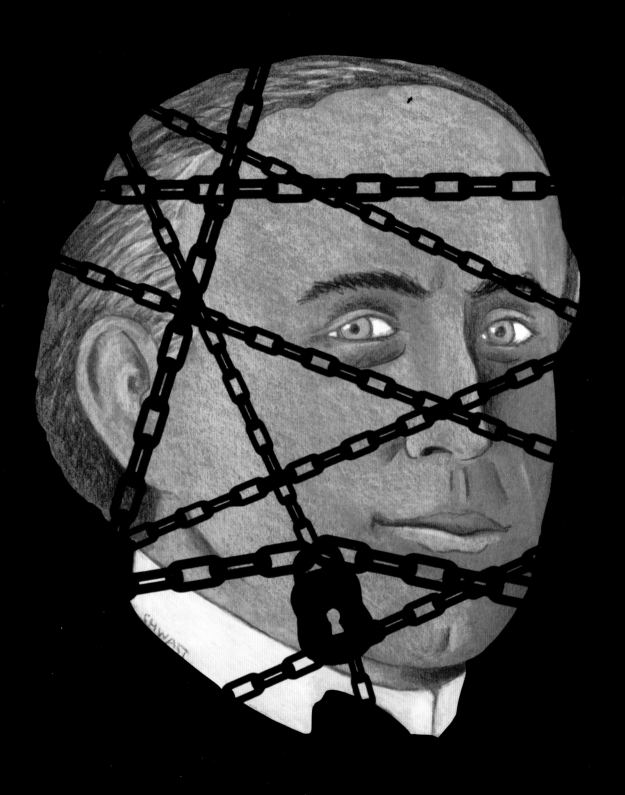

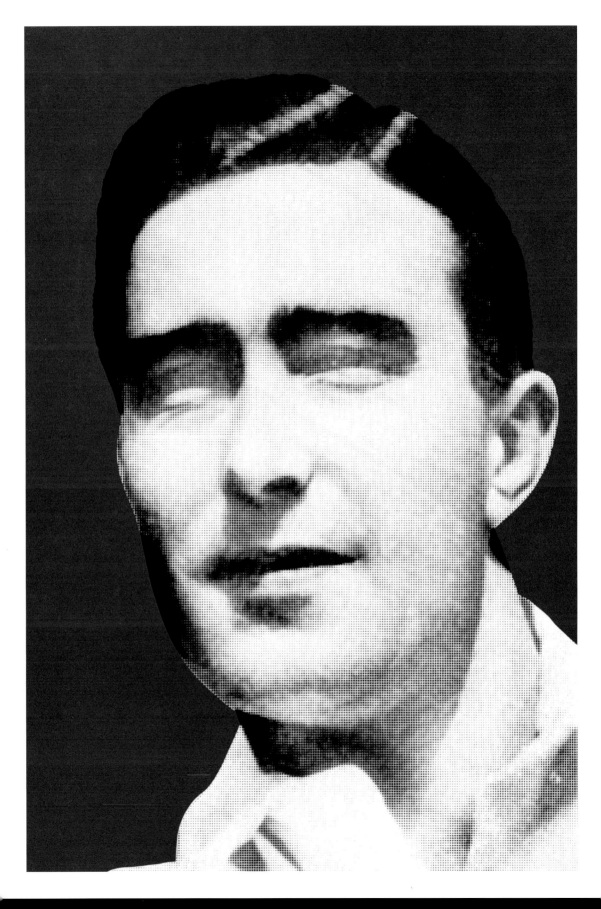

A SELECTION FROM A SUITE OF FIFTY-THREE MANIPULATIONS, DISTORTIONS, AND CORRUPTIONS USING THE SILK-SCREENED 24" X 36" IMAGE ABOVE.
T ORIGINATED IN ADS APPEARING IN MAGAZINES DURING THE MID TWENTIETH CENTURY. MIXED MEDIA, 1998.

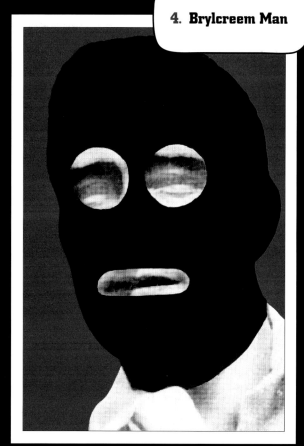

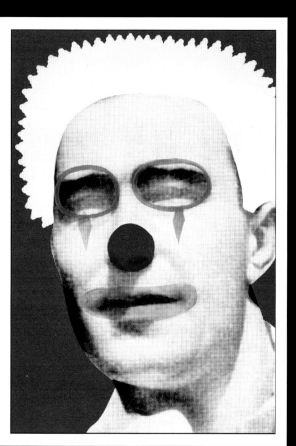

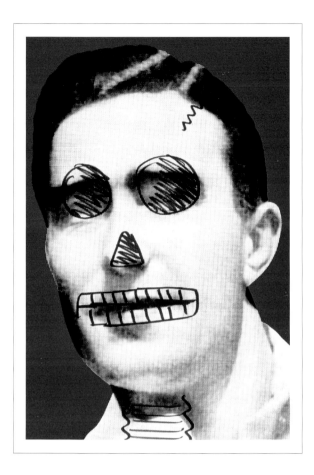
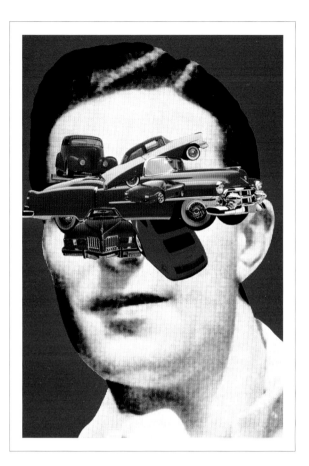
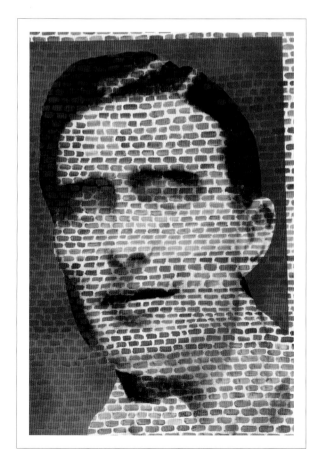

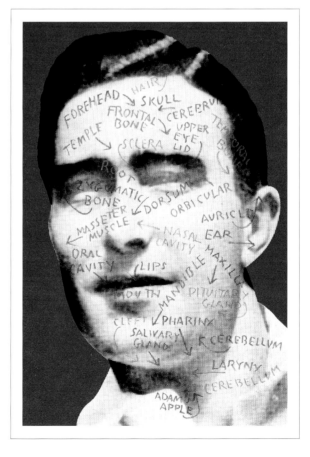

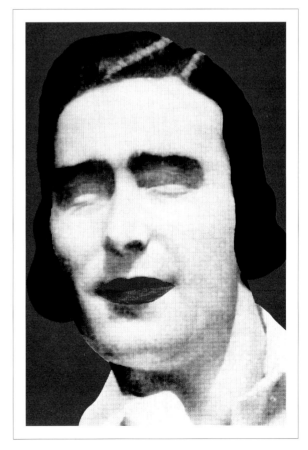

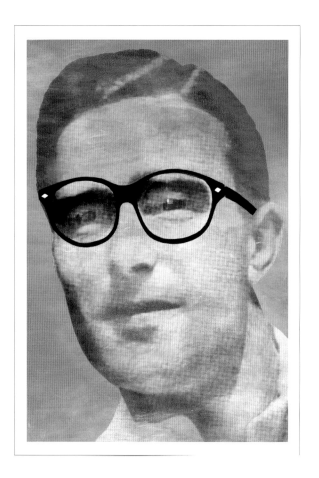
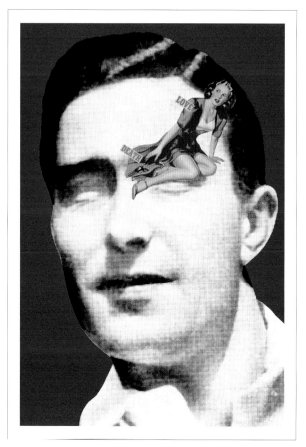
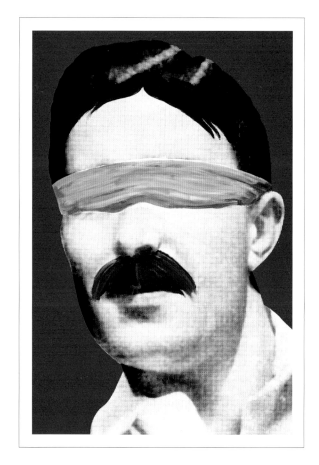
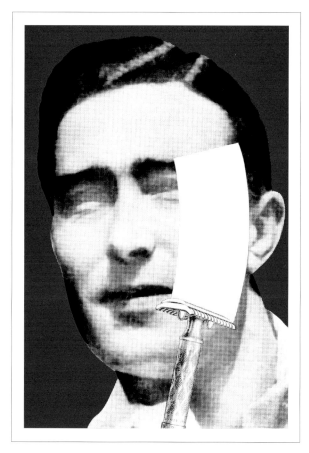

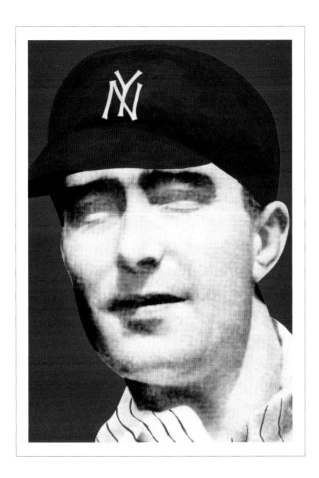
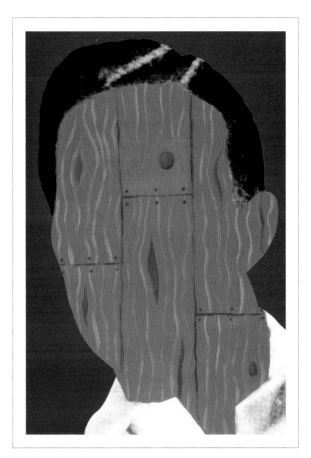
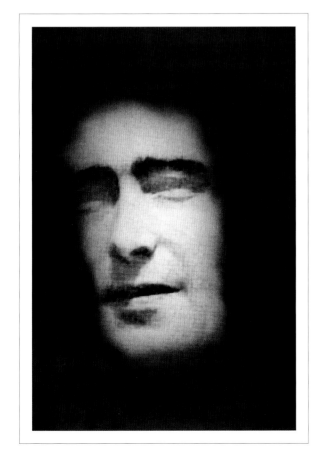

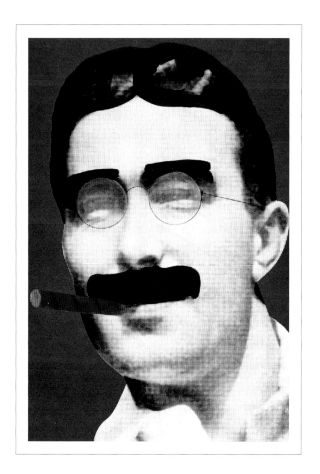

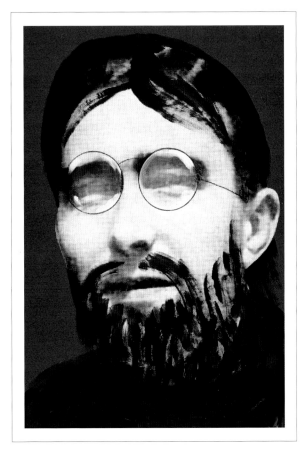

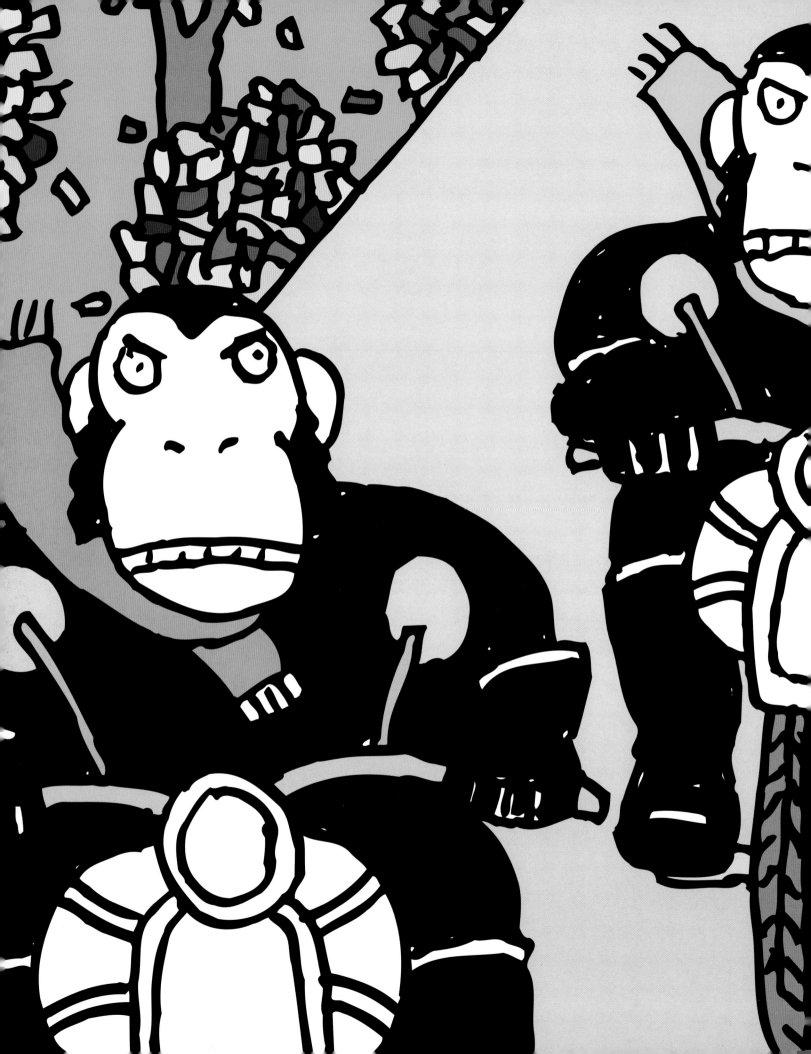

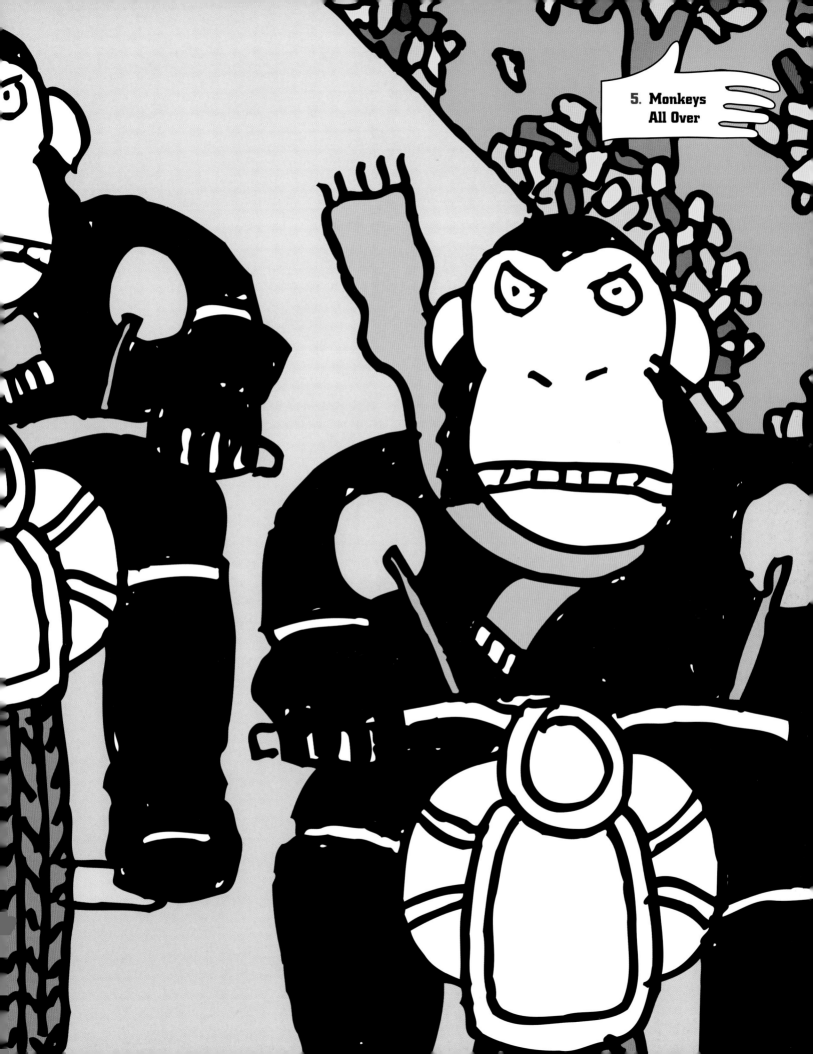

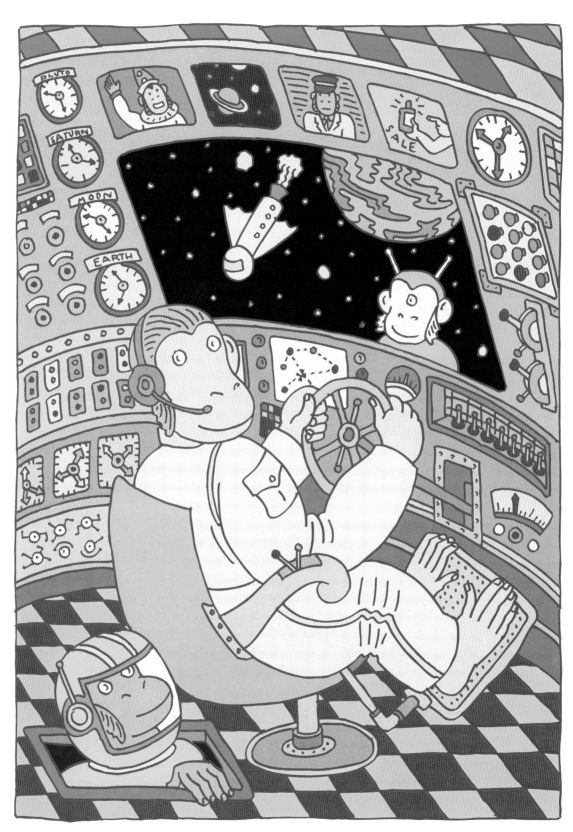

PREVIOUS SPREAD: *THE WILD ONES*, PEN, INK, AND DIGITAL COLOR ON PAPER, 2003
SPACE CRAFT OF THE APES, PEN, INK, AND DIGITAL COLOR ON PAPER, 2003

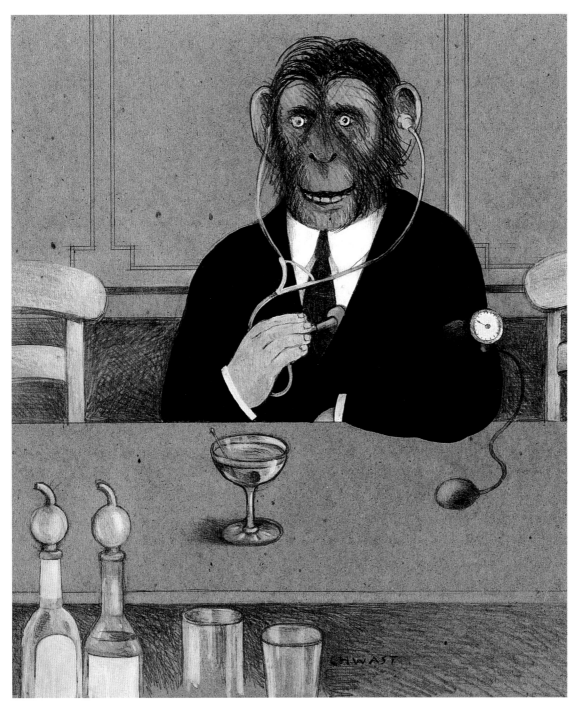

ANIMAL TESTING, GRAPHITE AND ACRYLIC ON BOARD, C. 1975

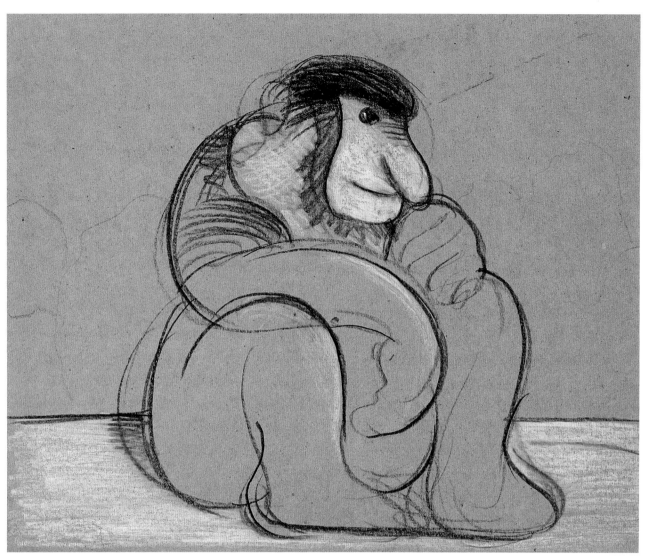

PENSIVE MONKEY, COLORED PENCIL AND PASTEL ON WRAPPING PAPER, 2006
OPPOSITE: *METAL MONKEY*, ACRYLIC ON CUTOUT SHEET METAL, 2003

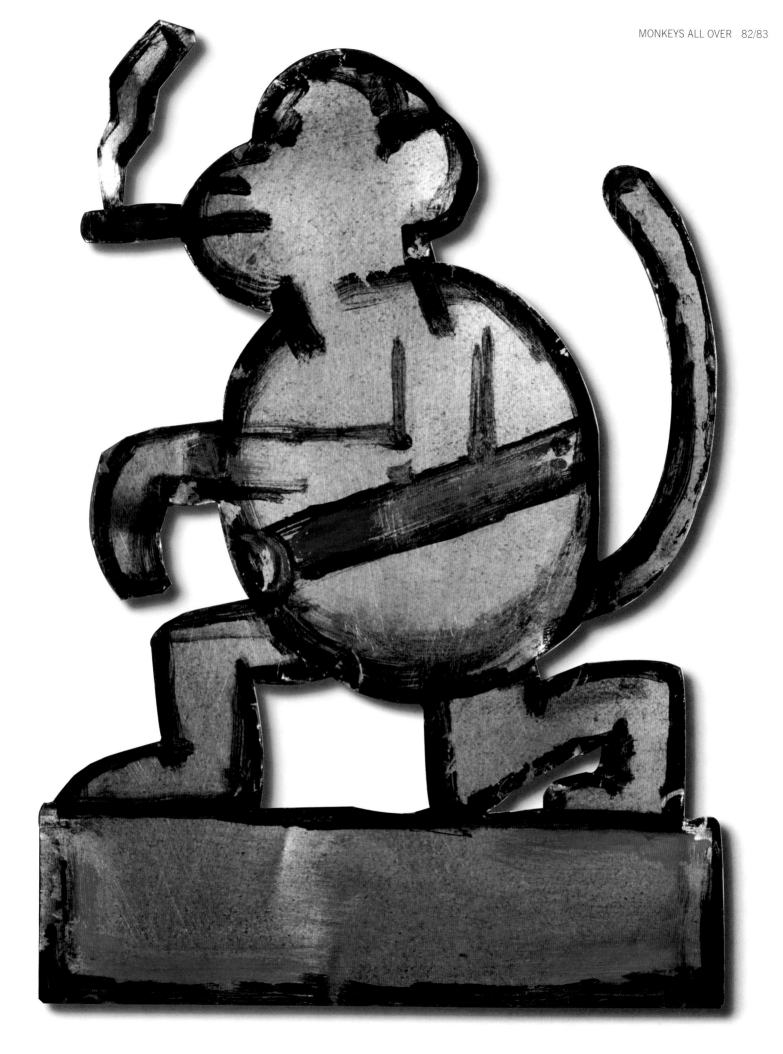

Cut Along Line

Cut Out

Cut Out

Cut Out
Attach String

Cut Out
Attach String

GENT, PEN AND INK ON PAPER, 1978

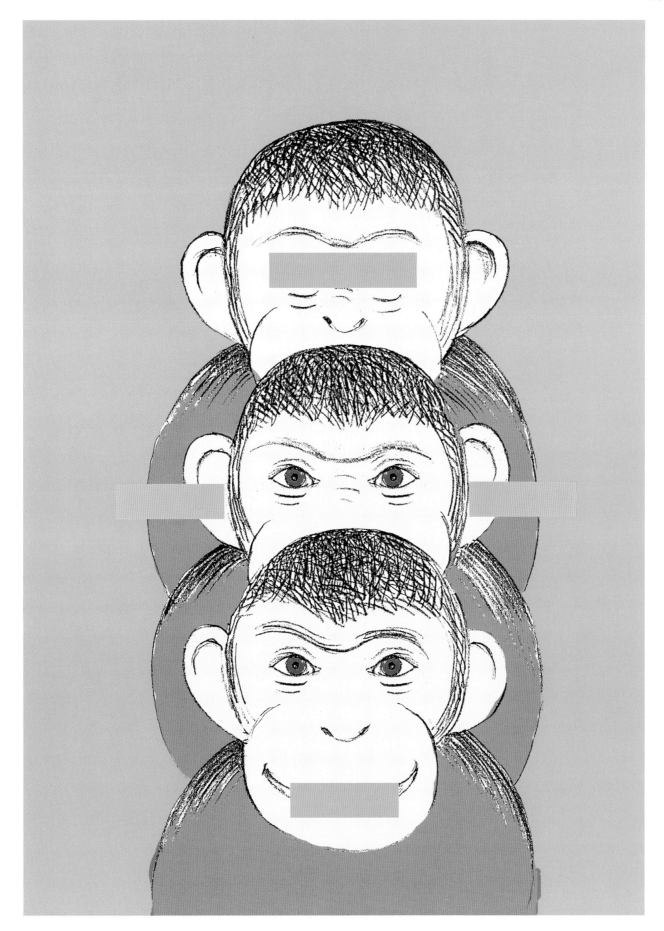

NO EVIL, CHINA MARKER AND DIGITAL COLOR ON PAPER, 2003

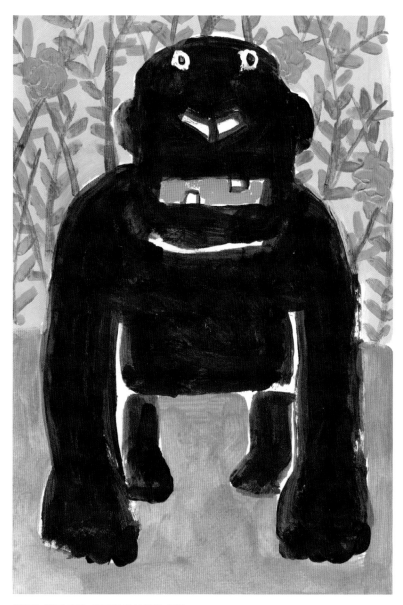

DENTAL CONCERNS, ACRYLIC ON PAPER, 2003
OPPOSITE: *FRIGHT*, WOODCUT ON PAPER, 2003

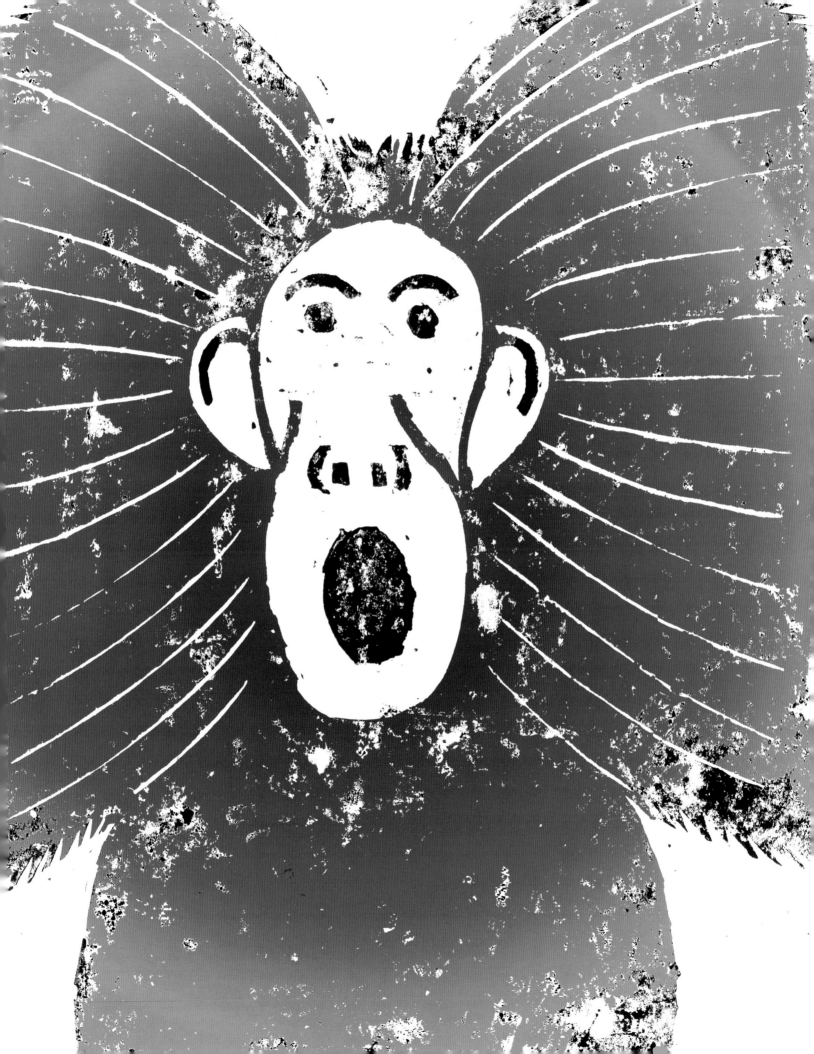

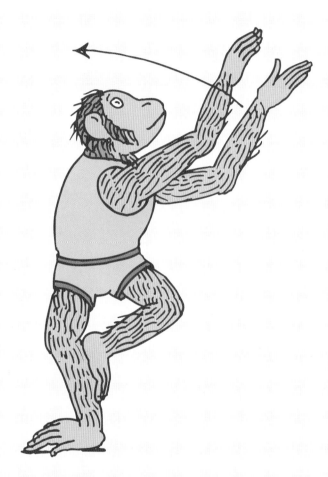

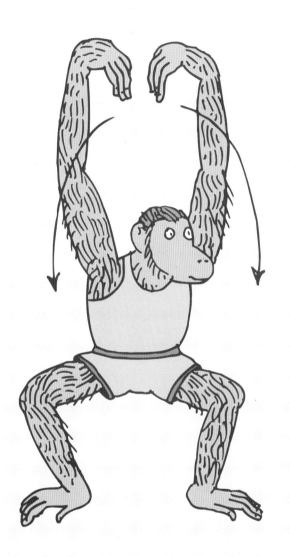
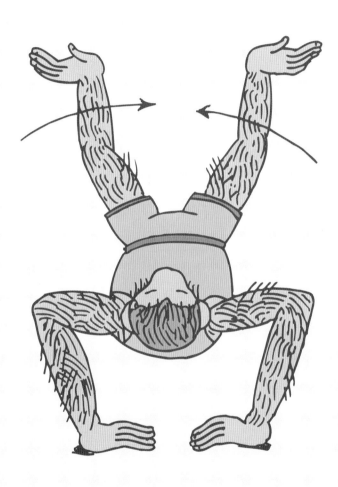

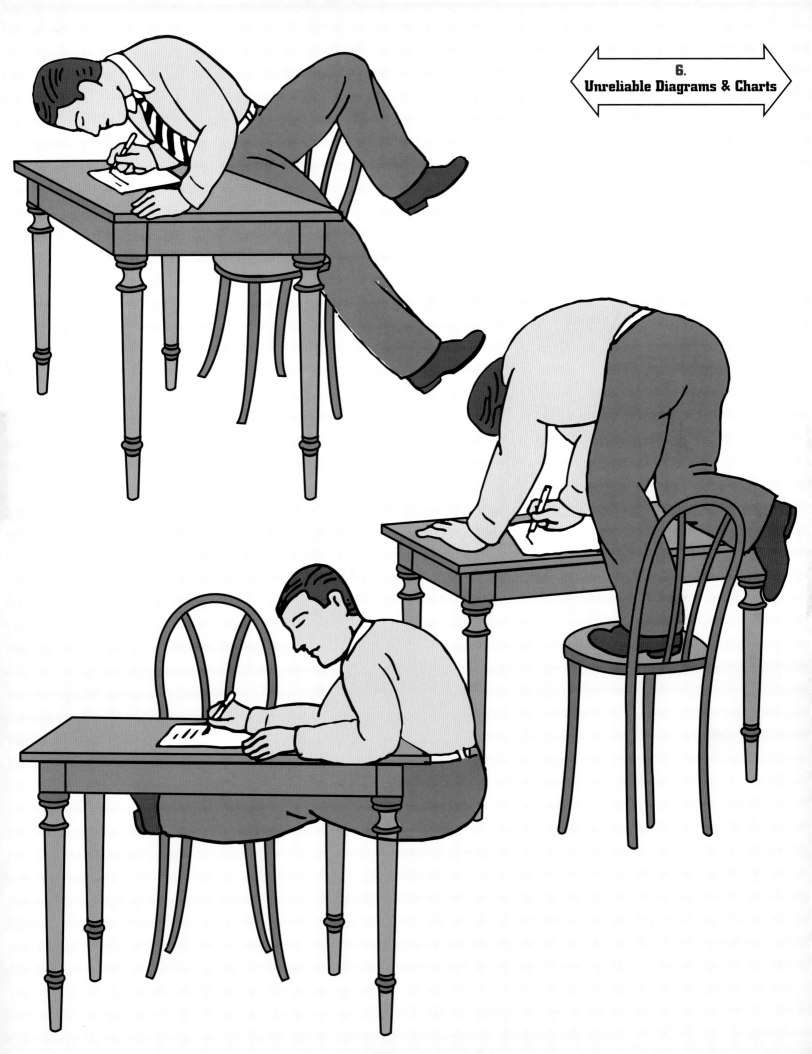

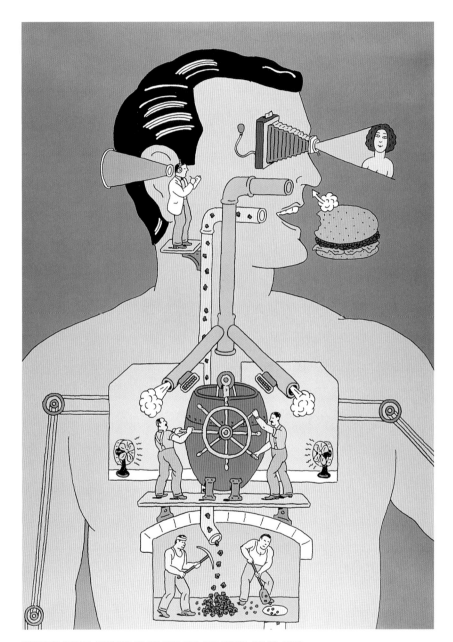

PREVIOUS SPREAD: POSTURE CHART, PEN, INK, AND DIGITAL COLOR, 2002
ART FOR A PROMOTIONAL POSTER, PEN, INK, AND COLOR FILM, 1995
OPPOSITE: MAGAZINE ILLUSTRATION, PEN, INK, AND DIGITAL COLOR, 2001

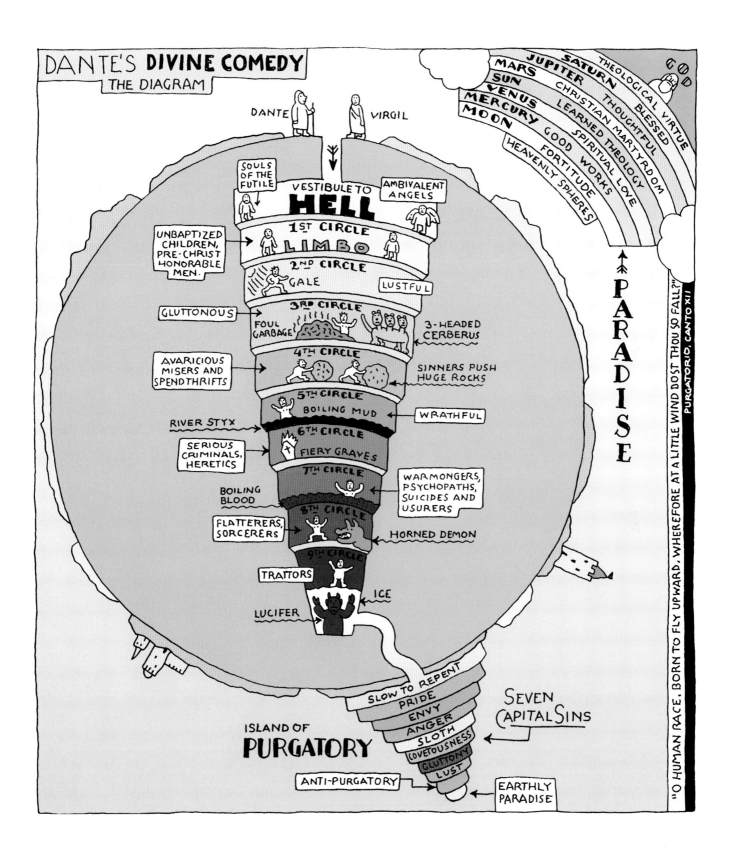

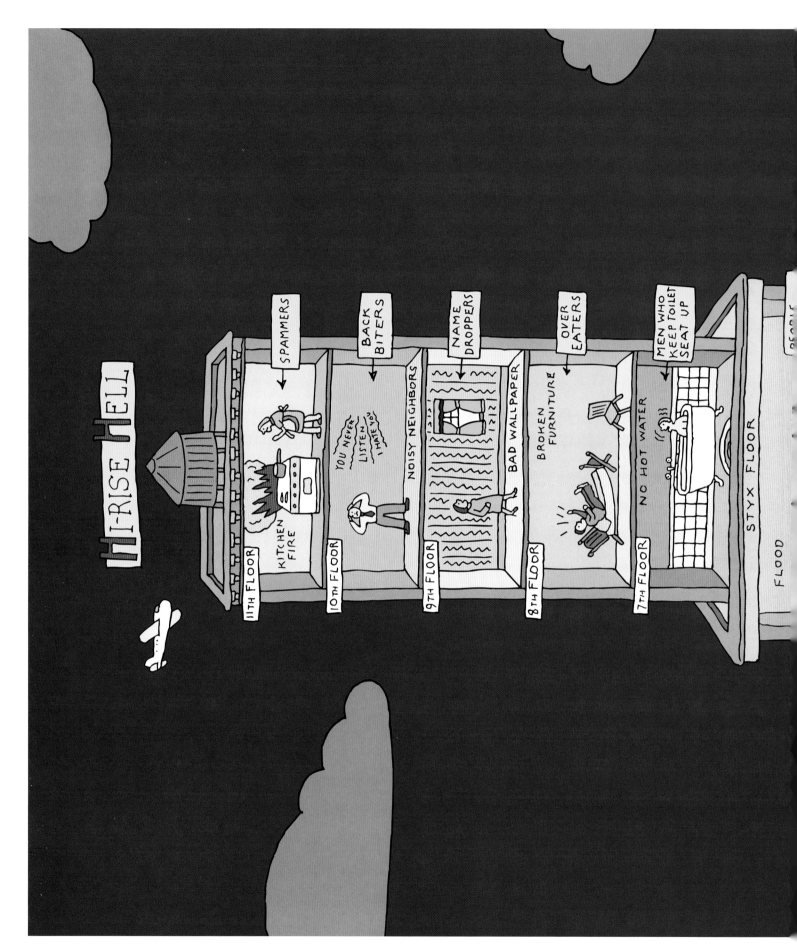

ILLUSTRATION FOR THE *NOSE*, 2004

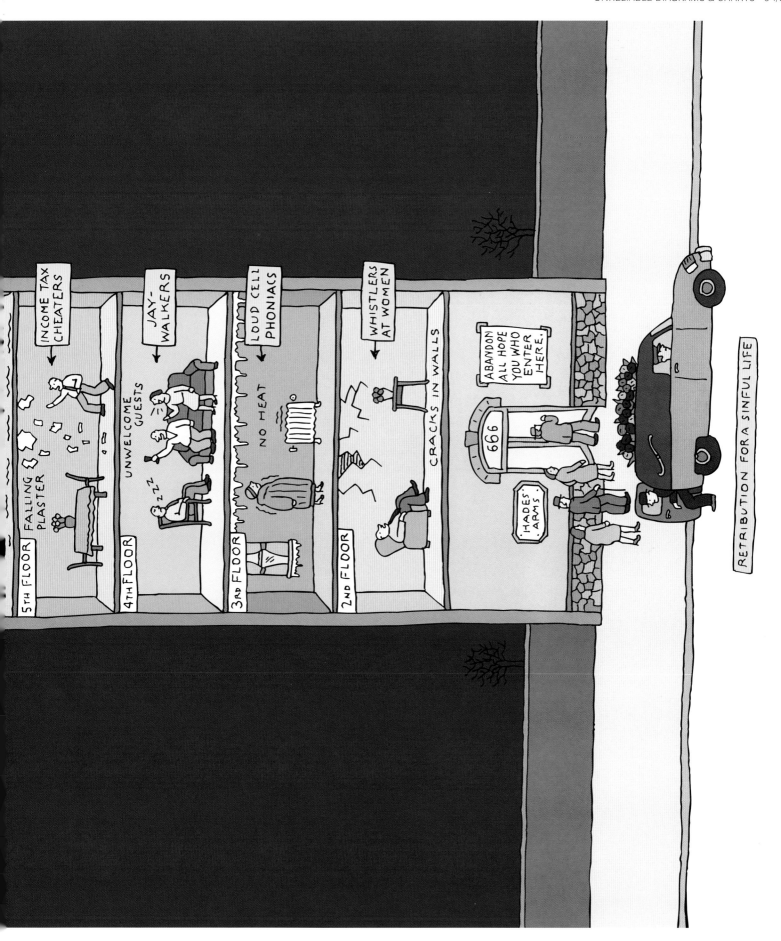

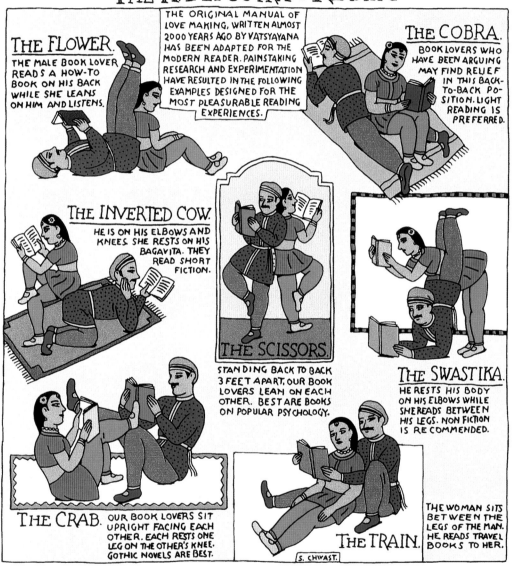

MAGAZINE ILLUSTRATION, PEN, INK, AND DIGITAL COLOR, 1998

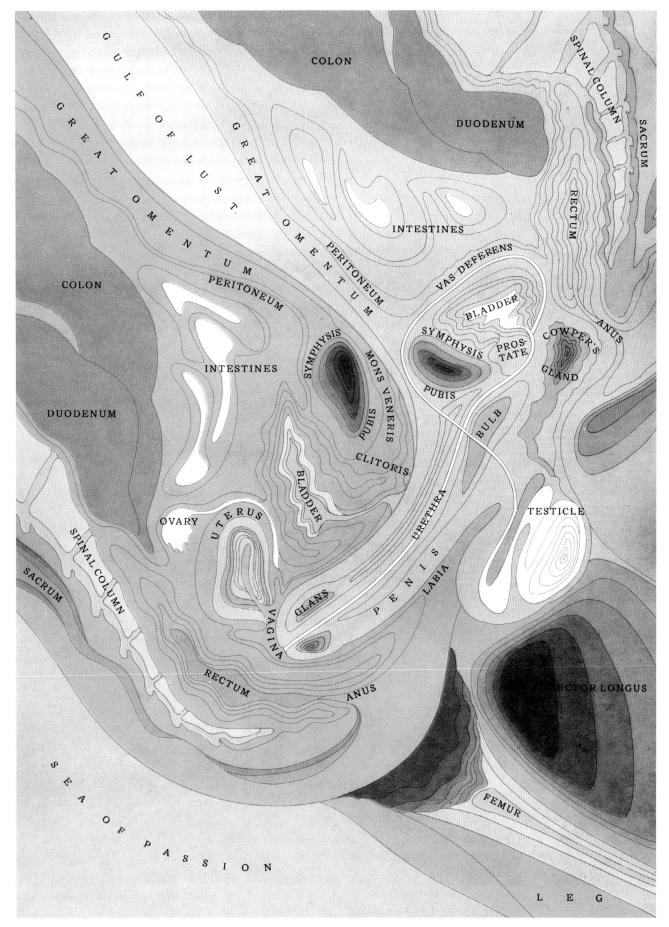

COITUS TOPOGRAPHICUS, PEN, INK, AND COLOR FILM, 1980

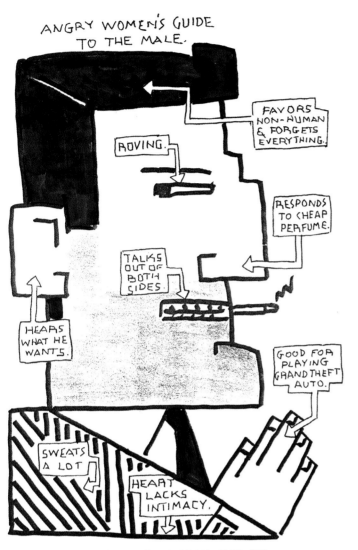

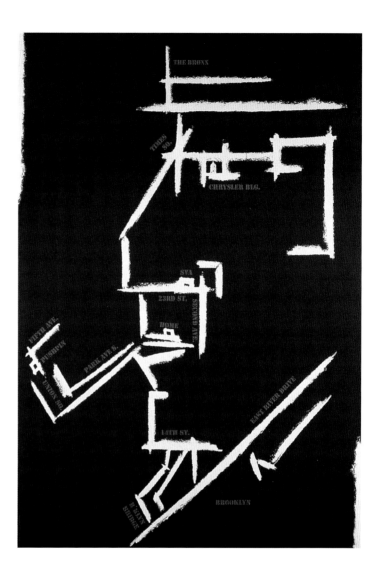

LEFT: *ANGRY WOMEN'S GUIDE*, MARKER AND PEN ON PAPER, 2008
RIGHT: EXHIBITION ANNOUNCEMENT, PEN, INK, AND TYPOGRAPHY, 1997

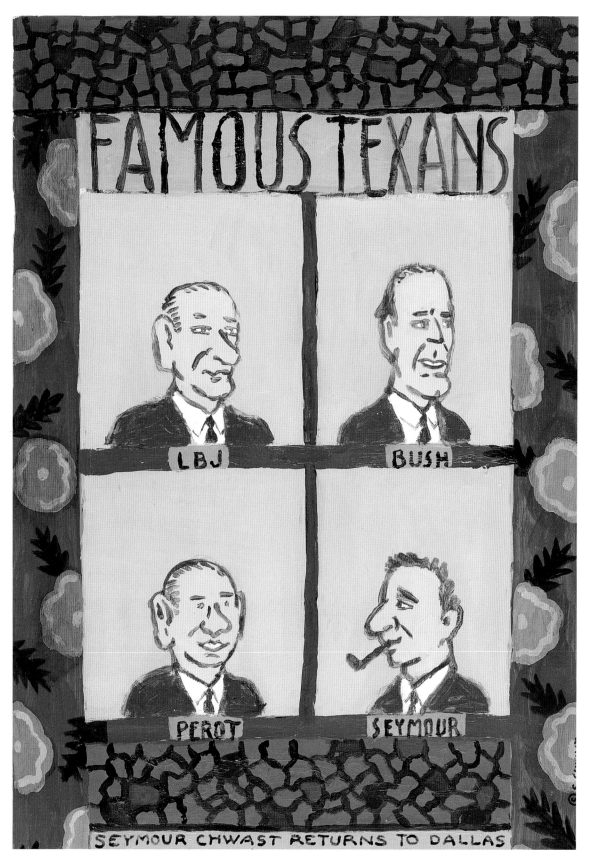

ANNOUNCEMENT FOR A LECTURE IN DALLAS, ACRYLIC ON BOARD, 1993

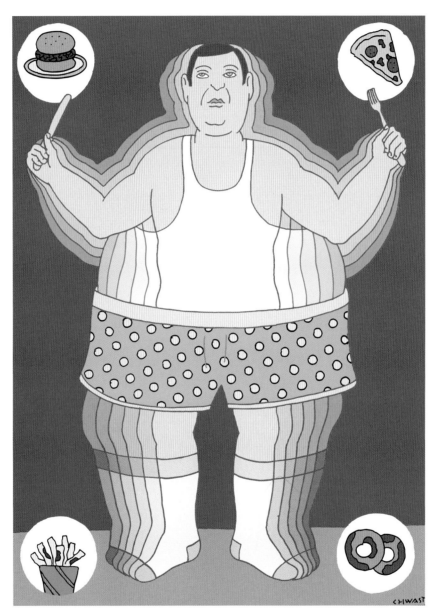

DIET?, MAGAZINE ILLUSTRATION, PEN, INK, AND DIGITAL COLOR, 2001

FOUR HEADS, SEVEN BODIES, MAGAZINE ILLUSTRATION, PEN AND INK WITH DIGITAL COLOR, 2003

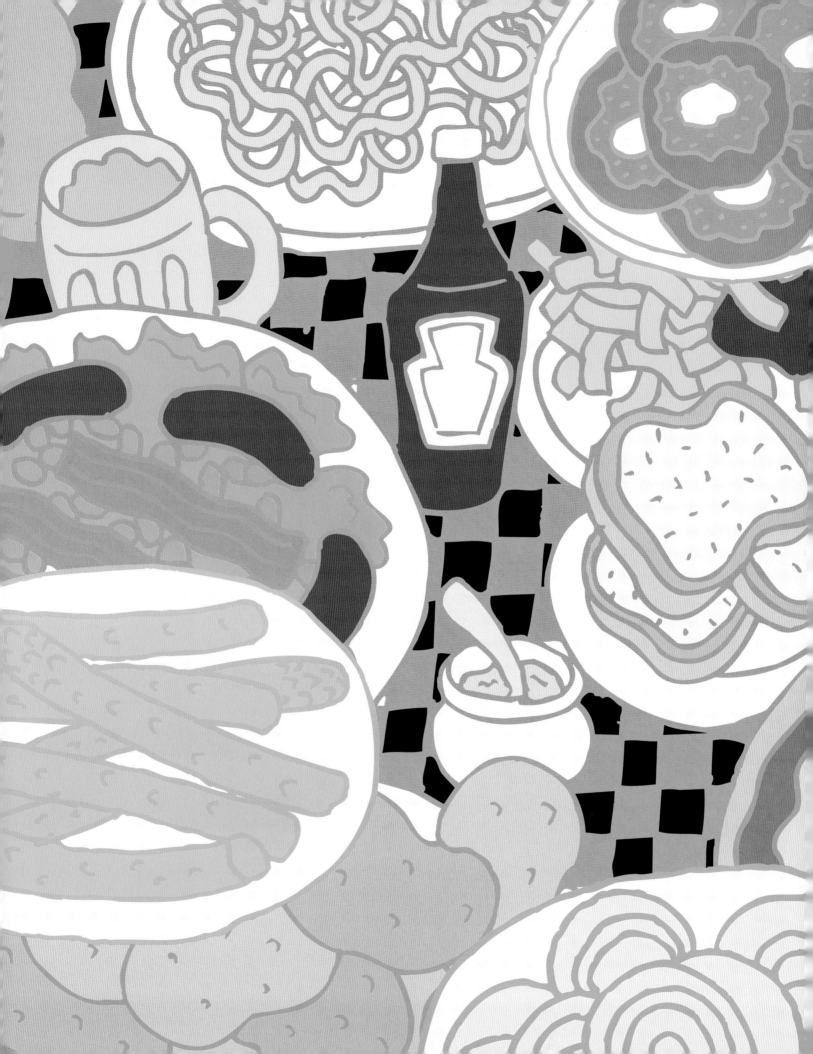

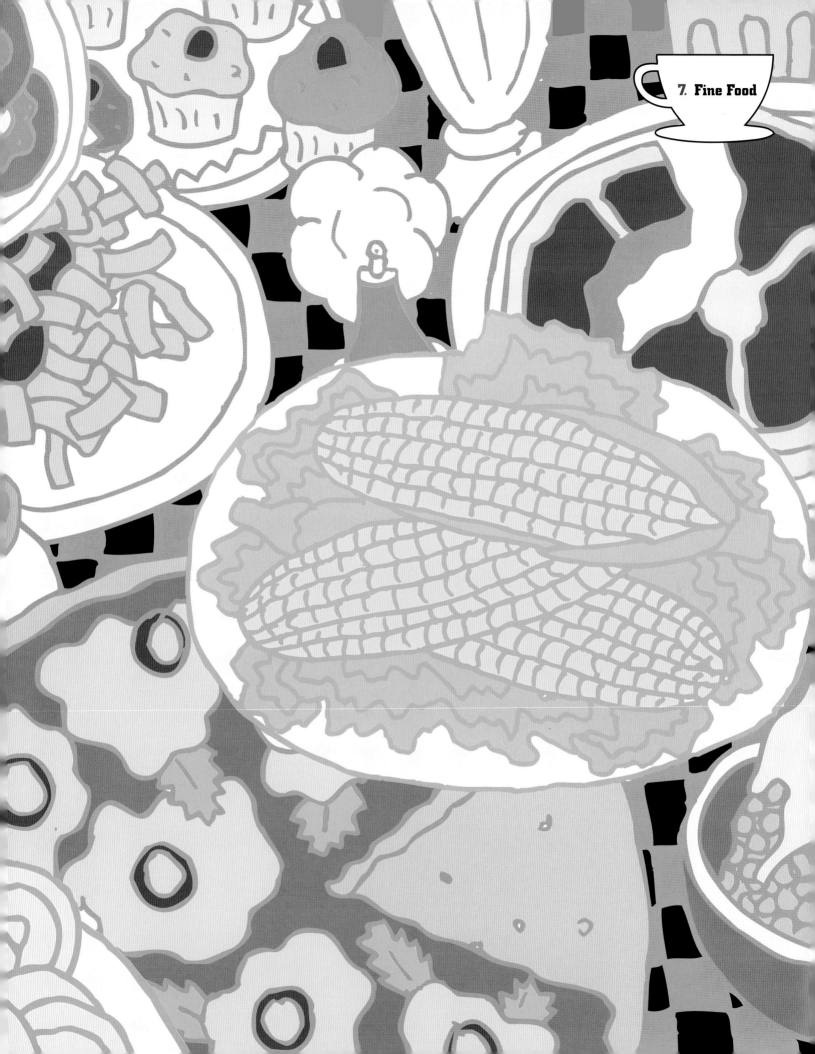

PREVIOUS SPREAD: *A FINE SPREAD*, DETAIL, PEN, INK, AND DIGITAL COLOR, 2008
FIVE PEAS, PEN, INK, AND COLOR FILM, 1979
OPPOSITE: *PASTA*, ACRYLIC ON CUTOUT SHEET METAL, 2002

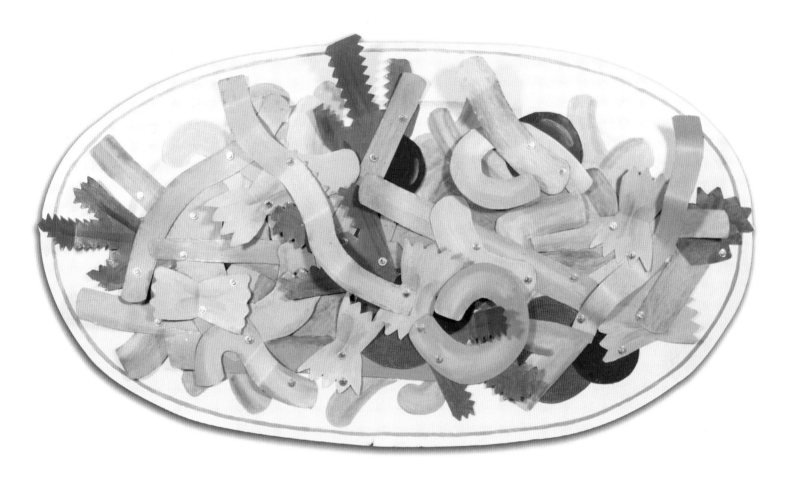

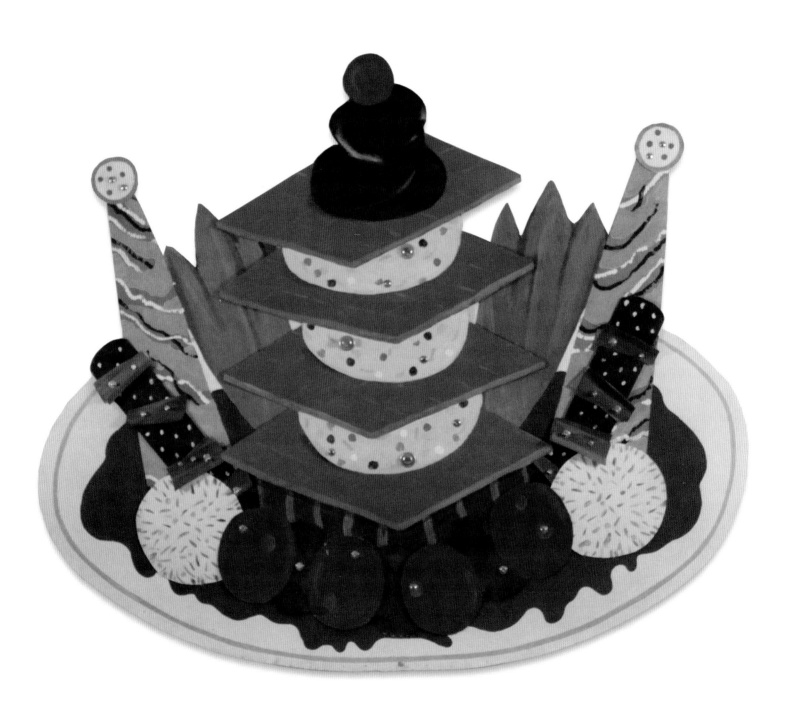

ABOVE: *FINE DINING 1*, AND OPPOSITE: *FINE DINING 2*. BOTH ACRYLIC ON CUTOUT SHEET METAL, 2002

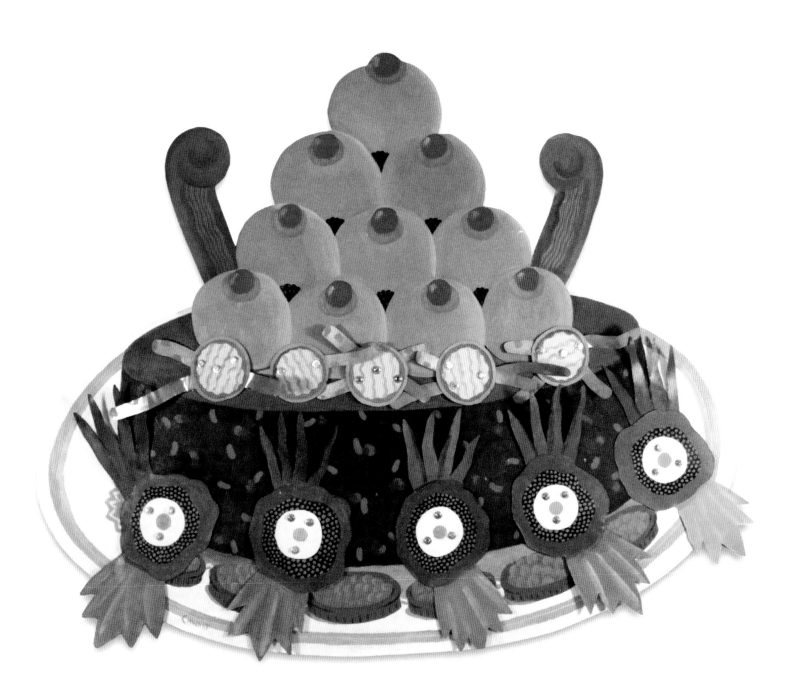

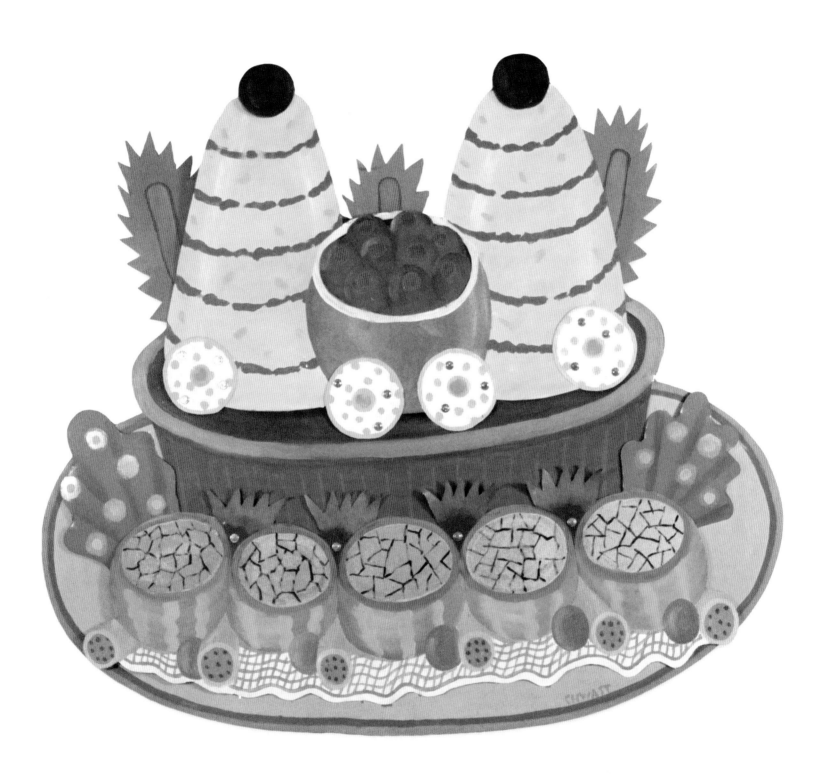

ABOVE: *FINE DINING 3*, AND OPPOSITE: *FINE DINING 4*. BOTH ACRYLIC ON CUTOUT SHEET METAL, 2002

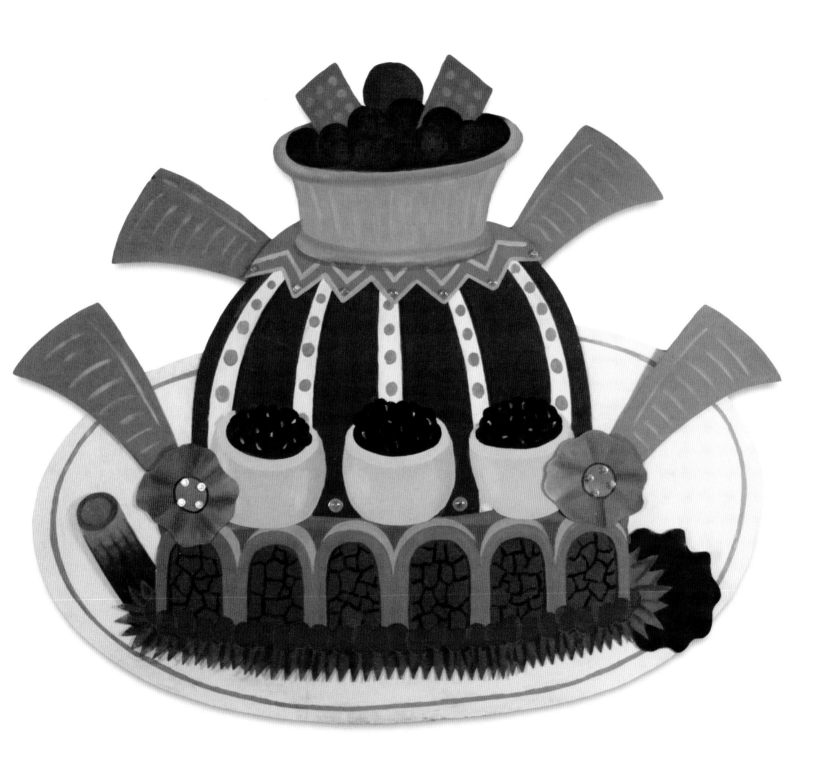

THE FOOD WE LOVE, ACRYLIC ON PAPER, 2001
OPPOSITE: *FOODIES*, PEN, INK, AND DIGITAL COLOR, 2001

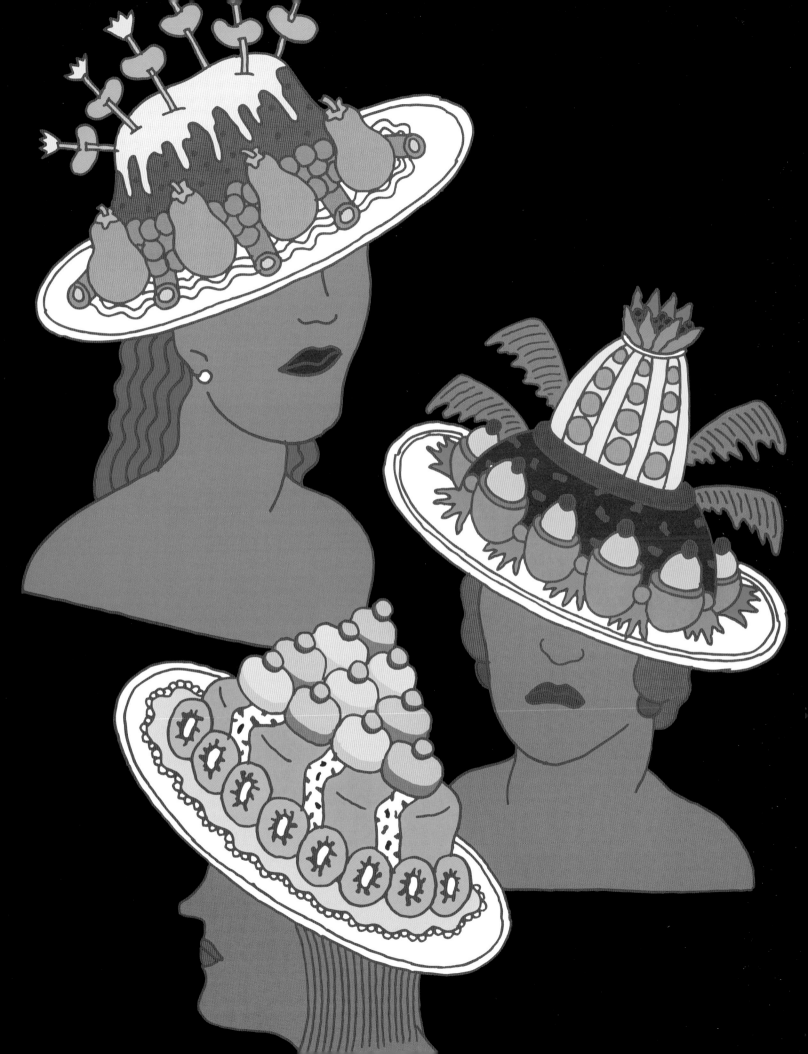

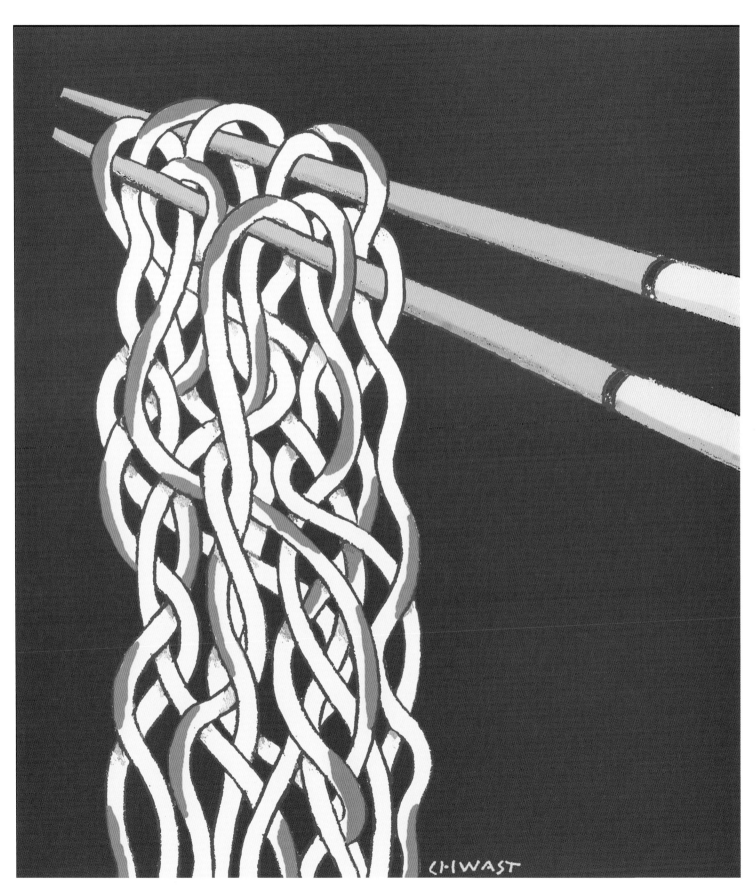

OPPOSITE: *LUNCH*, DETAIL, PEN, INK, AND DIGITAL COLOR ON PAPER, 2001
NOODLES, PEN, INK, AND DIGITAL COLOR ON PAPER, 2006

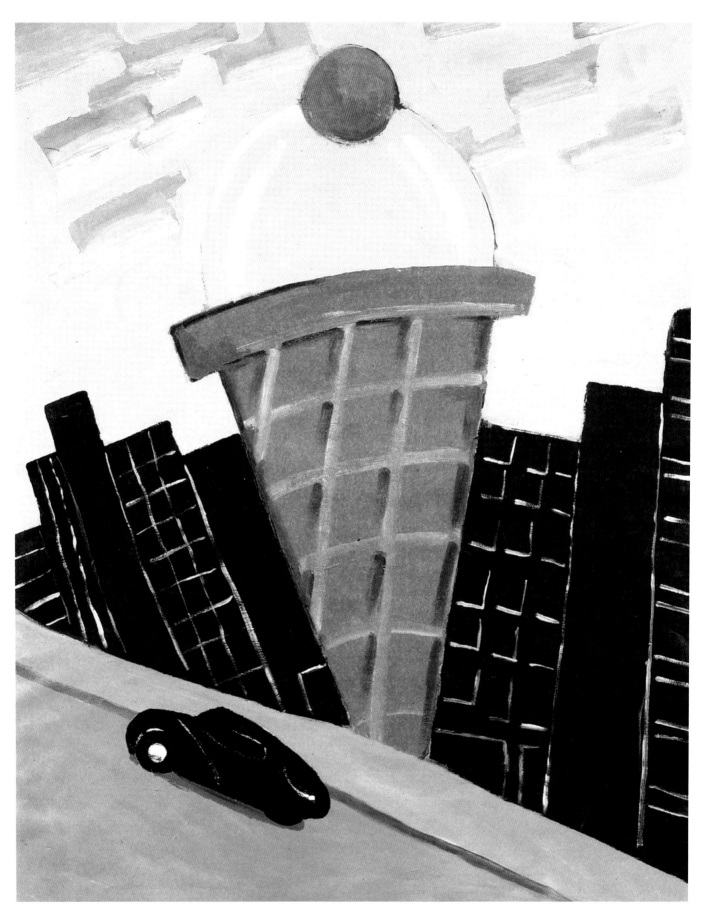

CONDO CONE, ACRYLIC ON BOARD, 1990

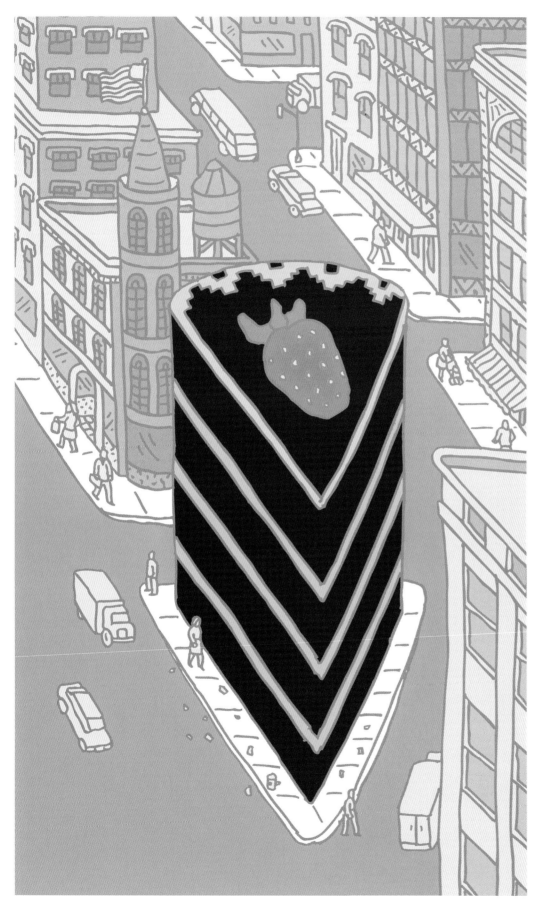

FLATIRON, PEN, INK, AND DIGITAL COLOR ON PAPER, 2006

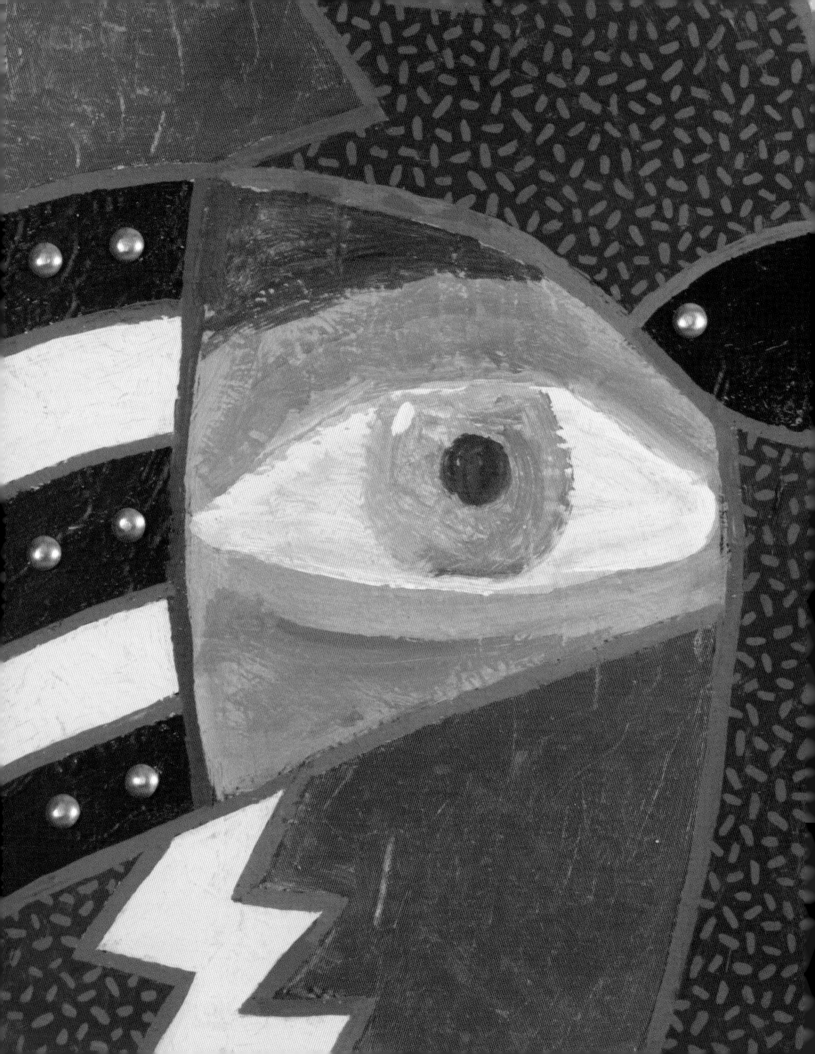

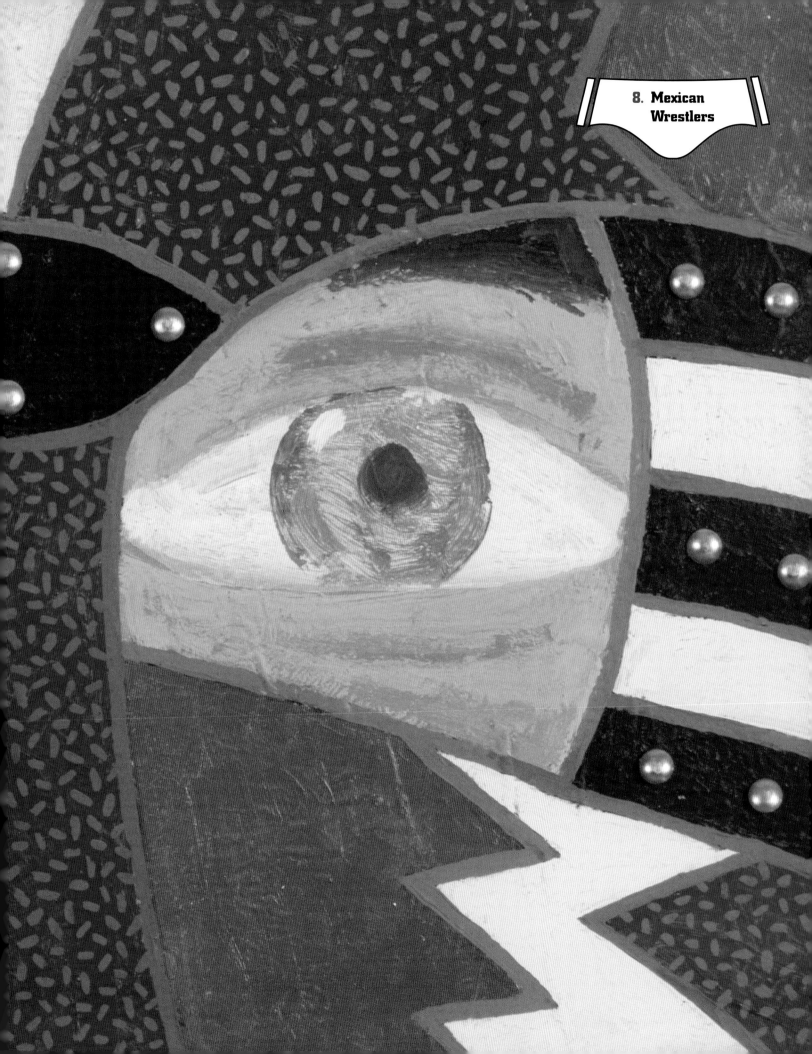

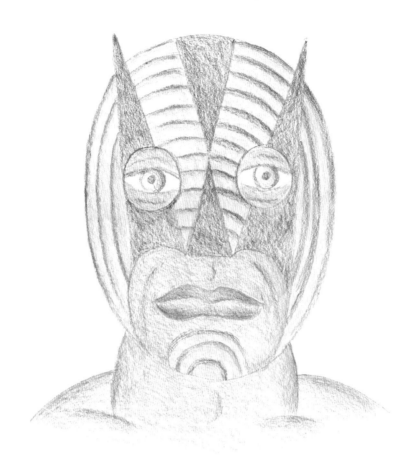

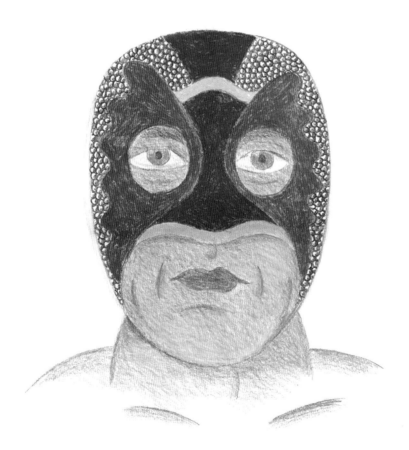

PREVIOUS SPREAD: *MEXICAN IDOL*, DETAIL, ACRYLIC ON CUTOUT SHEET METAL
MASK 9 AND *MASK 10*, PASTEL ON PAPER, 2006
OPPOSITE: *BLACK MASK*, CHARCOAL ON PAPER, 2006

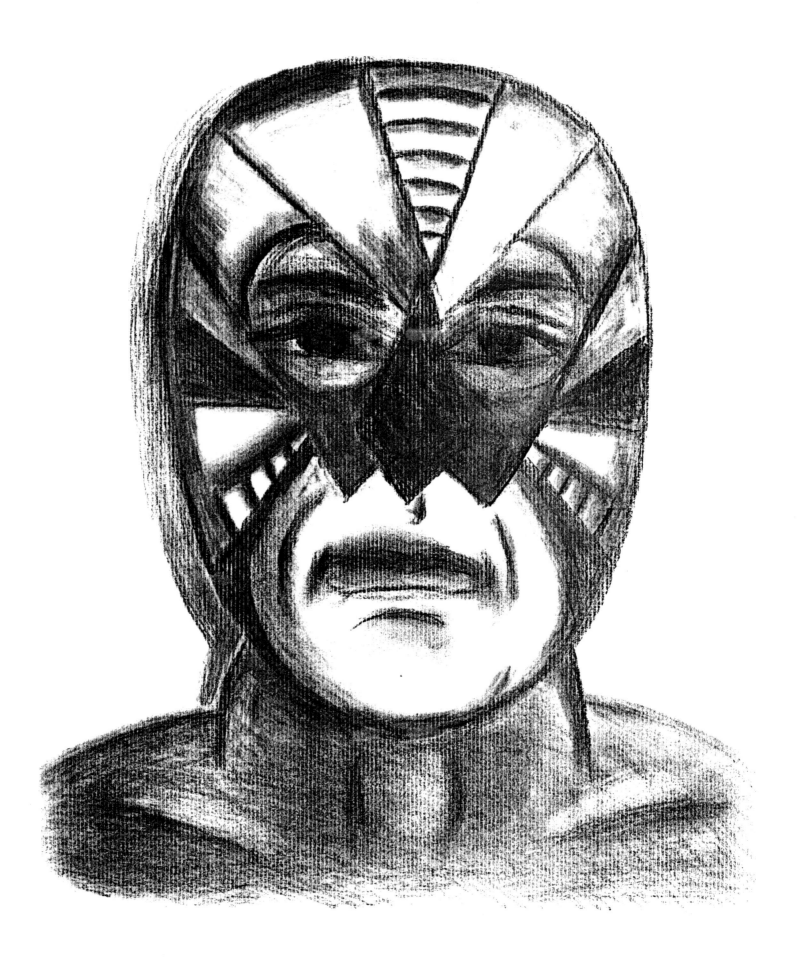

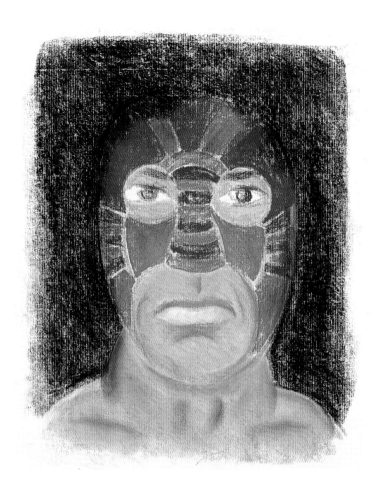
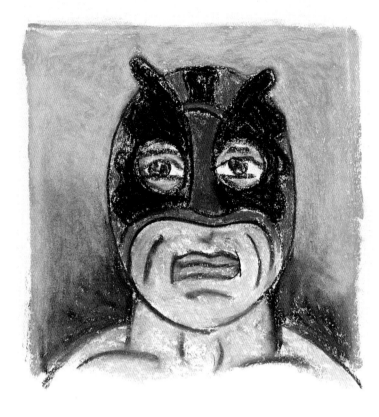
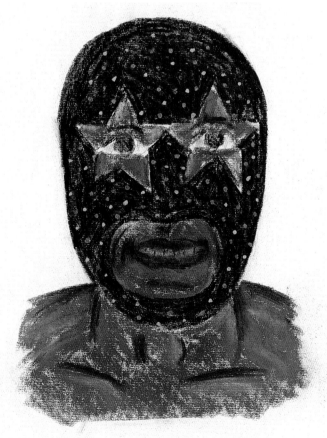
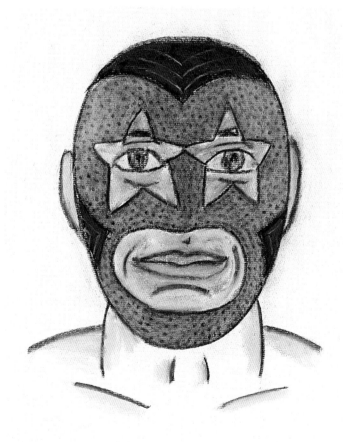

THIS SPREAD: *MEXICAN WRESTLERS*, PASTEL ON PAPER, 2006

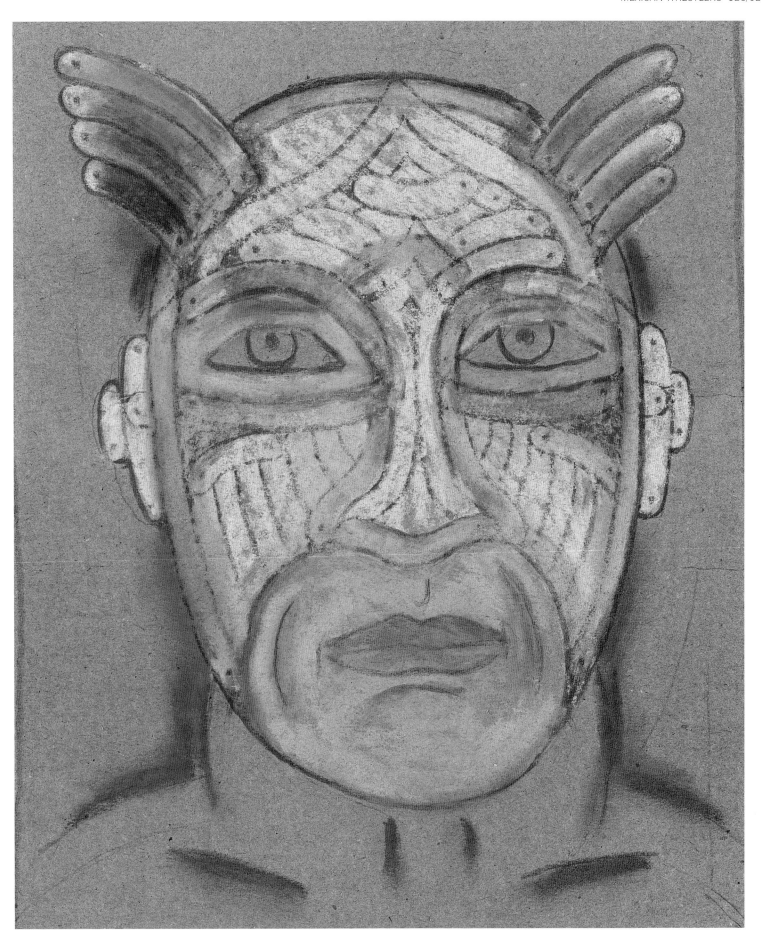

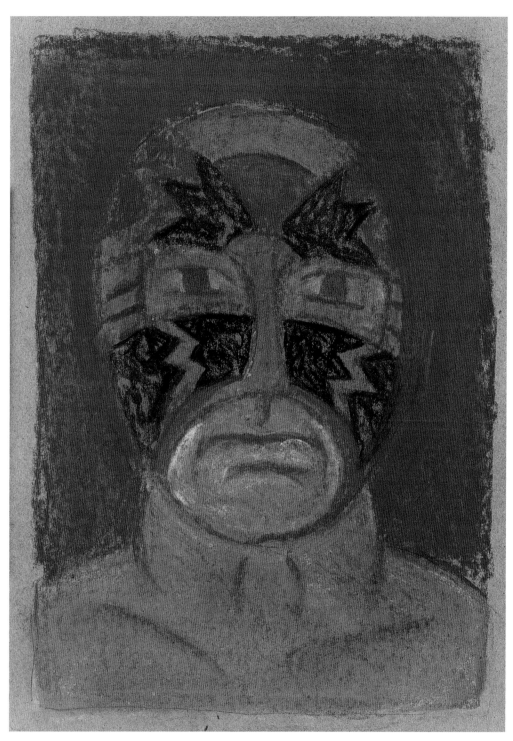

MASK 2, PASTEL ON PAPER, 2006
OPPOSITE: *MUCHO GUSTO*, ACRYLIC AND COLORED PENCIL ON CHIPBOARD, 2008

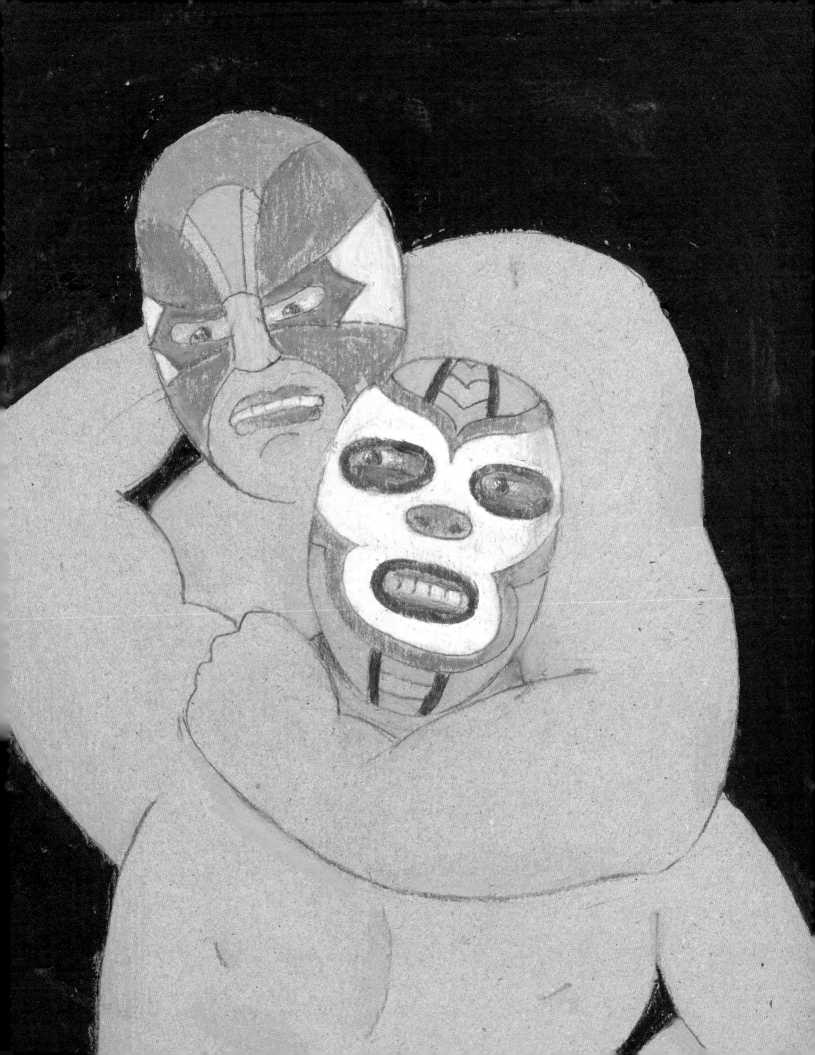

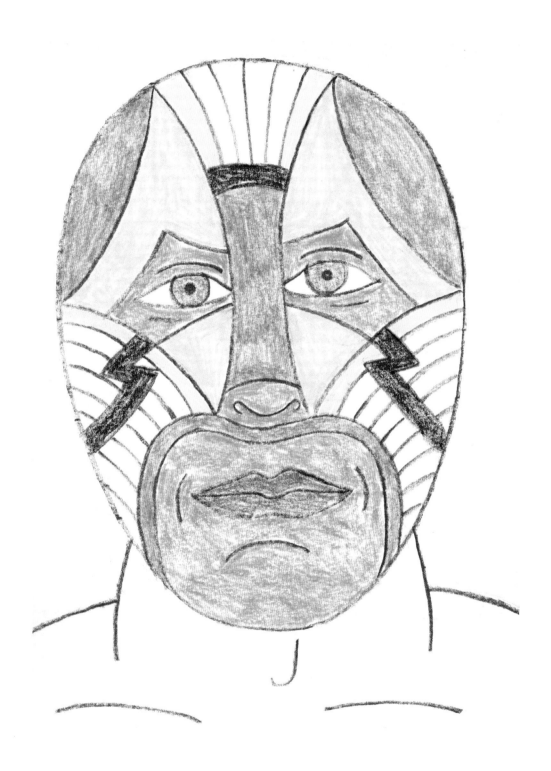

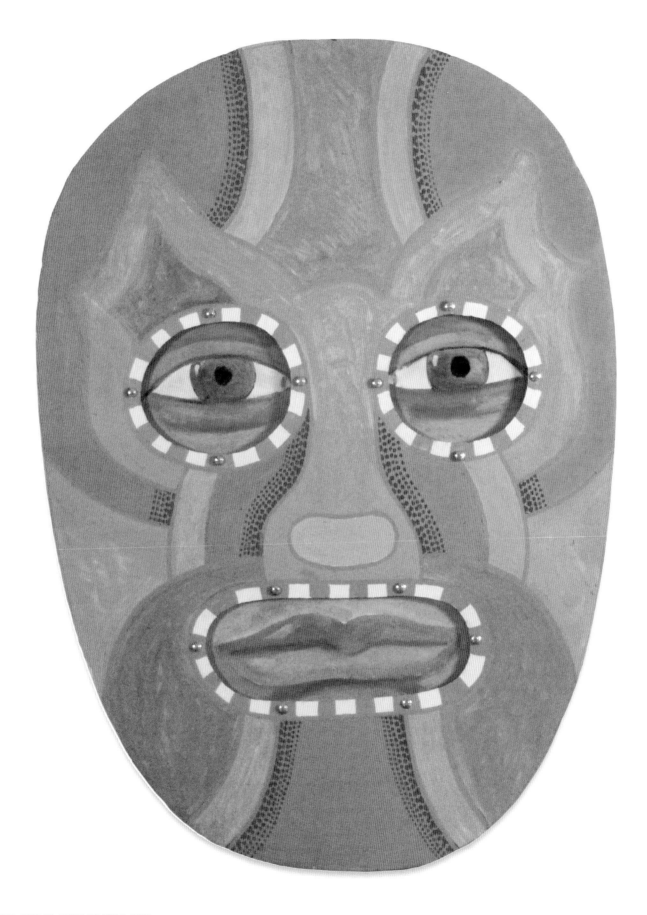

OPPOSITE: *MASK 12*, PASTEL ON PAPER, 2006
FACE AND MASK, ACRYLIC ON CUTOUT SHEET METAL WITH BOLTS, 2006

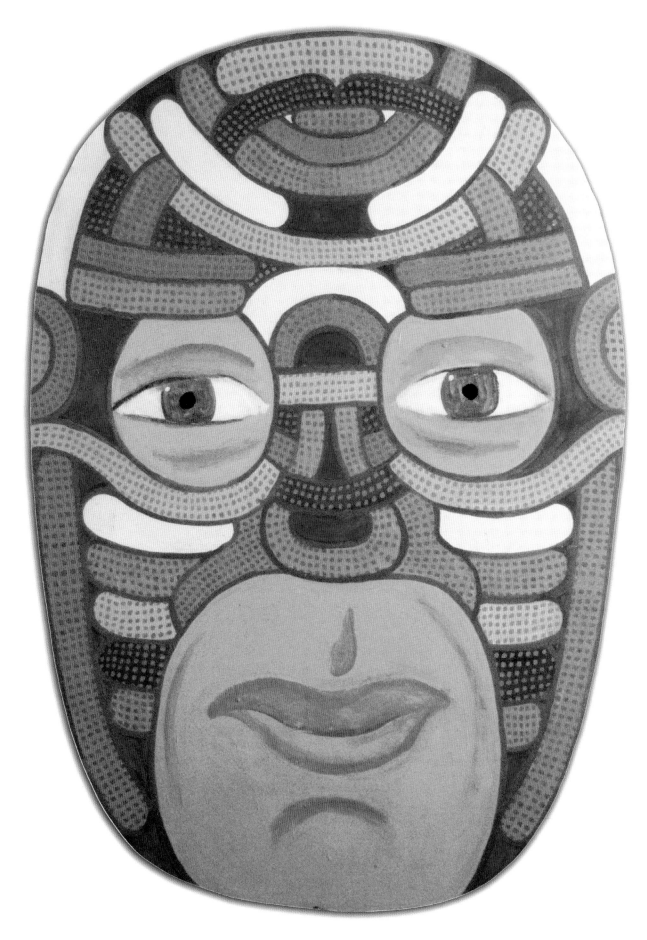

MASK WITH SMILE, ACRYLIC ON CUTOUT SHEET METAL, 2006

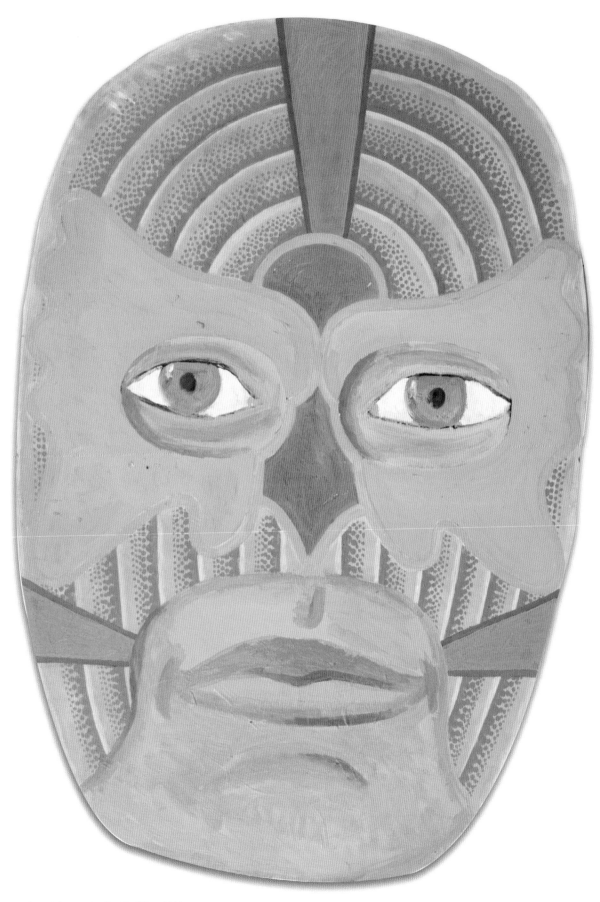

SERIOUS MASK, ACRYLIC ON CUTOUT SHEET METAL, 2006

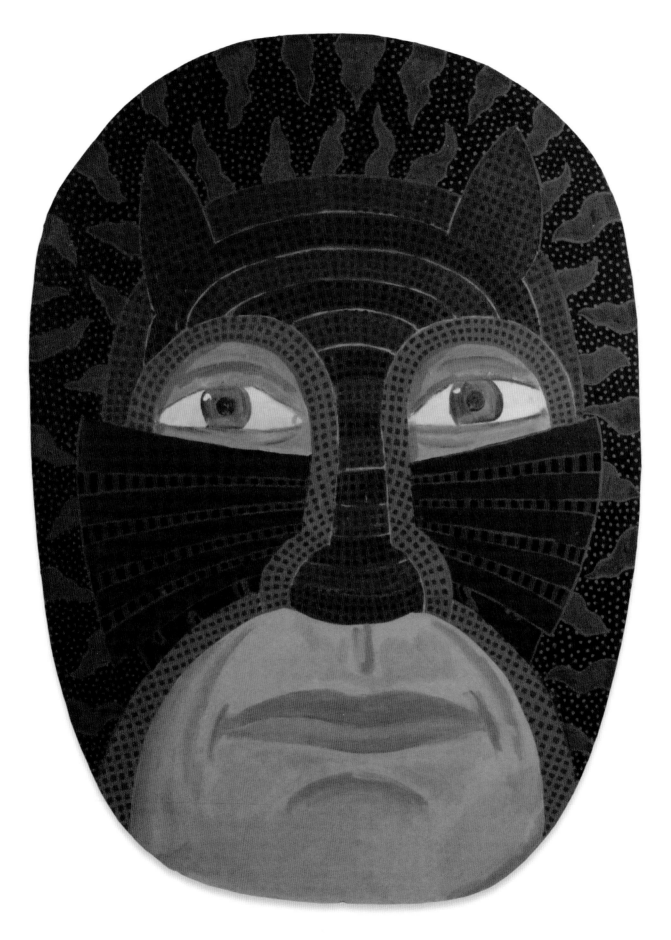

CAT MASK, ACRYLIC ON CUTOUT SHEET METAL, 2006

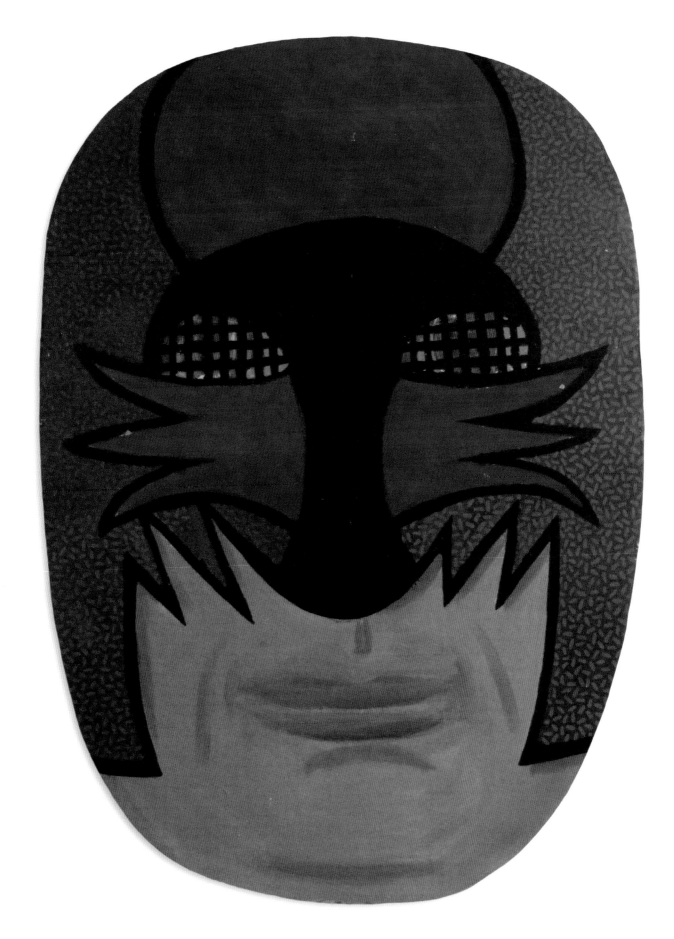

GRINNING MASK, ACRYLIC ON CUTOUT SHEET METAL, 2006

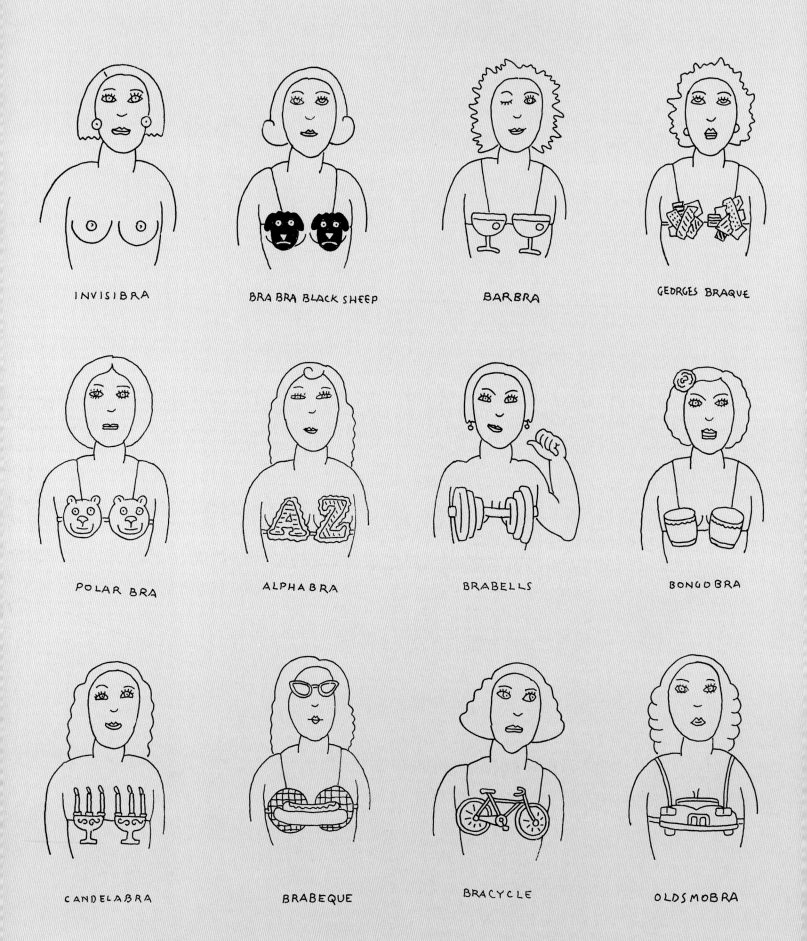

INVISIBRA

BRA BRA BLACK SHEEP

BARBRA

GEORGES BRAQUE

POLAR BRA

ALPHABRA

BRABELLS

BONGOBRA

CANDELABRA

BRABEQUE

BRACYCLE

OLDSMOBRA

UMBRALLA

SOMBRARO

COBRA

ZEBRA

MARLBRA

BRAZIL

CHASTITY BRA

ERIN-GO-BRA

BRALESQUE

ABRA-KA-DABRA

TUBRA

McBRA

PREVIOUS SPREAD: MOST OF *BRA FASHION BY STEPHANIE,* PEN AND INK, 1990
ABOVE AND RIGHT: *FANTASY FASHION,* COLORED PENCIL ON PAPER, 1990

14TH STREET, ACRYLIC AND COLORED PENCIL ON BOARD, 1984

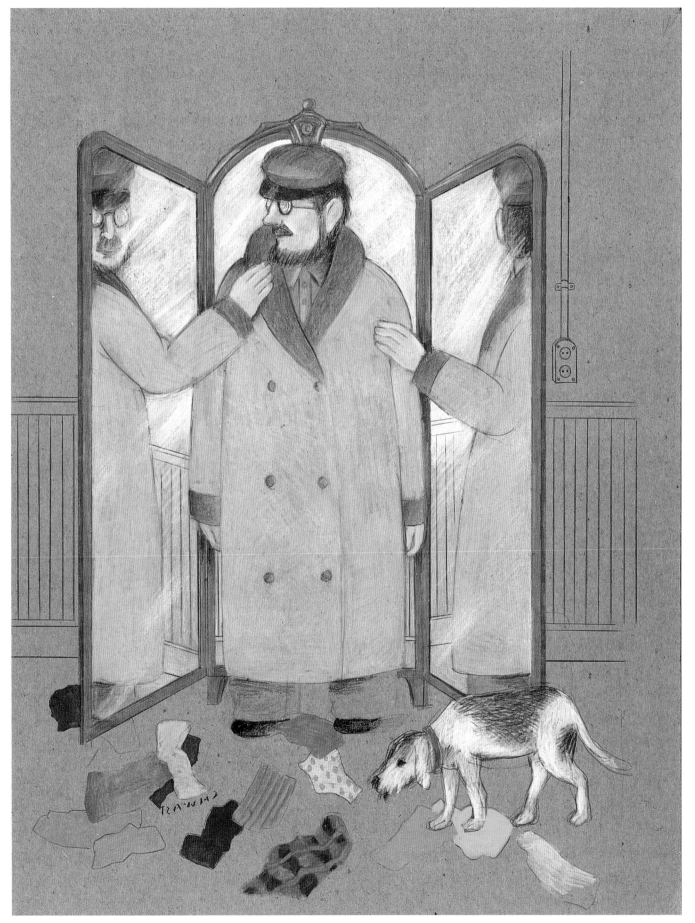

ILLUSTRATION FOR A GOGOL STORY, PEN, ACRYLIC, AND COLORED PENCIL, 1982

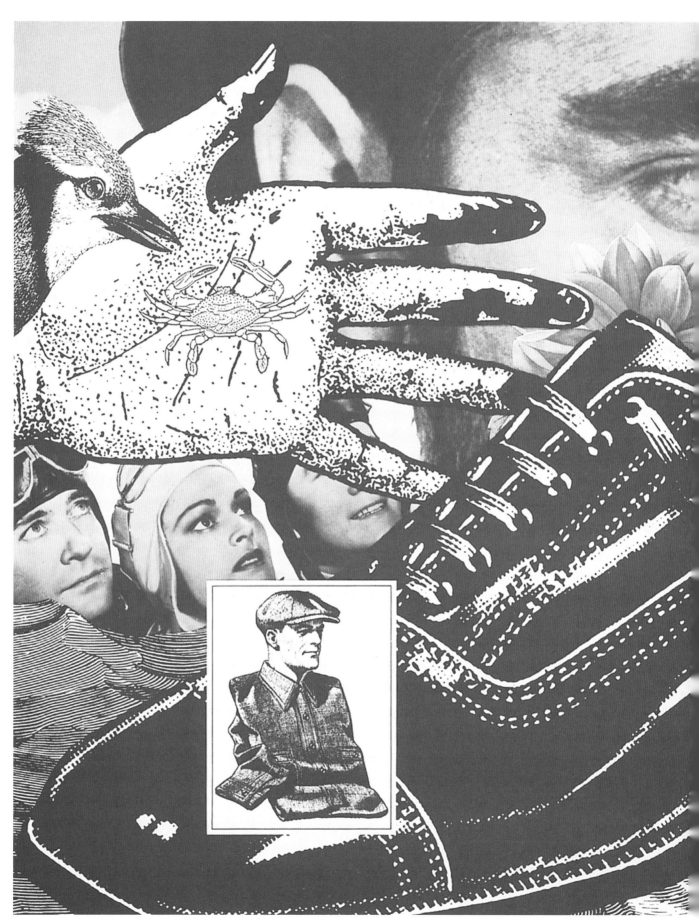

EVERYTHING BLUE, COLLAGE, 1979

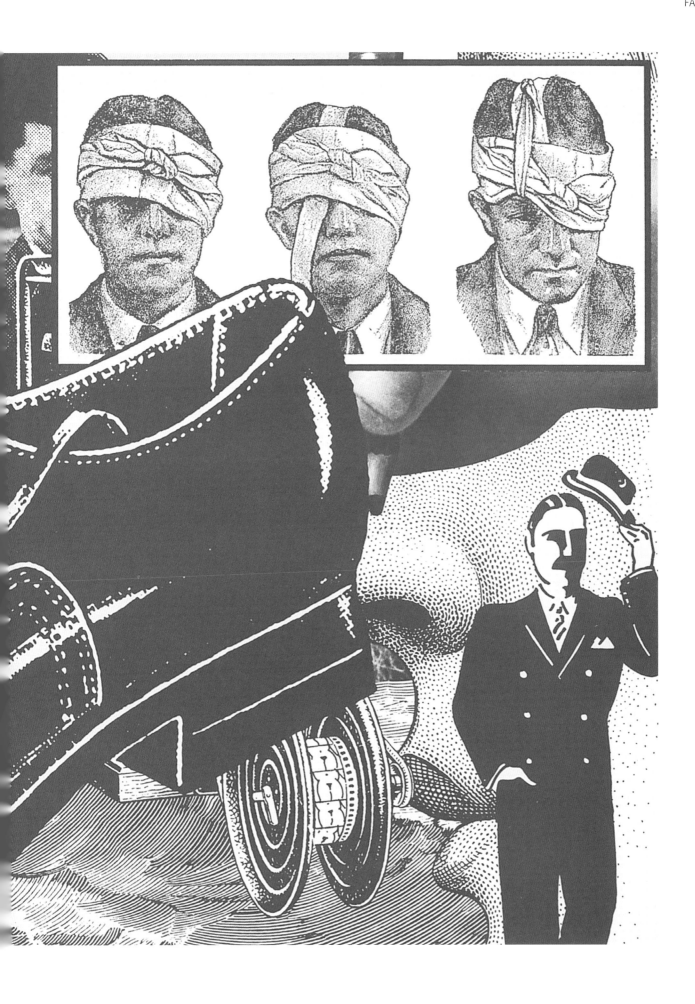

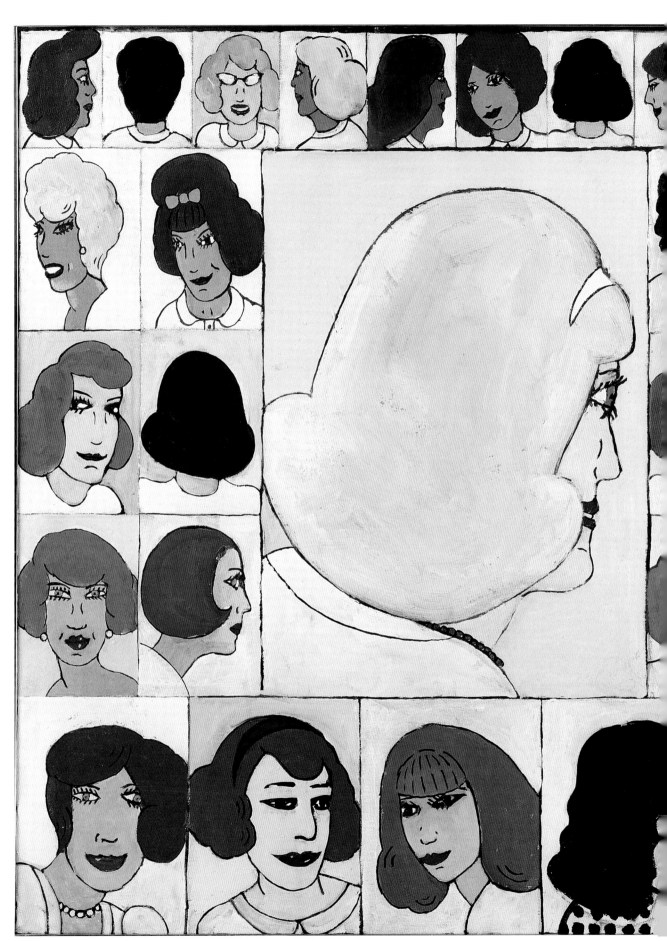

AT THE SALON, ACRYLIC ON CANVAS, C. 1972

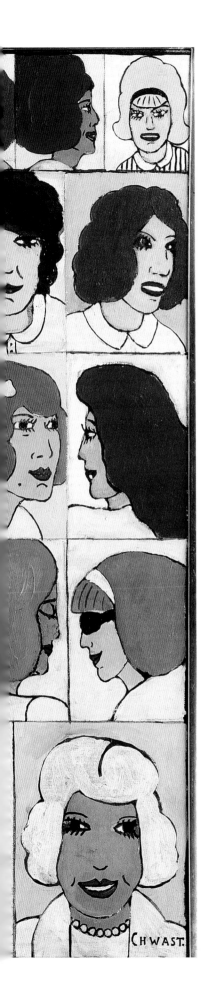

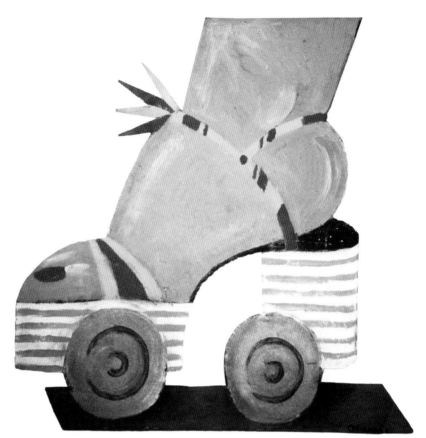

CHIC ON WHEELS 2, ACRYLIC ON CUTOUT SHEET METAL, 1995

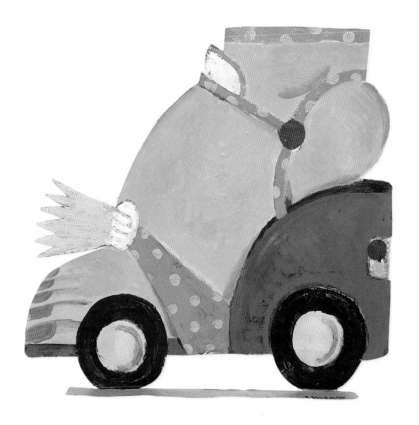

CHIC ON WHEELS 1, ACRYLIC ON CUTOUT SHEET METAL, 1994

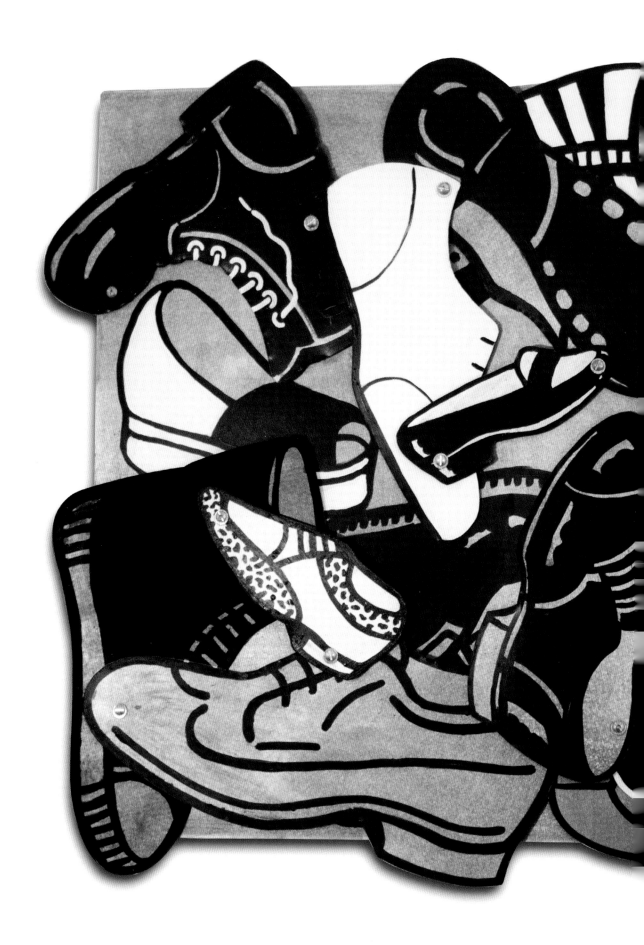

STEEL SHOES, ACRYLIC ON CUTOUT SHEET METAL WITH BOLTS, 1997

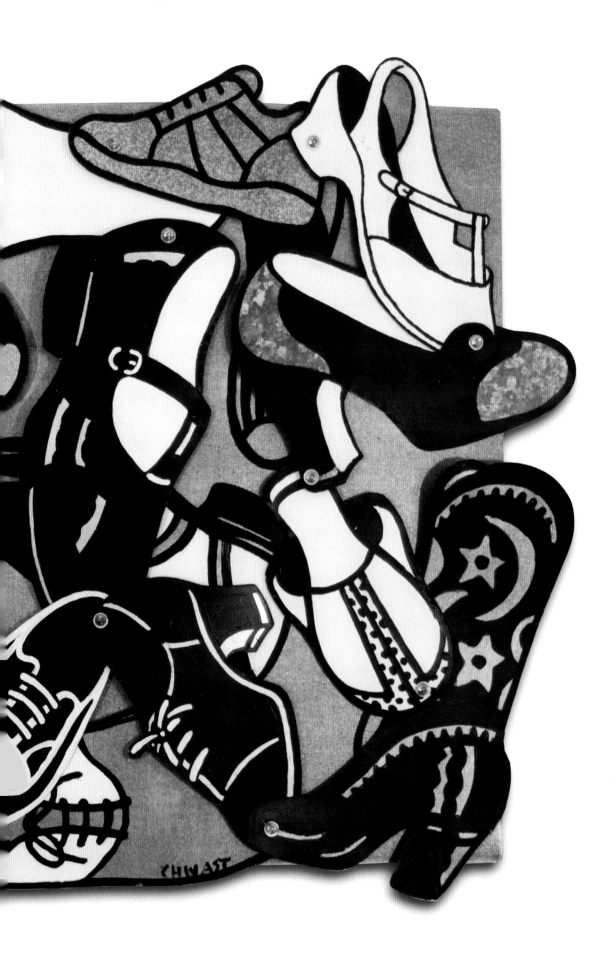

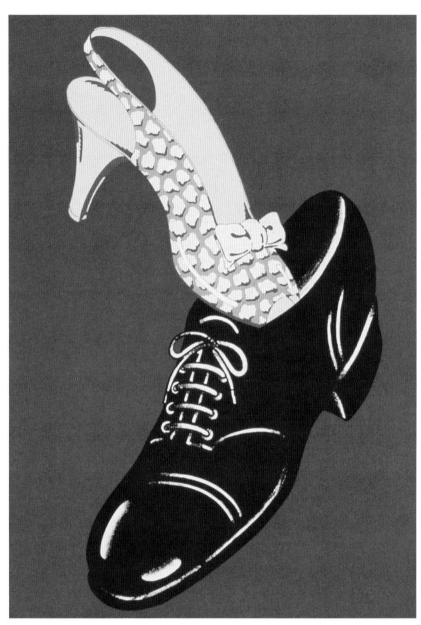

FRED AND ROSALIE, SILK SCREEN, 1979
OPPOSITE: *PUSH PIN MOVES*, PEN AND INK ON COLOR FILM, 1980

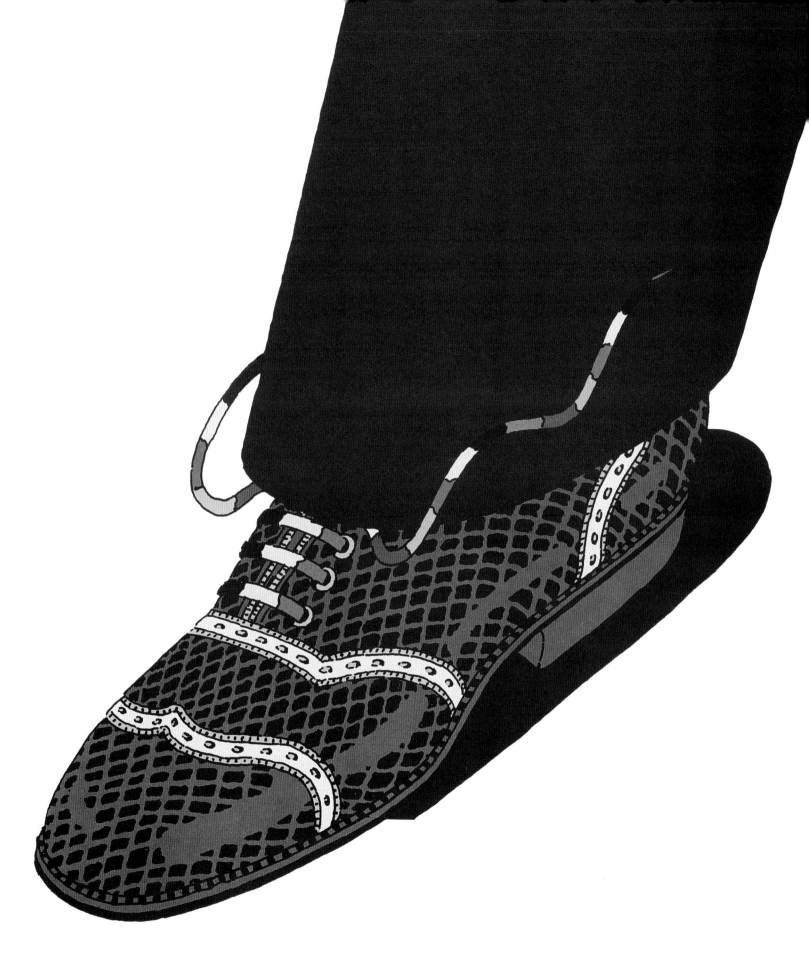

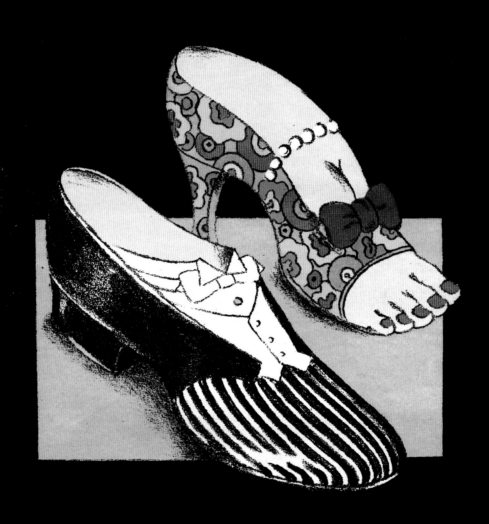

WELL SHOD, COLORED PENCIL AND COLOR FILM, 1987
OPPOSITE: *STEEL BRA*, ACRYLIC AND HARDWARE ON CUTOUT SHEET METAL, 1993

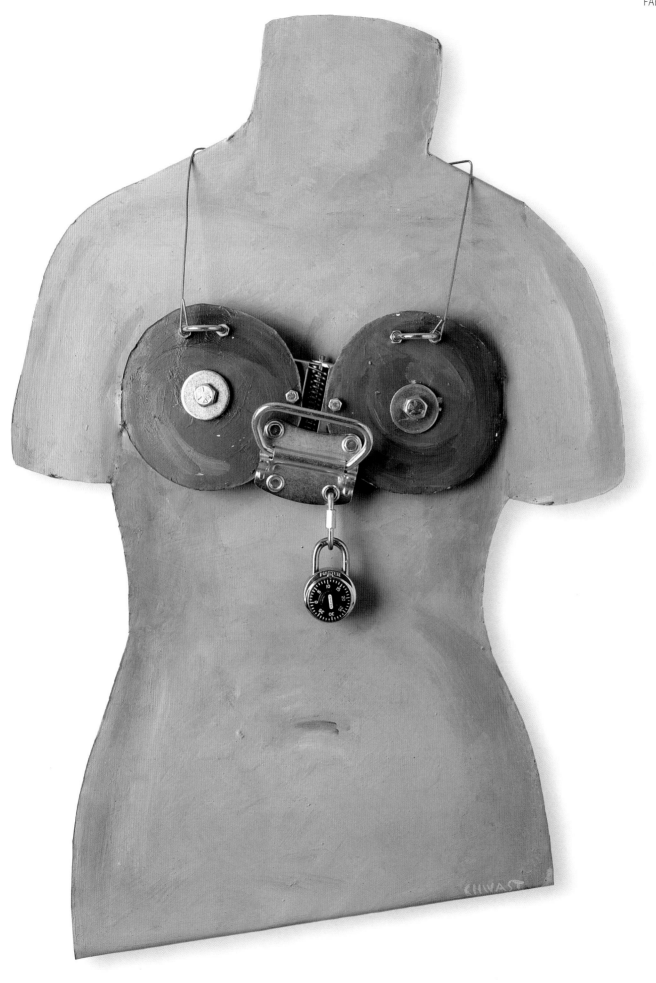

DANCE FASHION, MIXED MEDIA, 1990
OPPOSITE: *CLERIC AND HAT*, PEN, INK, AND PASTEL, 2001

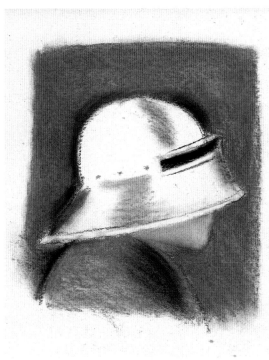

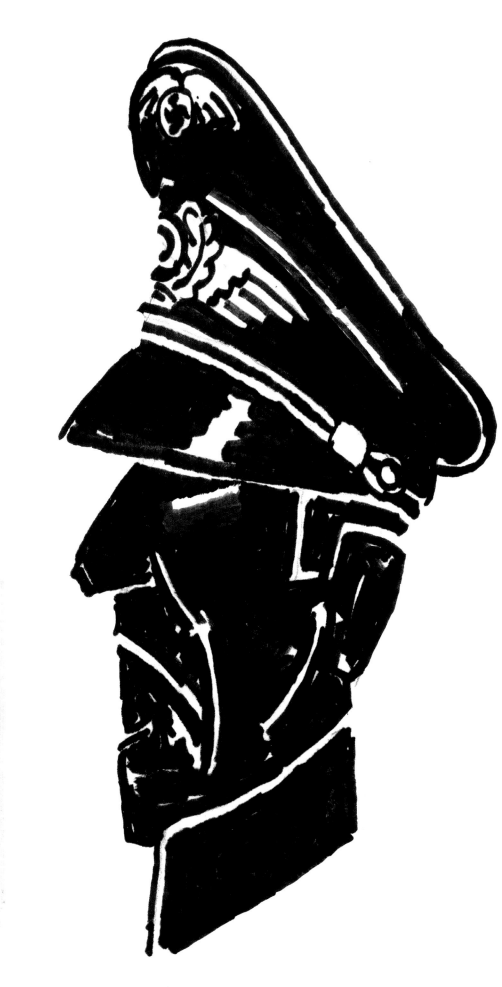

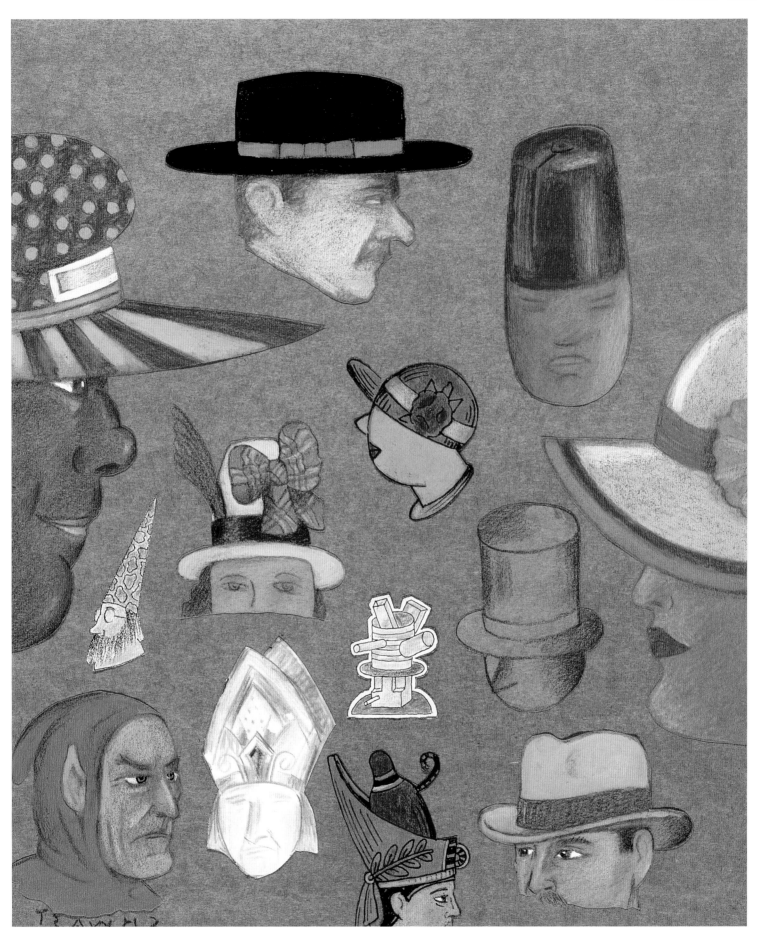

OPPOSITE LEFT: *MEDIEVAL HELMET*, PASTEL ON PAPER, 2006
OPPOSITE RIGHT: *NAZI FASHION PLATE*, MARKER ON PAPER, 2001
HAT OBSESSION, MIXED MEDIA ON WRAPPING PAPER, 1991

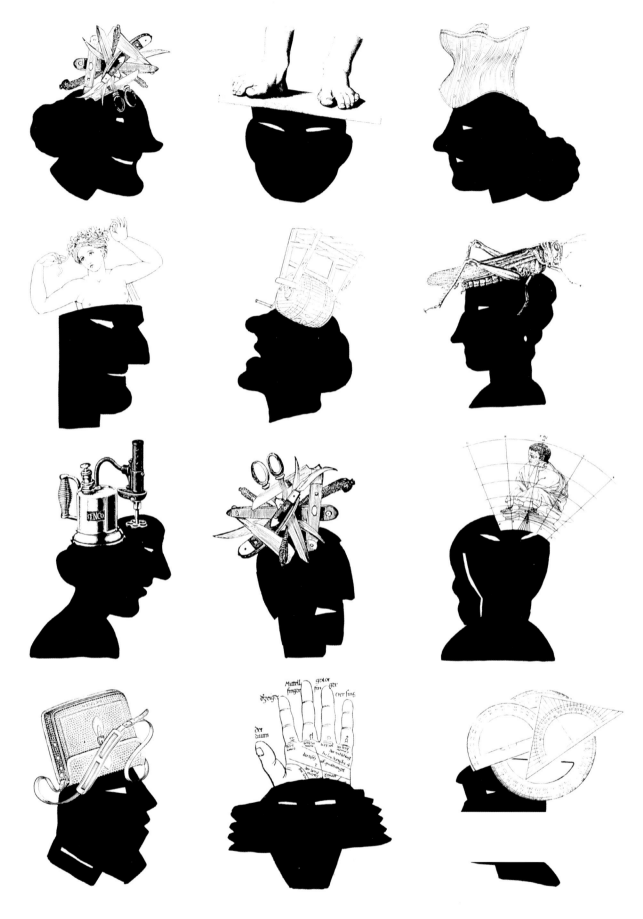

FOUND ART COLLAGE WITH SILHOUETTES, 1991

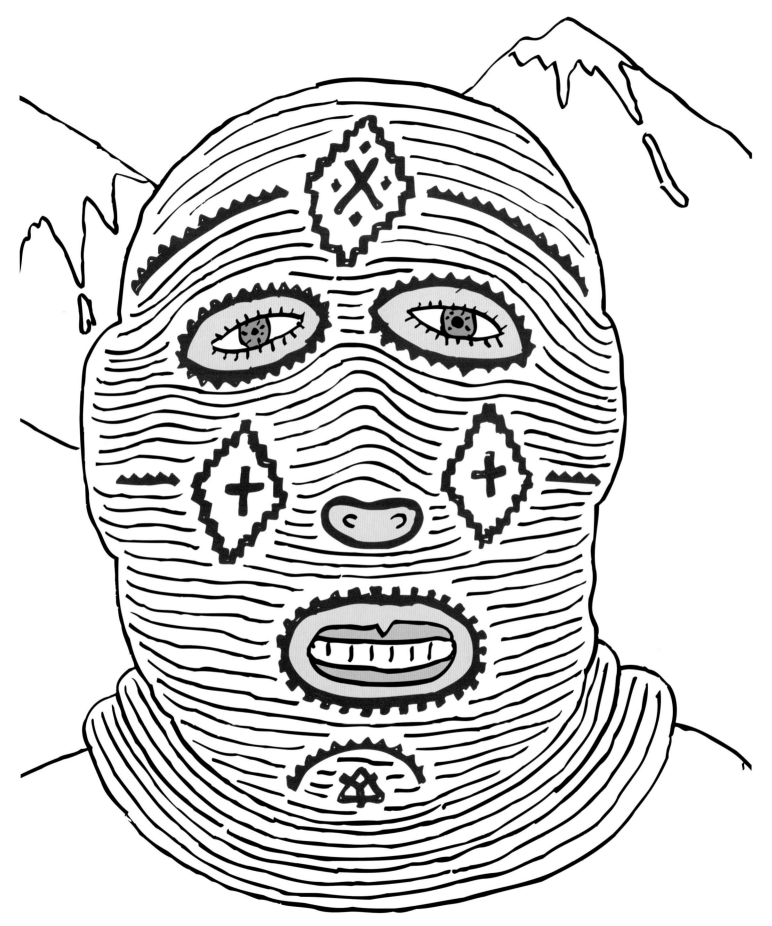

READY FOR WINTER, PEN, INK, AND DIGITAL COLOR, 1991

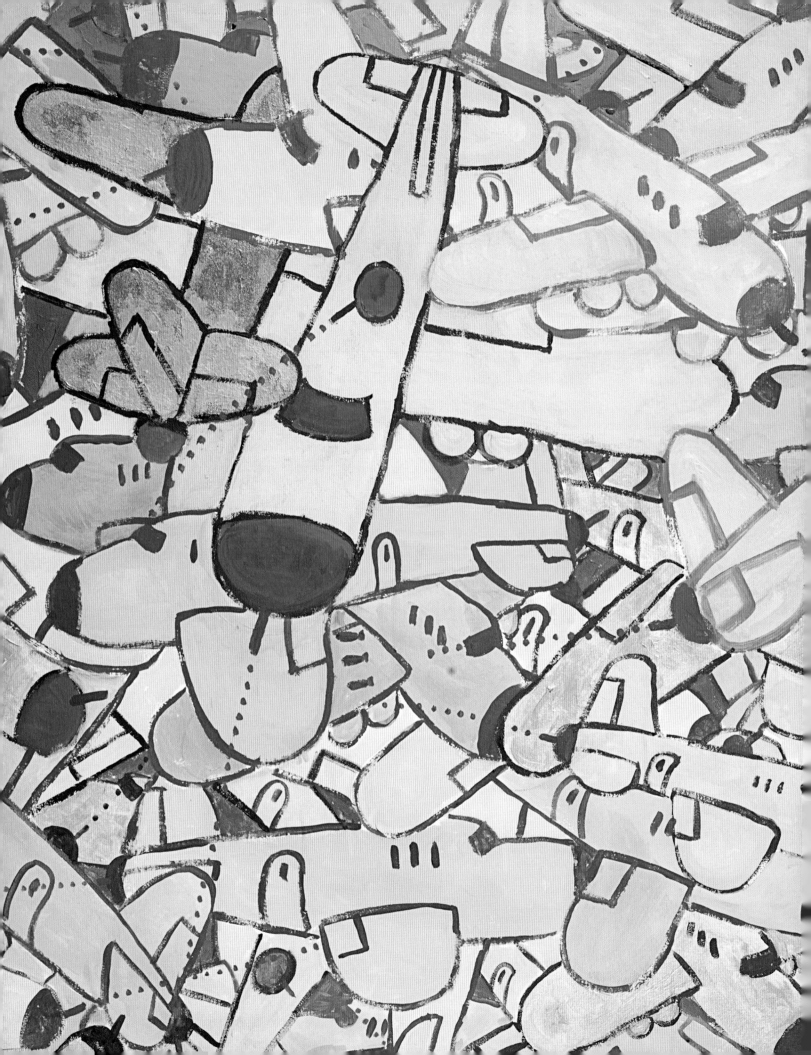

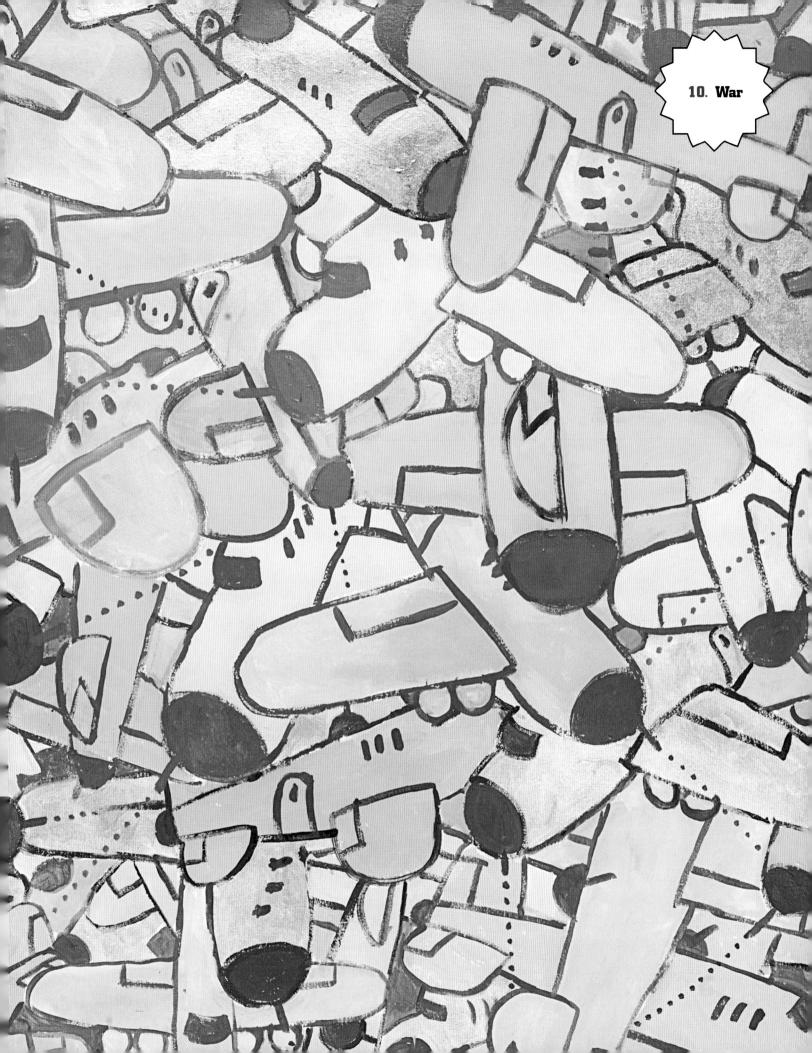

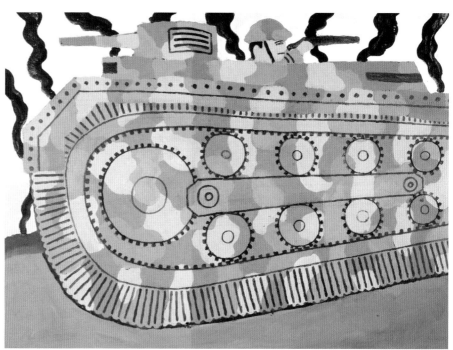

PREVIOUS SPREAD: *OVERCAST 6*, DETAIL, ACRYLIC ON CANVAS, 2006
TANK I, TANK II, ACRYLIC ON CANVAS, 2002
OPPOSITE: *SCRAP*, DETAIL, ACRYLIC ON CANVAS, 2008

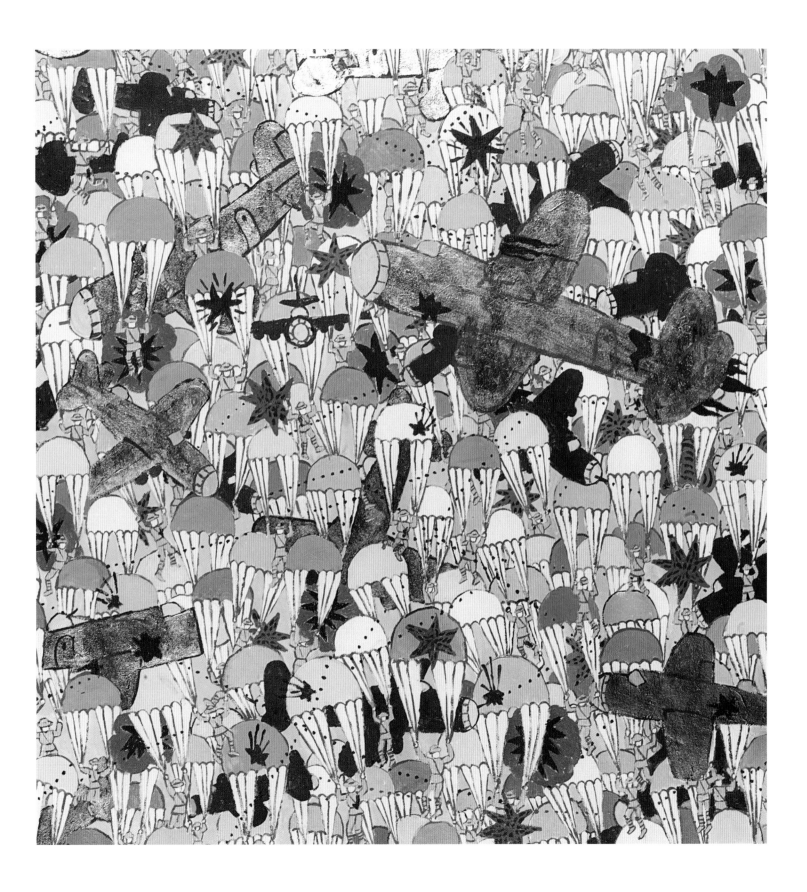

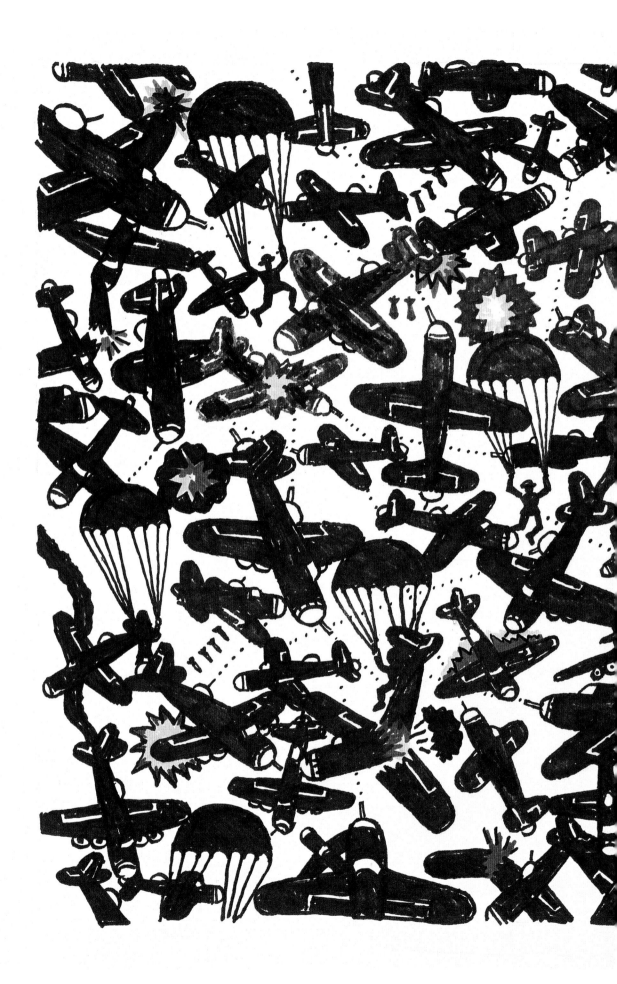

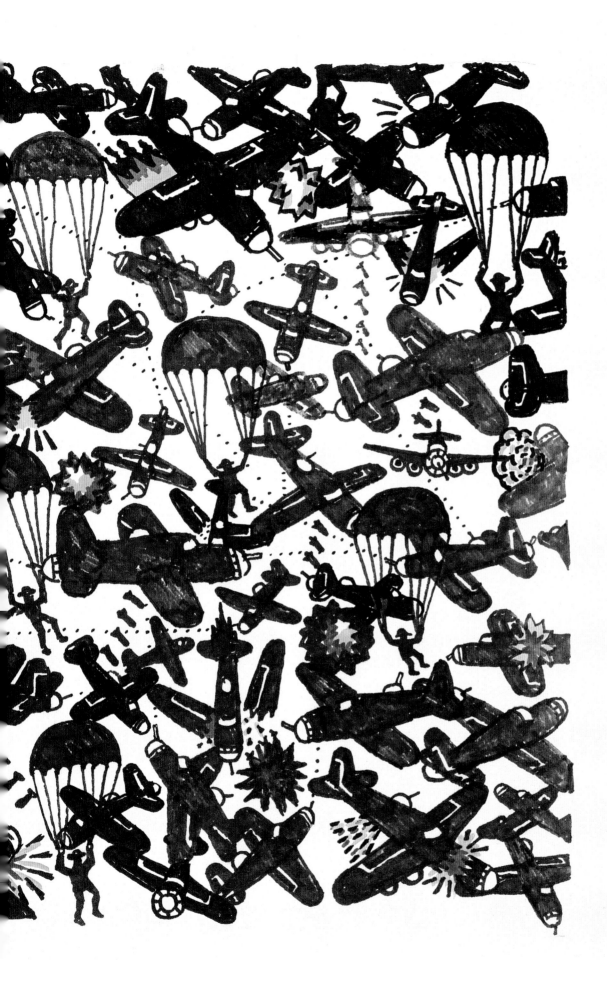

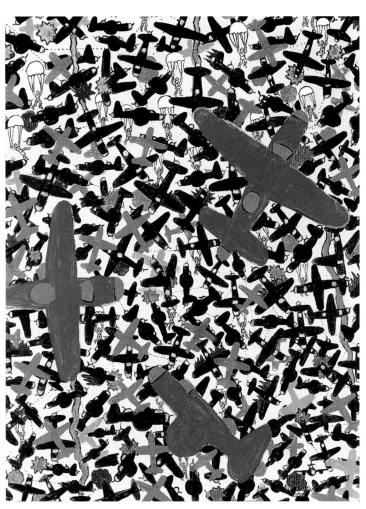

OVERCAST 17, ACRYLIC ON BOARD, 2007
RIGHT: *OVERCAST 18*, ACRYLIC ON CANVAS, 2007

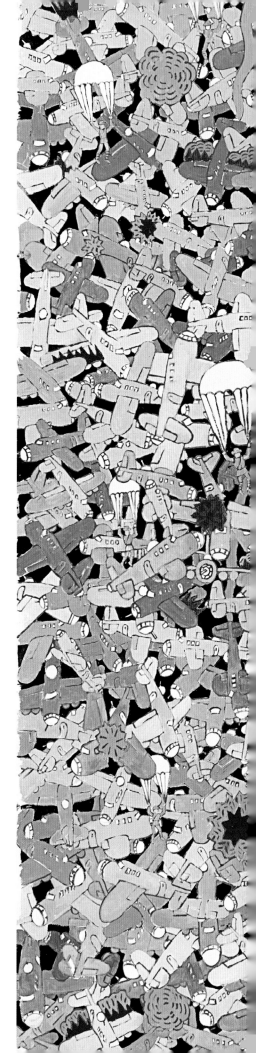

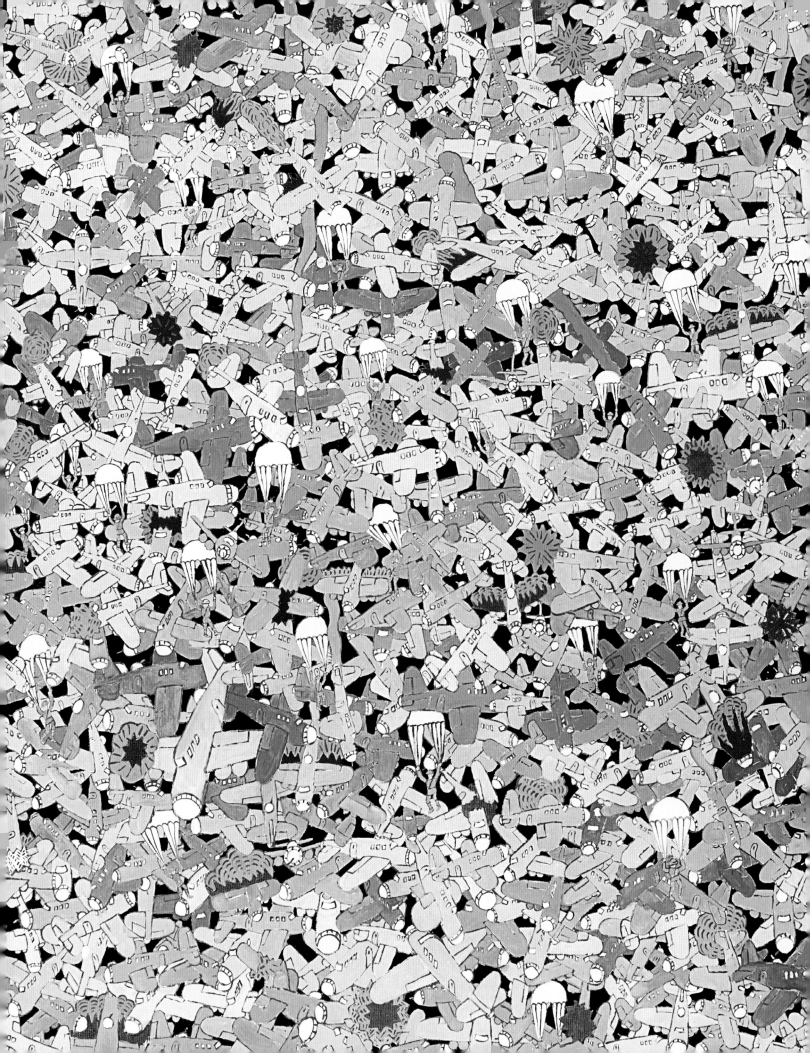

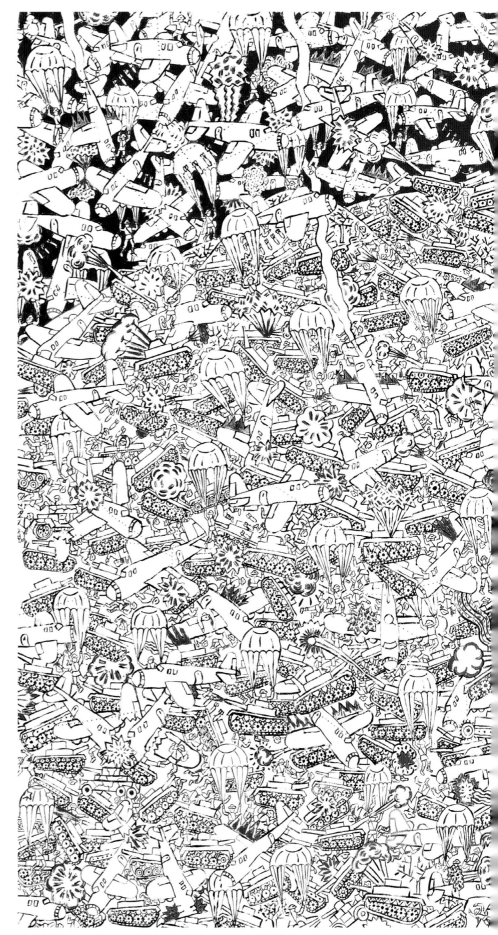

DUMP, DETAIL, ACRYLIC ON CANVAS, 2007

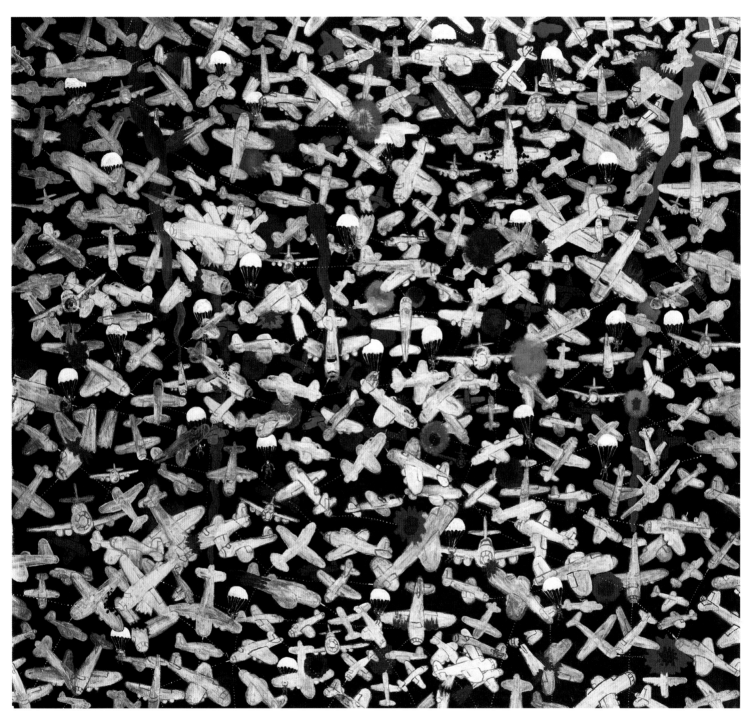

OVERCAST 7, ACRYLIC ON CANVAS, 2008

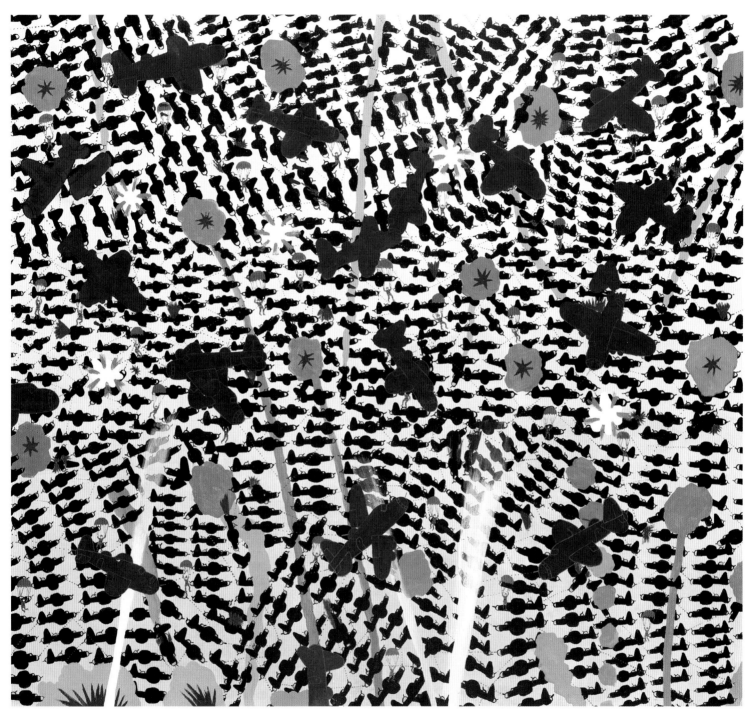

OVERCAST 2, ACRYLIC ON CANVAS, 2008

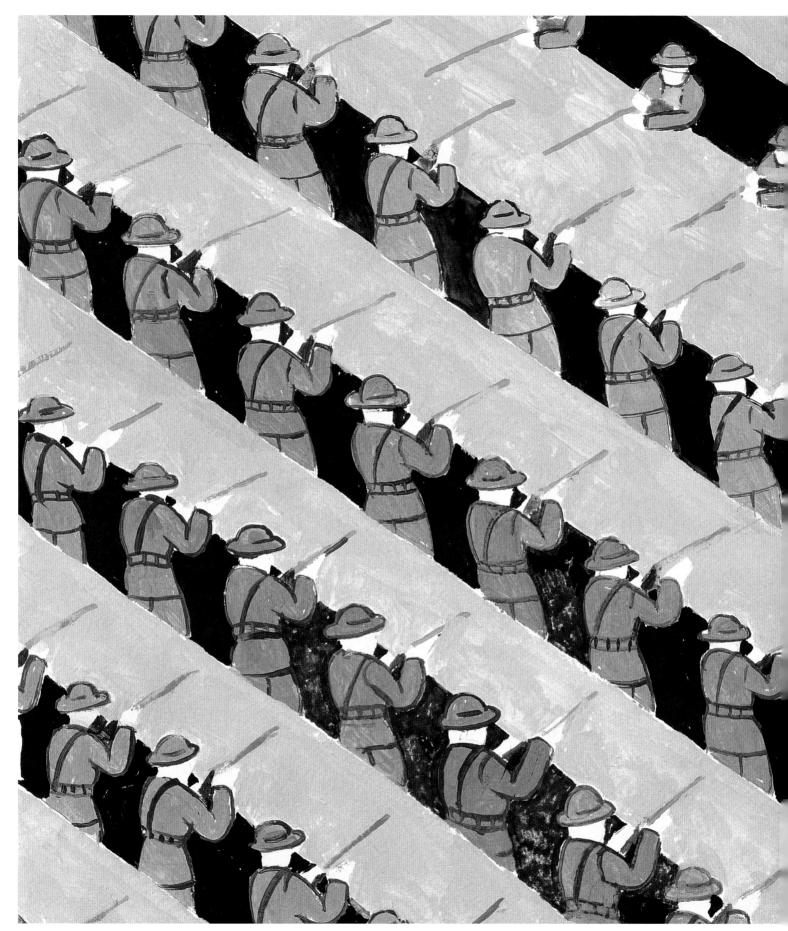

TRENCHES, ACRYLIC ON PAPER, 2007

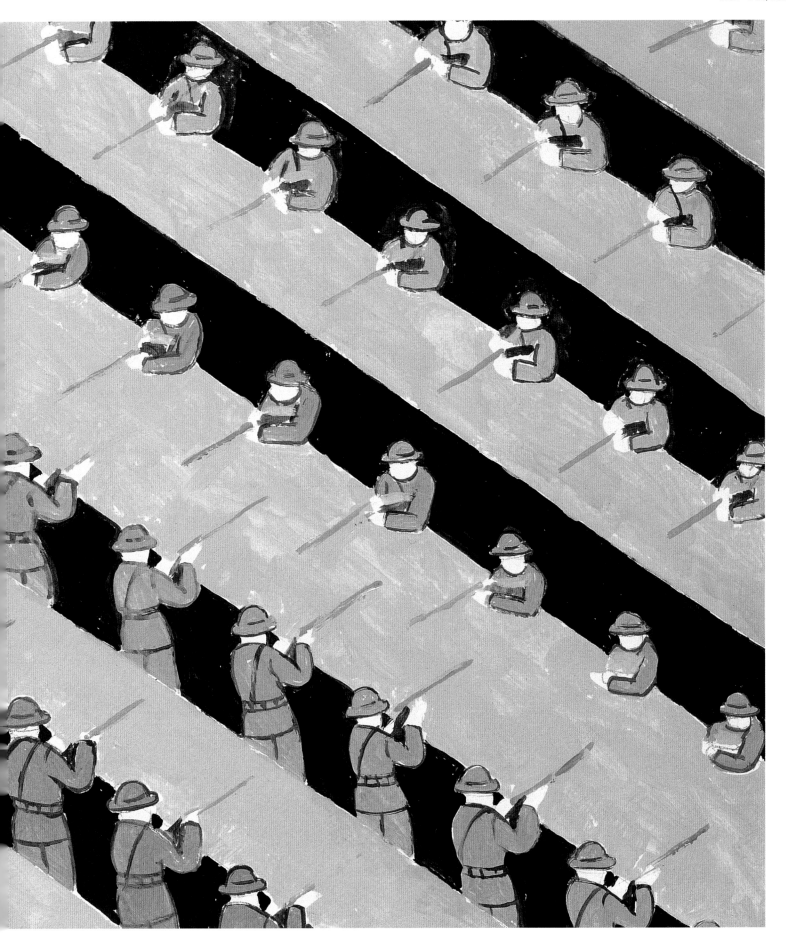

Car Removal in Iraq

February 10, 2004
A car bomb in the central Iraqi town of Iskandariyah, killed at least 50 and wounded nearly 60 people.

September 29, 2005
98 people were killed in three coordinated car bomb attacks in the town of Balad.

September 13, 2006
A parked car bomb exploded in Baghdad, killing 8 people and wounding 17.

January 18, 2004
A suicide car bomb killed 18 people and wounded dozens in Baghdad.

June 8, 2004
A car bomb in Baquba and Mosul killed 15 and injured 126.

June 3, 2006
A suicide car bombing in Al-Basrah killed at least 27 people and injured about 60.

February 28, 2005
A suicide car bombing in Hilla killed 125 and injured at least 130 others.

December 14, 2003
A car bomb in Khaldiyah killed at least 17 and wounded 30.

July 18, 2006
At least 54 people were killed and dozens were wounded by a car bomb in Kufa.

November 12, 2003
A suicide truck bomb killed 29 people and wounded at least 100.

September 19, 2005
12 people were killed by car bombs in Mahmoudiya and Latifya.

July 13, 2005
At least 27 people, mostly children, were killed and at least 50 were injured by a suicide car bomb in Baghdad.

September 13, 2006
In Baghdad, a car bomb killed at least 19 people and wounded more than 62.

March 1, 2005
A car bomb in Hillah killed 120 people and wounded more than 130.

August 29, 2005
In Najaf, a car bomb killed at least 125 people and wounded 142.

July 15, 2004
A car bomb killed 10 people and wounded 9 in Haditha.

May 11, 2005
A car bombing in Tikrit killed 30 people and wounded another 40.

IRAQ, PEN, BRUSH, AND INK ON PAPER, 2007

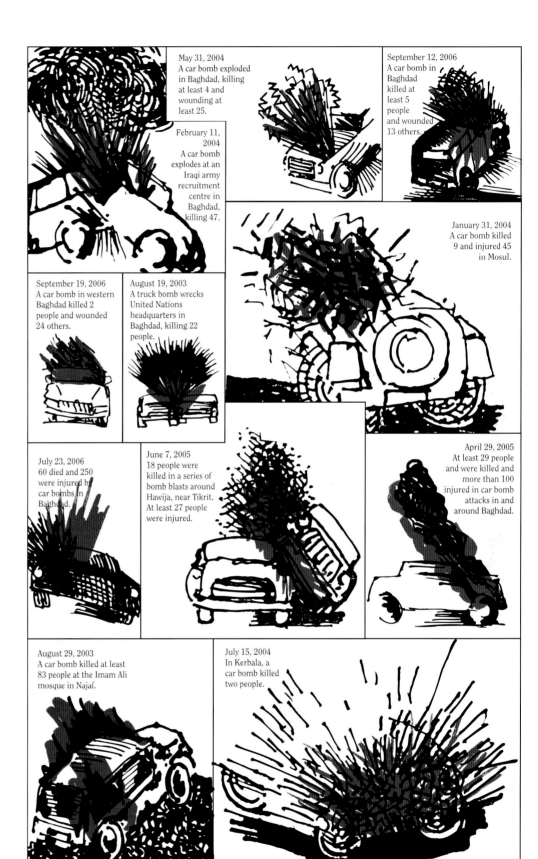

July 16, 2005
A truck bomb
in Mussayib
killed at least
98 people.

June 16, 2005
5 people were
killed by a car bomb
near Ramadi.

May 30, 2006
At least 22 people were
killed and more than 50
were injured in a car
bombing in Baghdad.

May 9, 2006
A car bomb killed at least
17 people and wounded 35
others in Tal Afar.

July 28, 2004
70 people were
killed and 50
were wounded
by a car bomb
in Baquba.

August 1, 2006
At least 10 people were
killed by a car bomb in
Central Baghdad.

September 13, 2006
In Baghdad, car bombs
killed 22 people and
wounded more than 80.

May 31, 2004
A car bomb exploded
in Baghdad, killing
at least 4 and
wounding at
least 25.

February 11,
2004
A car bomb
explodes at an
Iraqi army
recruitment
centre in
Baghdad,
killing 47.

September 12, 2006
A car bomb in
Baghdad
killed at
least 5
people
and wounded
13 others.

January 31, 2004
A car bomb killed
9 and injured 45
in Mosul.

September 19, 2006
A car bomb in western
Baghdad killed 2
people and wounded
24 others.

August 19, 2003
A truck bomb wrecks
United Nations
headquarters in
Baghdad, killing 22
people.

July 23, 2006
60 died and 250
were injured by
car bombs in
Baghdad.

June 7, 2005
18 people were
killed in a series of
bomb blasts around
Hawija, near Tikrit.
At least 27 people
were injured.

April 29, 2005
At least 29 people
and were killed and
more than 100
injured in car bomb
attacks in and
around Baghdad.

August 29, 2003
A car bomb killed at least
83 people at the Imam Ali
mosque in Najaf.

July 15, 2004
In Kerbala, a
car bomb killed
two people.

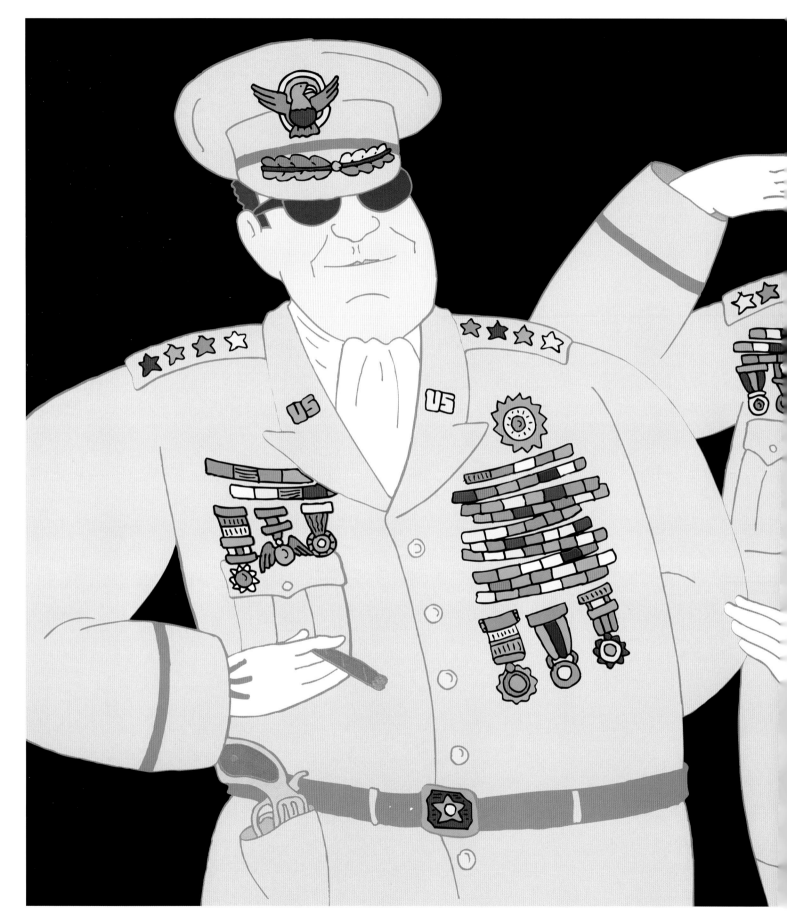

DEFENDERS, PEN, INK, AND DIGITAL COLOR, 2008

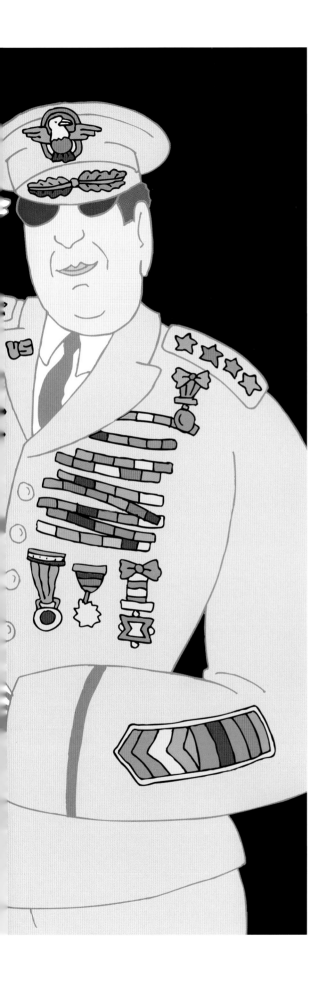

SOUTH VIETNAM, 1967, COLORED PENCIL ON PAPER, 1977

11. Fauna and a
Little Flora

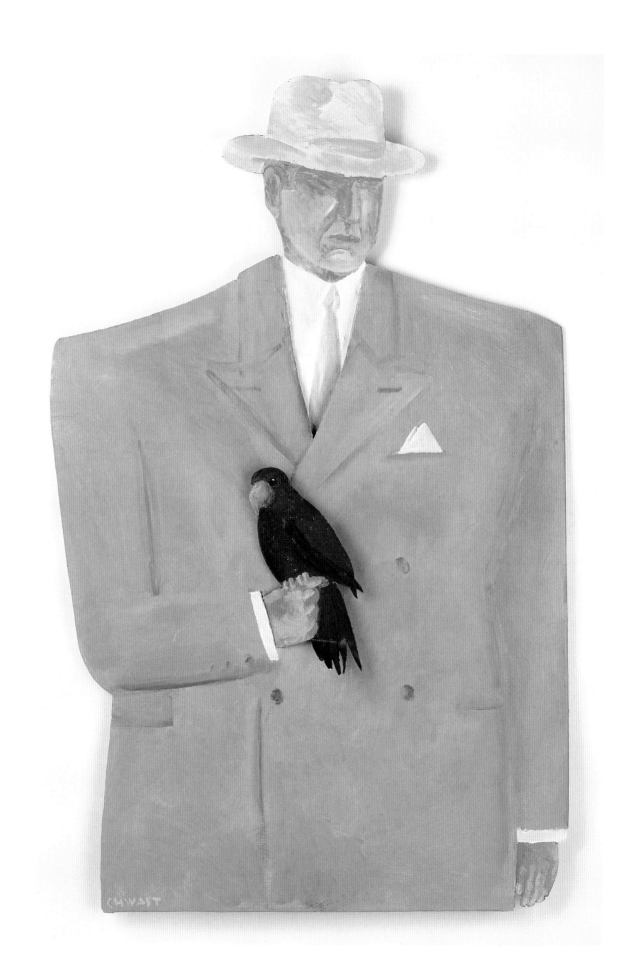

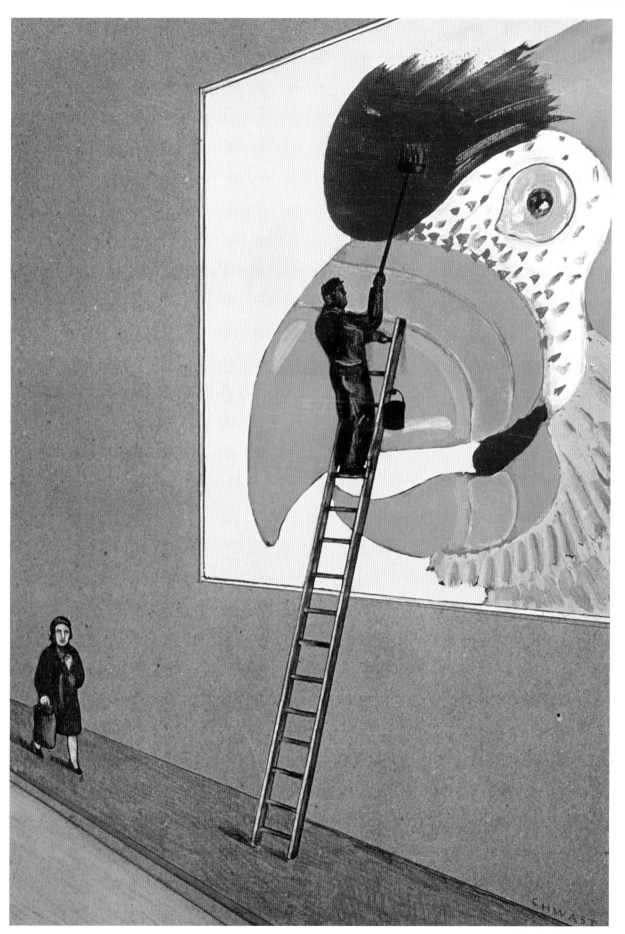

PREVIOUS SPREAD: *CHICKEN*, CHINA MARKER AND DIGITAL COLOR, 2001 (MODIFIED VERSION, 2007)
OPPOSITE: *MAN AND PARROT*, ACRYLIC ON CUTOUT SHEET METAL, 1983
ART FOR ADVERTISING, ACRYLIC AND COLORED PENCIL ON BOARD, 1981

FEAR OF THE SPIDER, MARKER, PEN, AND INK ON PAPER, 1992

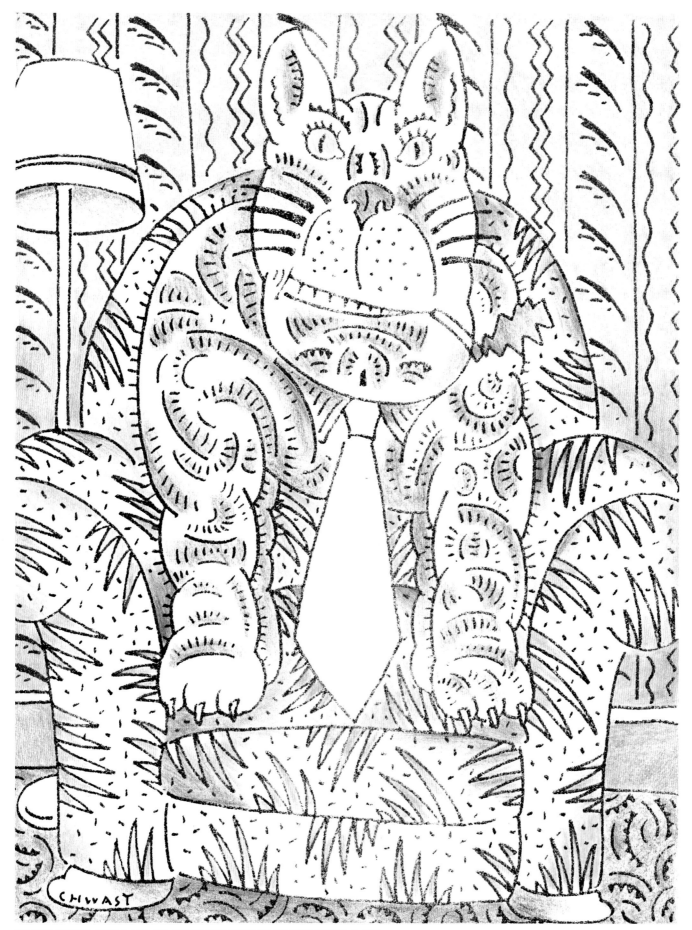

CAT WITH ATTITUDE, MARKER, PEN, INK, AND COLORED PENCIL ON PHOTOCOPY PAPER, C. 1992

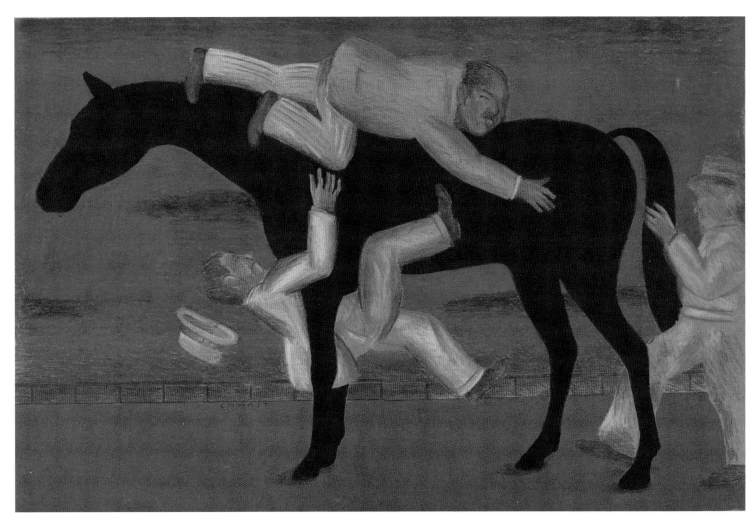

FOR THE LOVE OF A HORSE, COLORED PENCIL ON PAPER, N.D.
OPPOSITE: *GOD BLESS YOU*, MONOPRINT, 1972

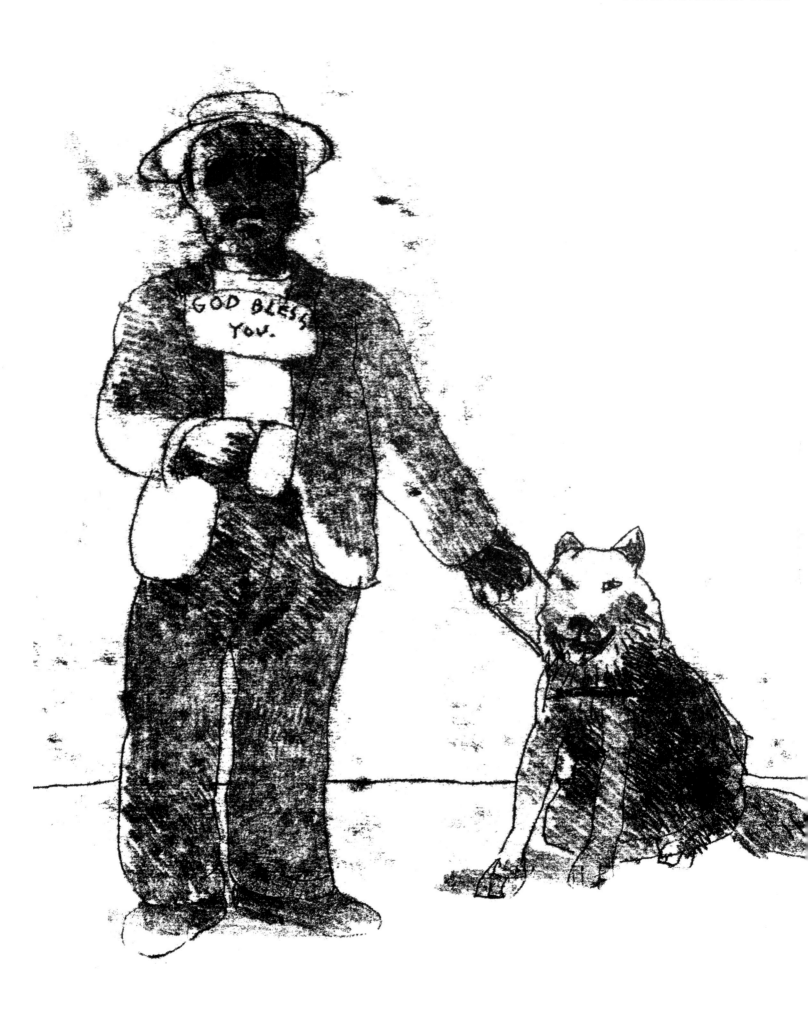

MAGAZINE ILLUSTRATION ABOUT PALM TREES, PEN, INK, AND COLORED PENCIL, 1987

BOOK ILLUSTRATION ABOUT ENVIRONMENTAL DEGRADATION, PEN AND INK ON PAPER, 2006

MOBIUS MOUSE, ART FOR A SHORT FILM, PEN AND INK, 2006

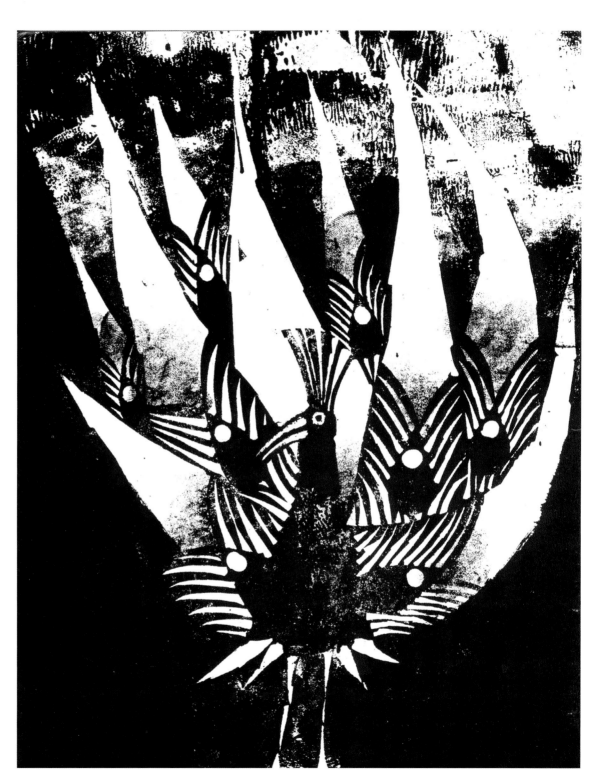

ILLUSTRATION FOR A NURSERY RHYME, LINOCUT, 1961

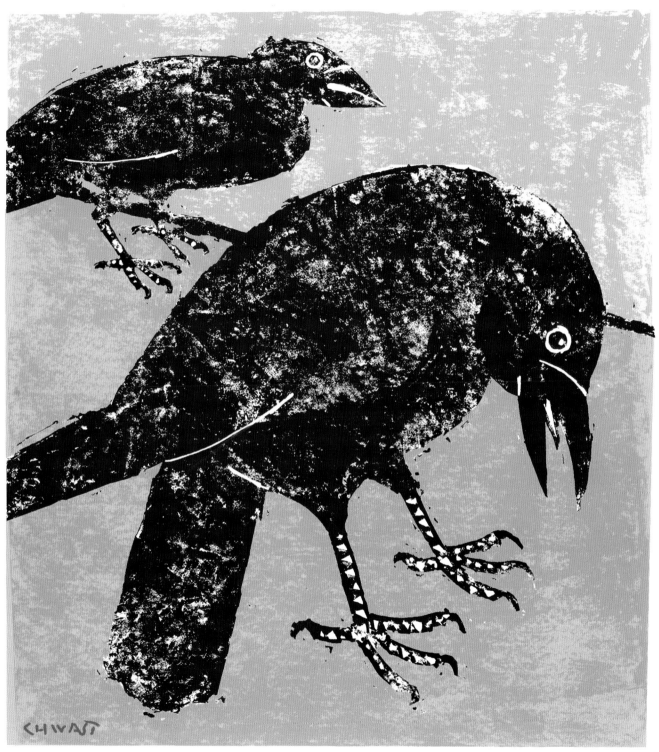

CROWS, MAGAZINE ILLUSTRATION, WOODCUT, 2006

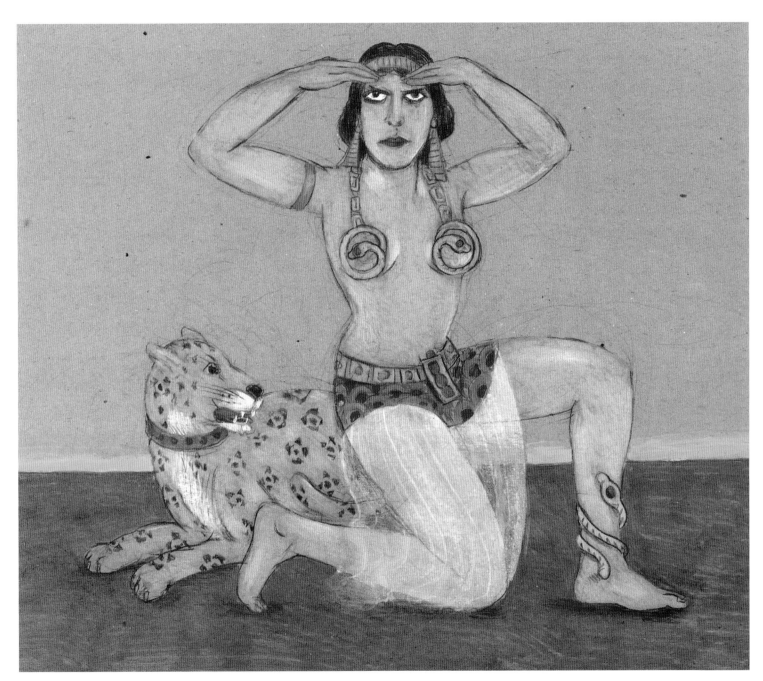

FEMMES FATALES. ABOVE: *SALOME*, AND OPPOSITE: *SARAH BERNHARDT*, BOTH ACRYLIC AND COLORED PENCIL ON BOARD, 1992

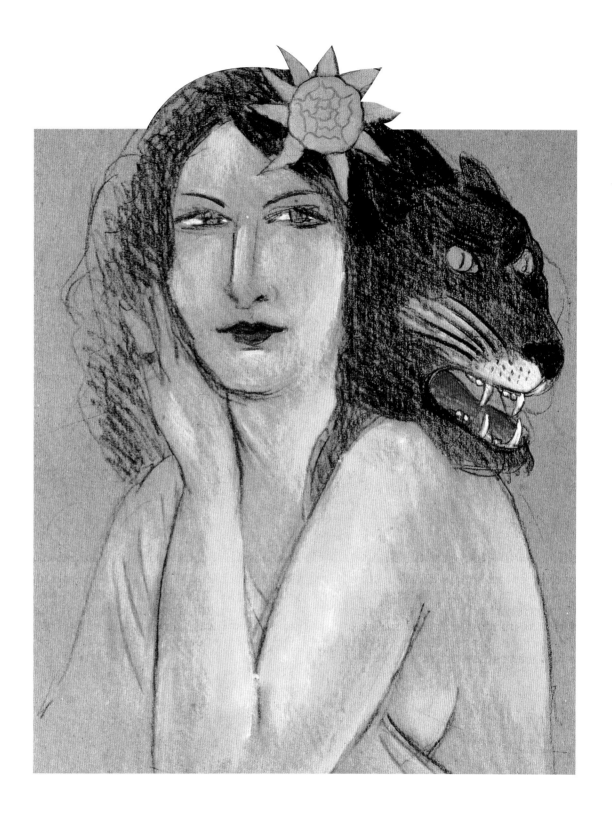

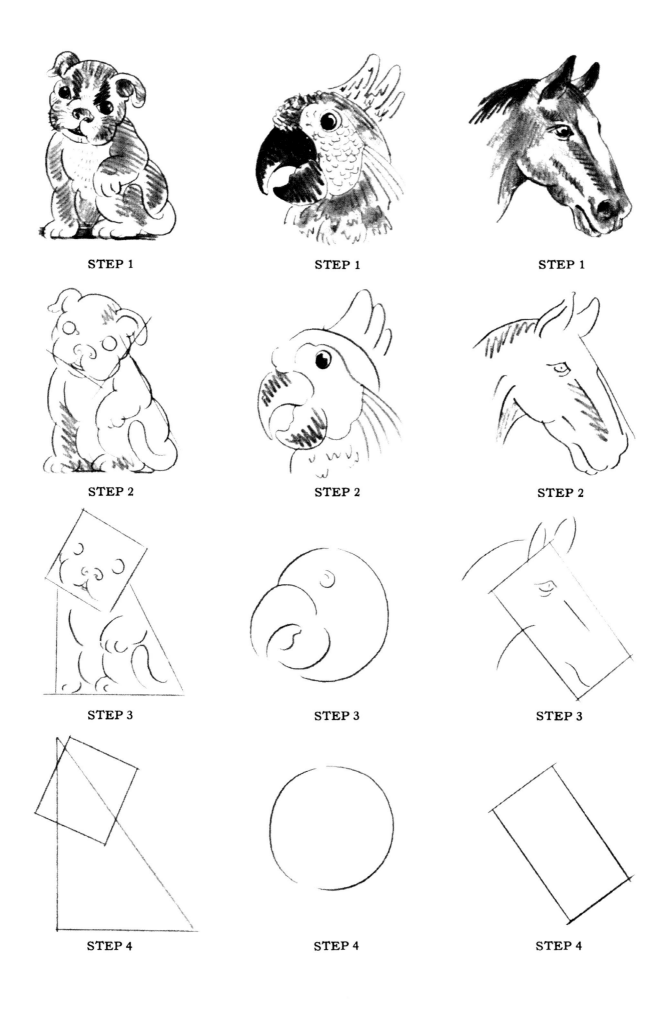

STEP 1 STEP 1 STEP 1

STEP 2 STEP 2 STEP 2

STEP 3 STEP 3 STEP 3

STEP 4 STEP 4 STEP 4

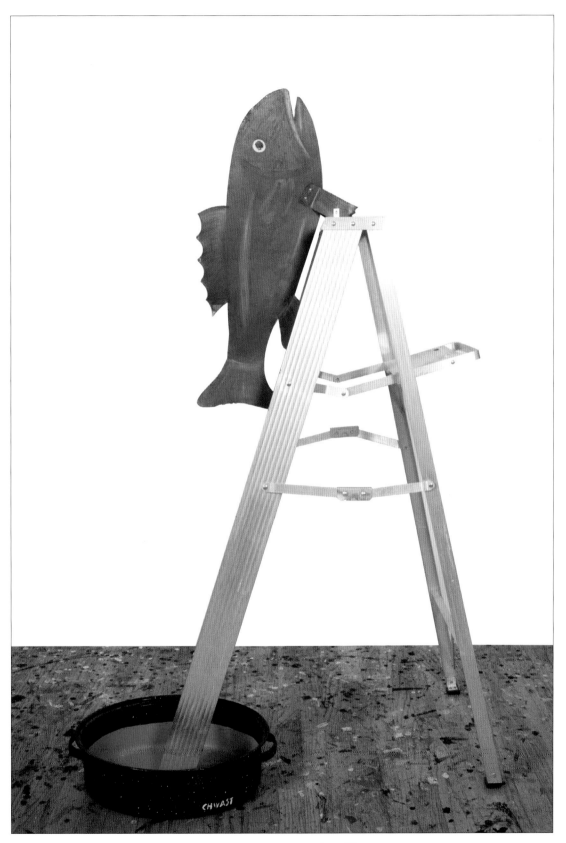

OPPOSITE: *HOW TO DRAW GEOMETRIC SHAPES*, PEN, INK, AND GRAPHITE ON PAPER, 1978
EVOLUTION, MIXED MEDIA WITH FIVE-FOOT LADDER, 1993

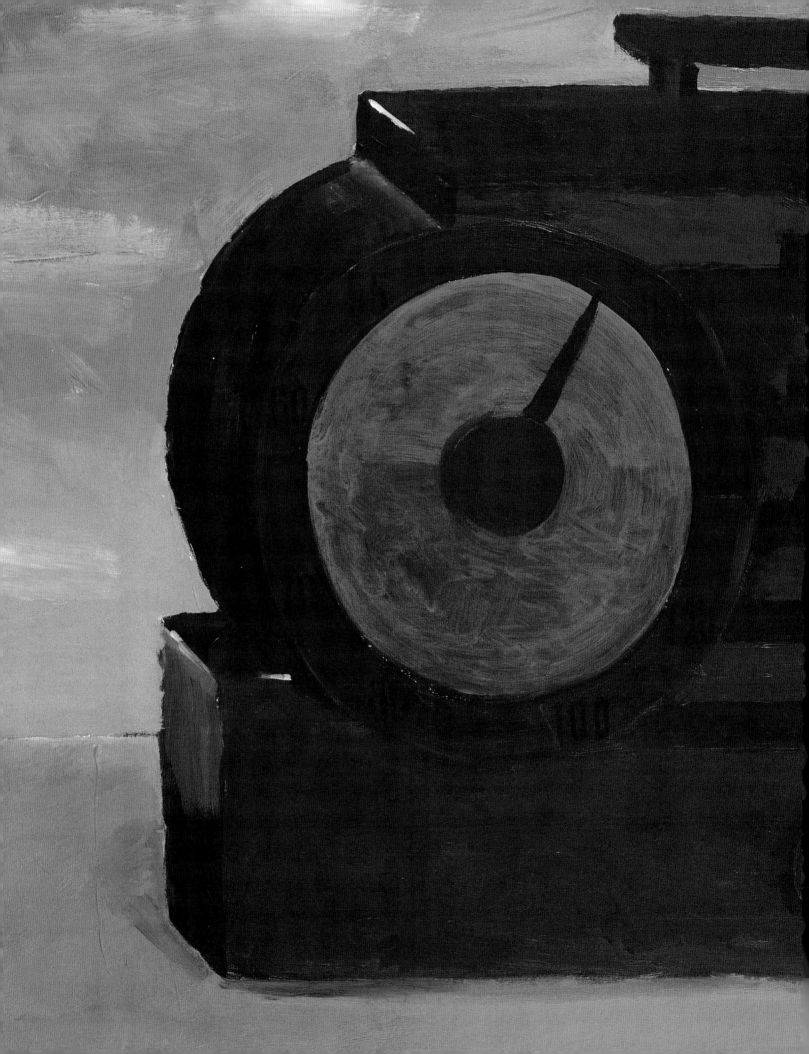

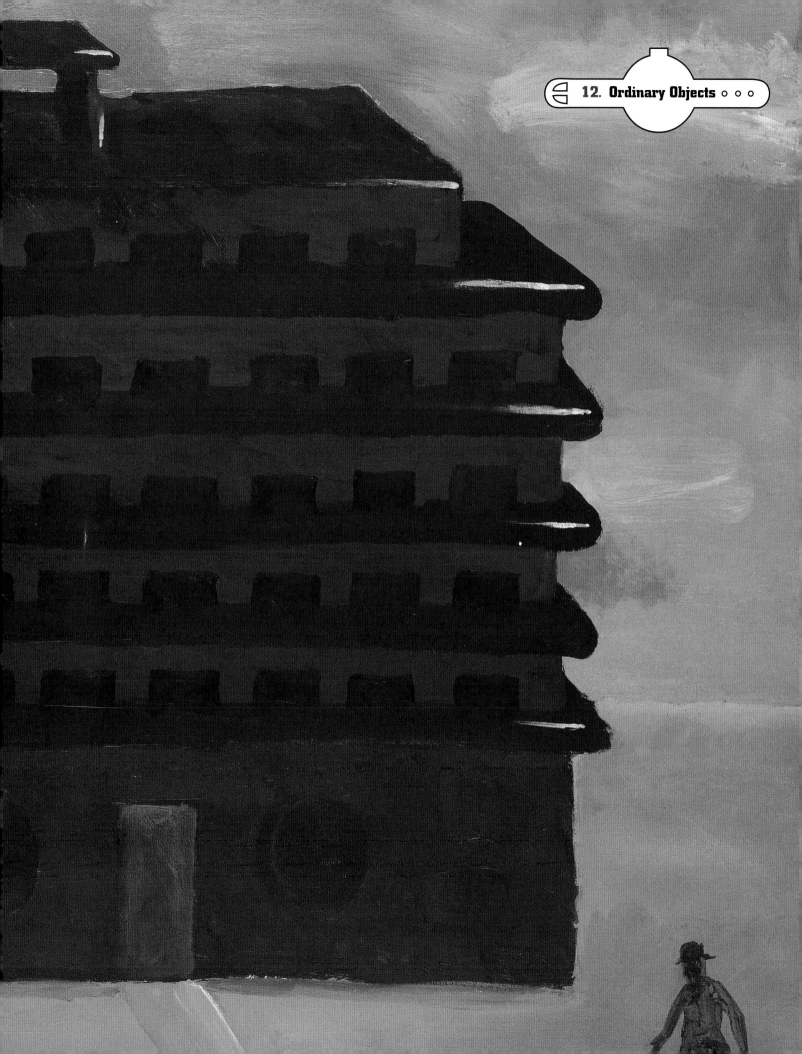

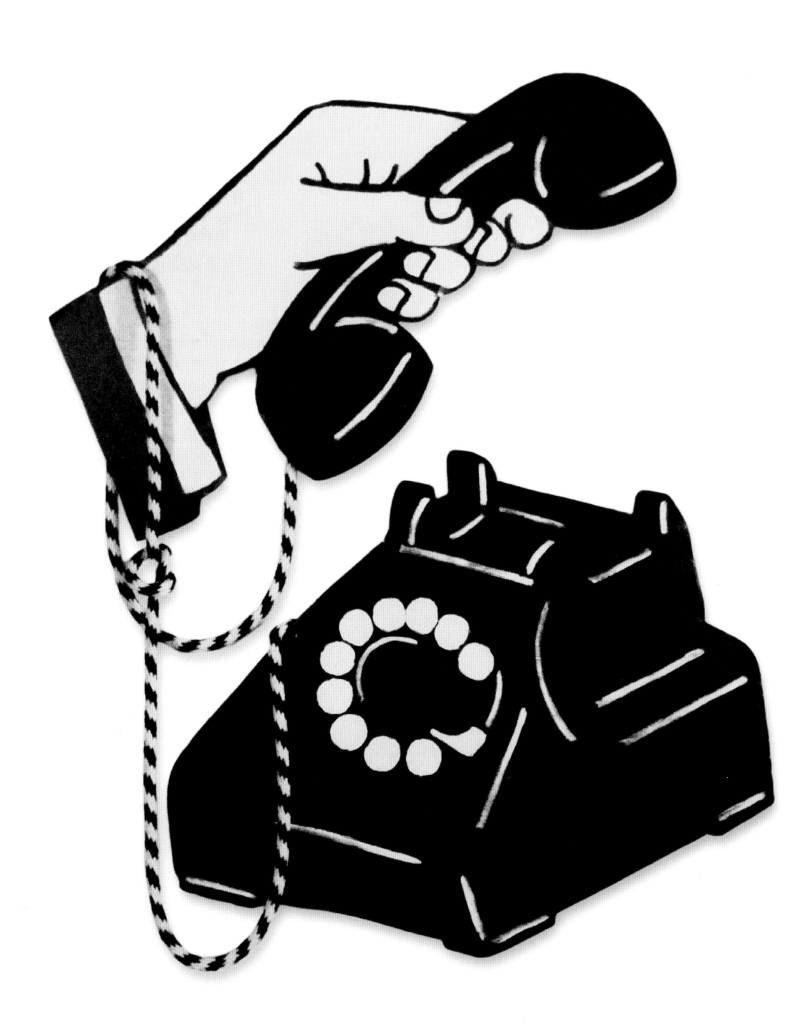

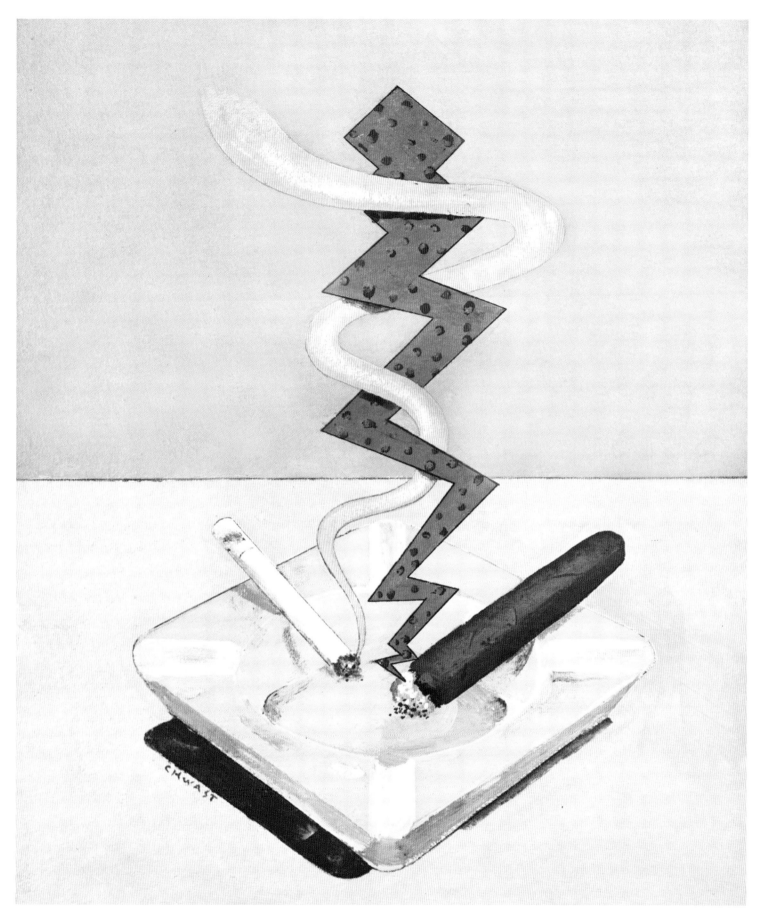

PREVIOUS SPREAD: *RADIO*, ACRYLIC AND COLORED PENCIL, 1990
OPPOSITE: *HANG UP!*, ACRYLIC ON CUTOUT SHEET METAL WITH ROPE, 1997
SMOKE, ACRYLIC ON PAPER, 1980

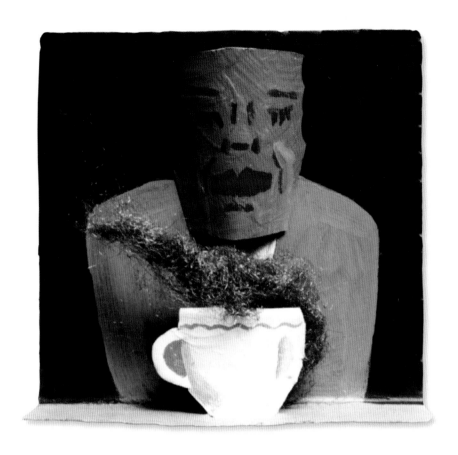

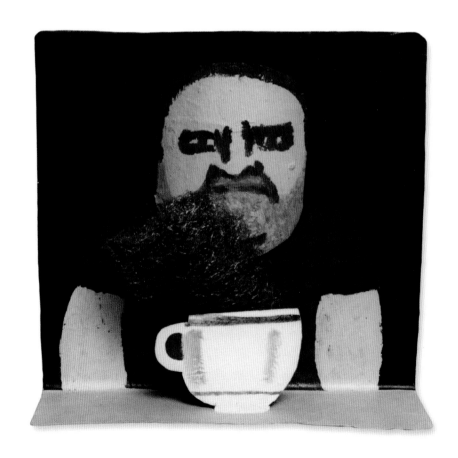

BREAKFAST COFFEE, ACRYLIC ON CUTOUT SHEET METAL WITH STEEL WOOL, 1995

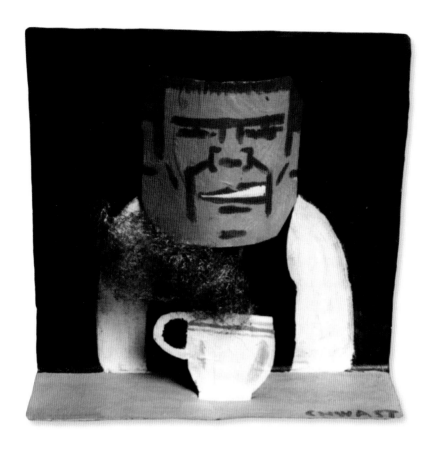

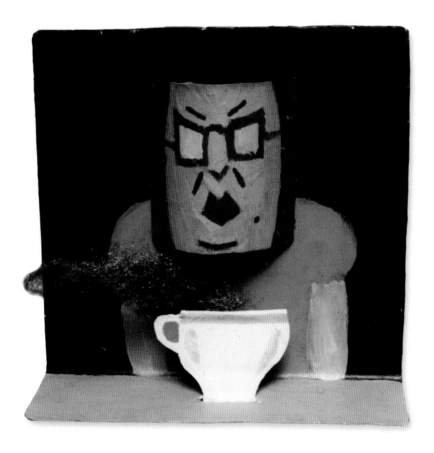

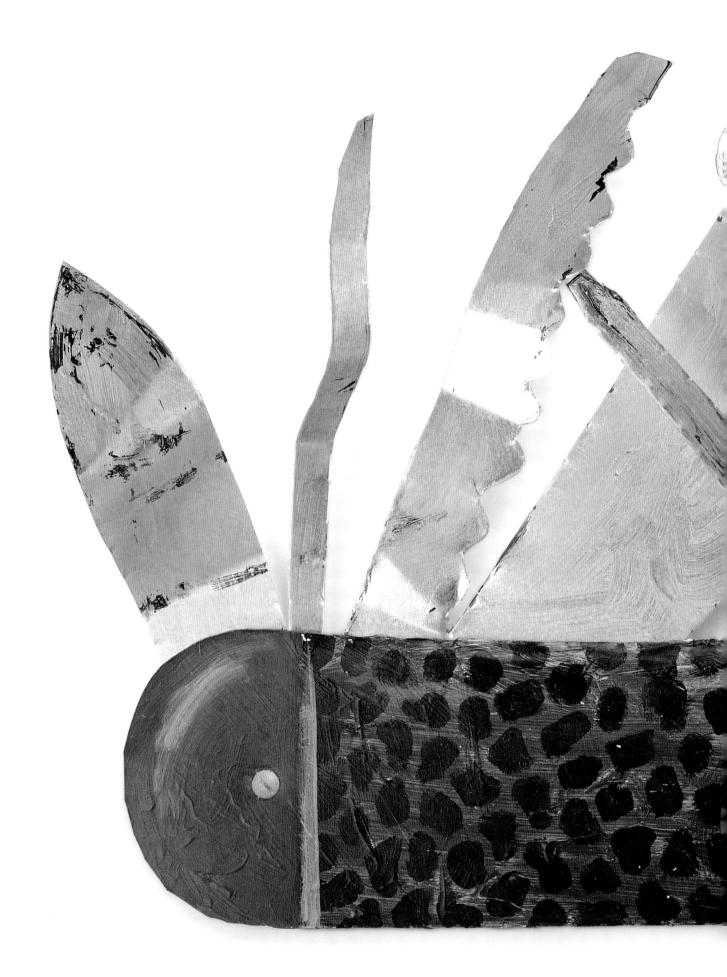

OFFICIAL SWISS NAVY KNIFE, ACRYLIC ON CUTOUT SHEET METAL, 1992

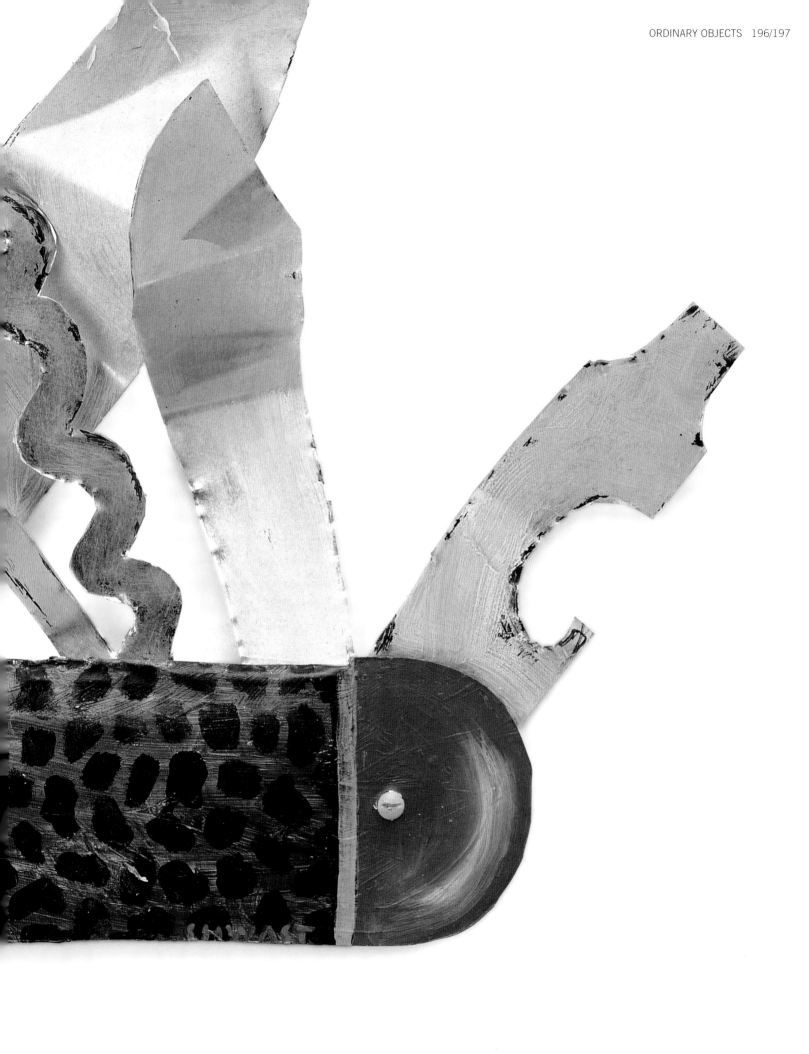

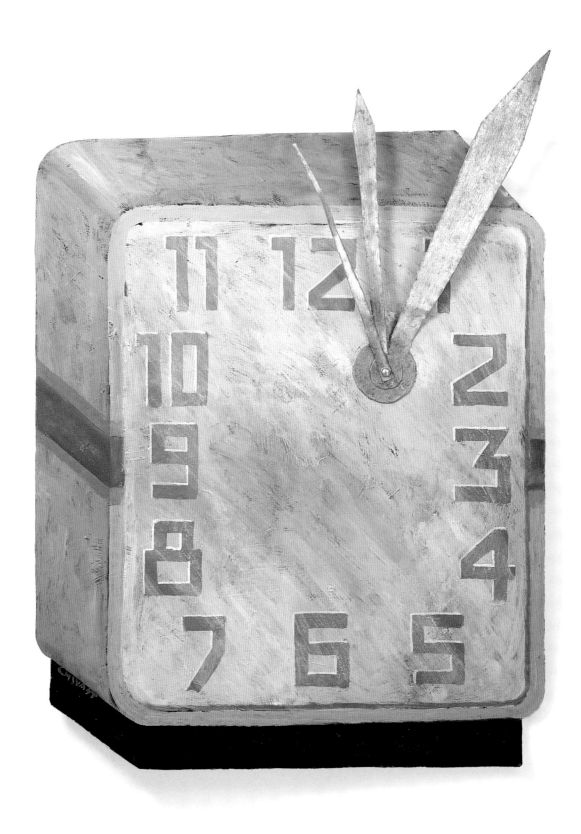

VERY BIG BEN, ACRYLIC ON CUTOUT SHEET METAL WITH SCREW, 1992

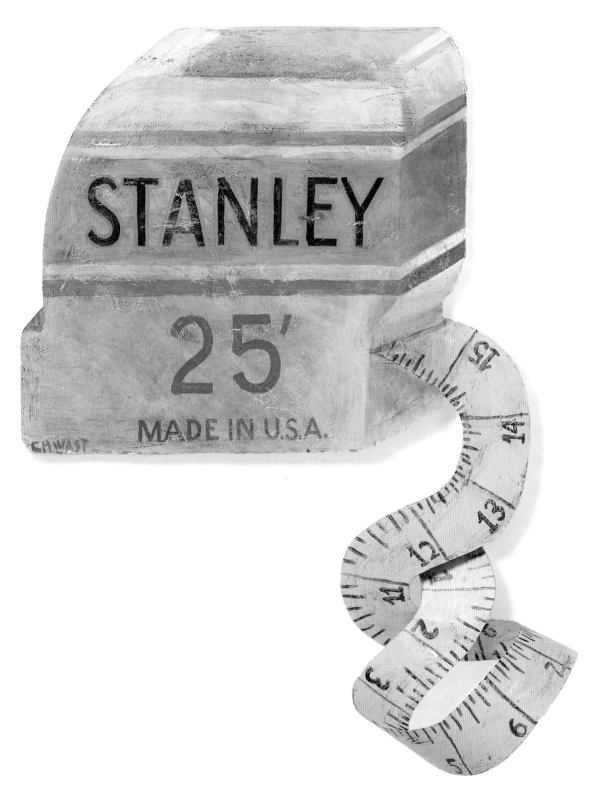

CONSTRUCTION IS UP, ACRYLIC ON CUTOUT SHEET METAL, 1992

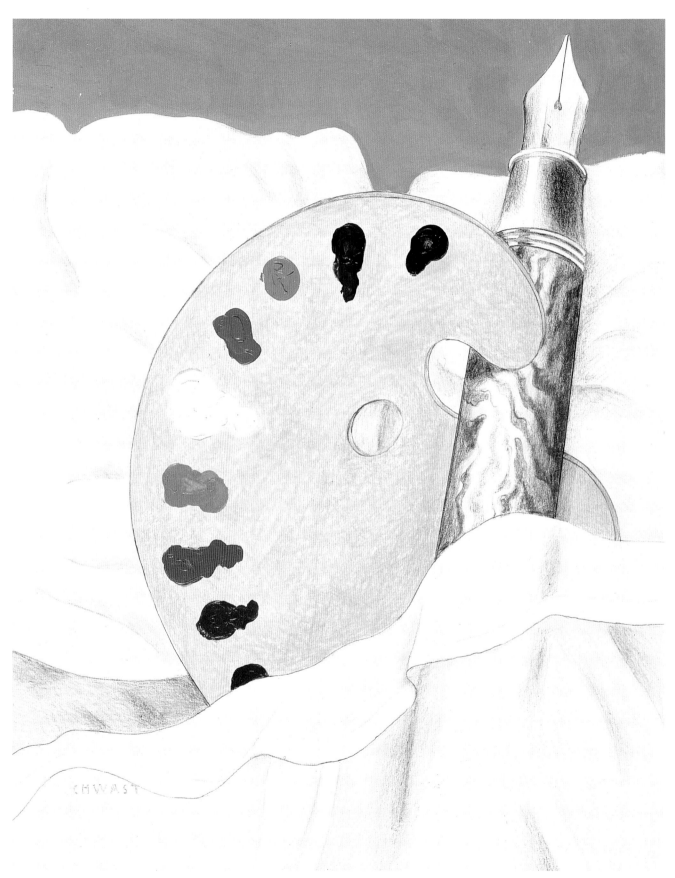

THE WEDDING NIGHT OF ART AND LITERATURE, COLORED PENCIL AND ACRYLIC ON BOARD, 1977

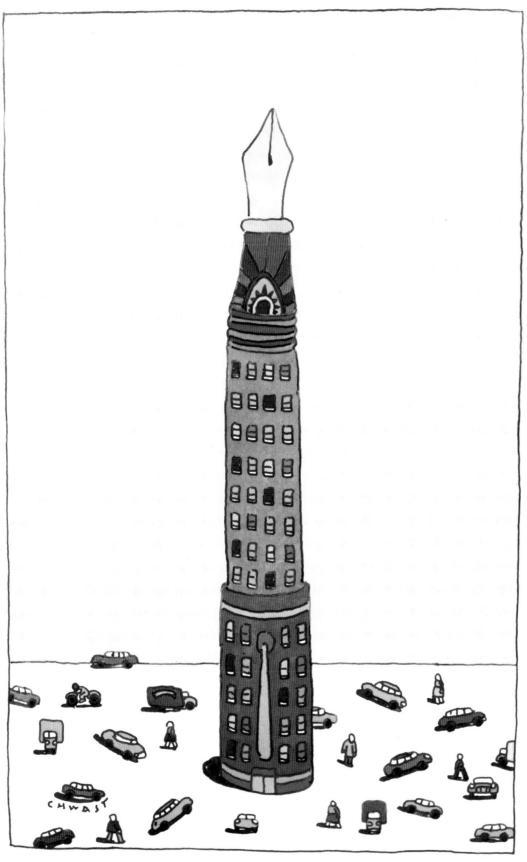

ART FOR A POSTER, PEN, INK AND COLOR FILM, 1988

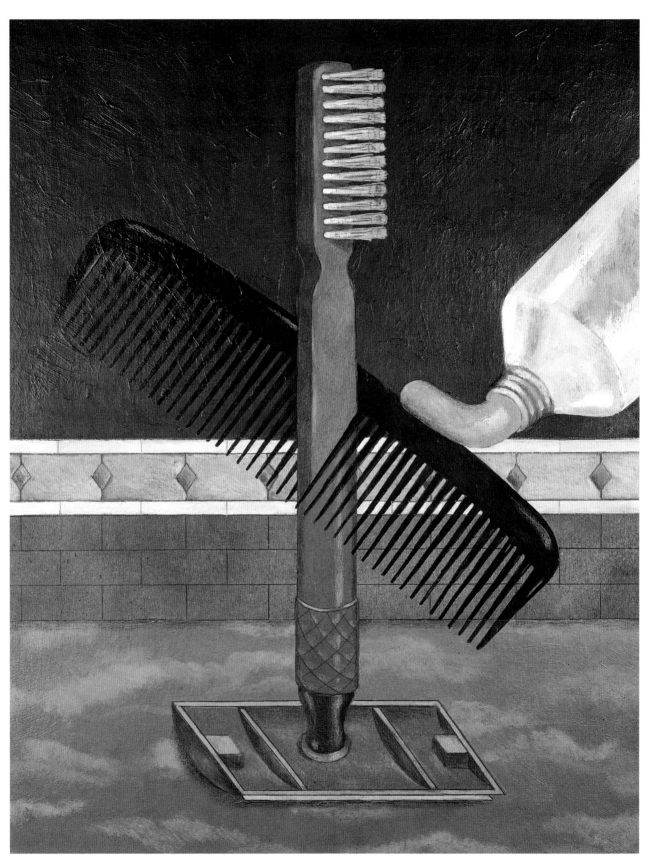

ART FOR A POSTER, COLORED PENCIL AND ACRYLIC ON BOARD, 1983

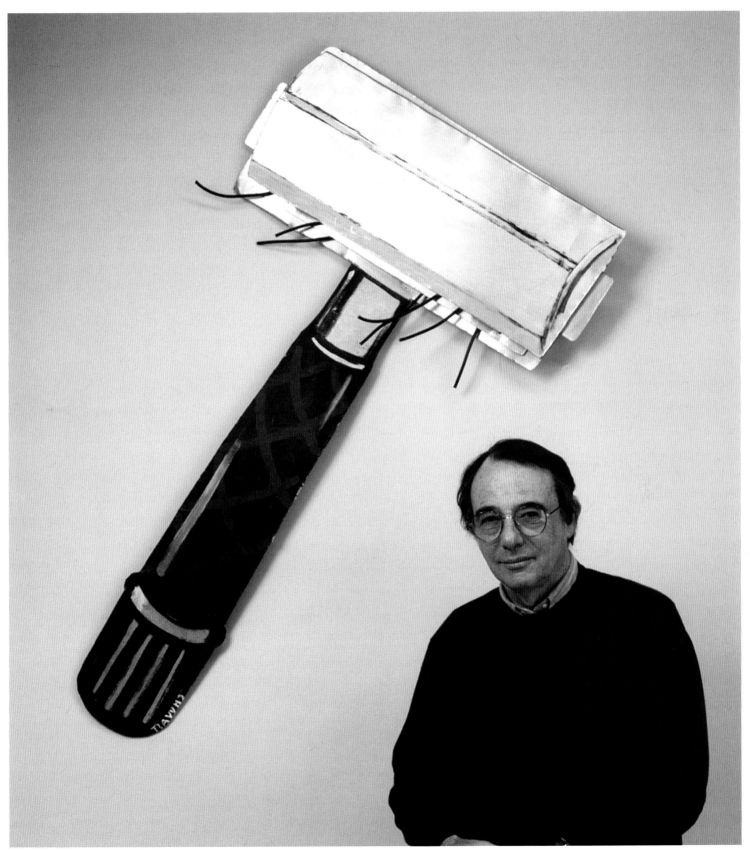

RAZOR, ACRYLIC ON CUTOUT SHEET METAL AND WIRE WITH THE ARTIST, 1994

IRON, ACRYLIC ON CUTOUT SHEET METAL, 1995
OPPOSITE: *WHITE WASH*, ACRYLIC ON CUTOUT SHEET METAL, 1995

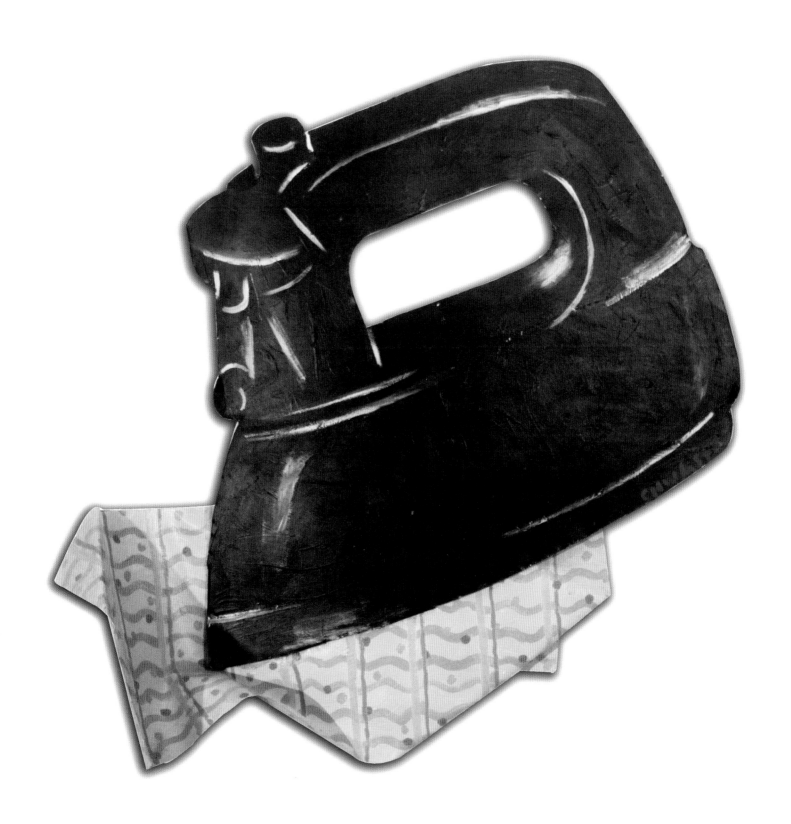

PREVIOUS SPREAD: *BODY WORK*, DETAIL, ACRYLIC ON CANVAS, 2005
PERFECTION, COLORED PENCIL ON PAPER, 2001

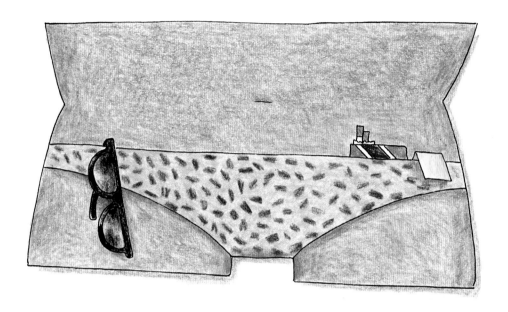

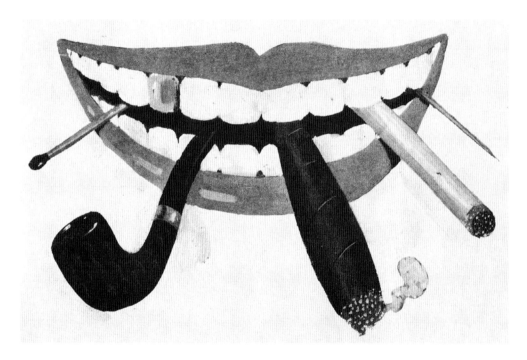

TOP: *MUSCLE MAN*, PEN, INK, AND COLORED PENCIL ON PAPER, 2008
ABOVE: FOR THE *PUSH PIN GRAPHIC*, INK ON PAPER, 1975
OPPOSITE: UNTITLED, DETAIL, ACRYLIC ON SHEET METAL, 1997

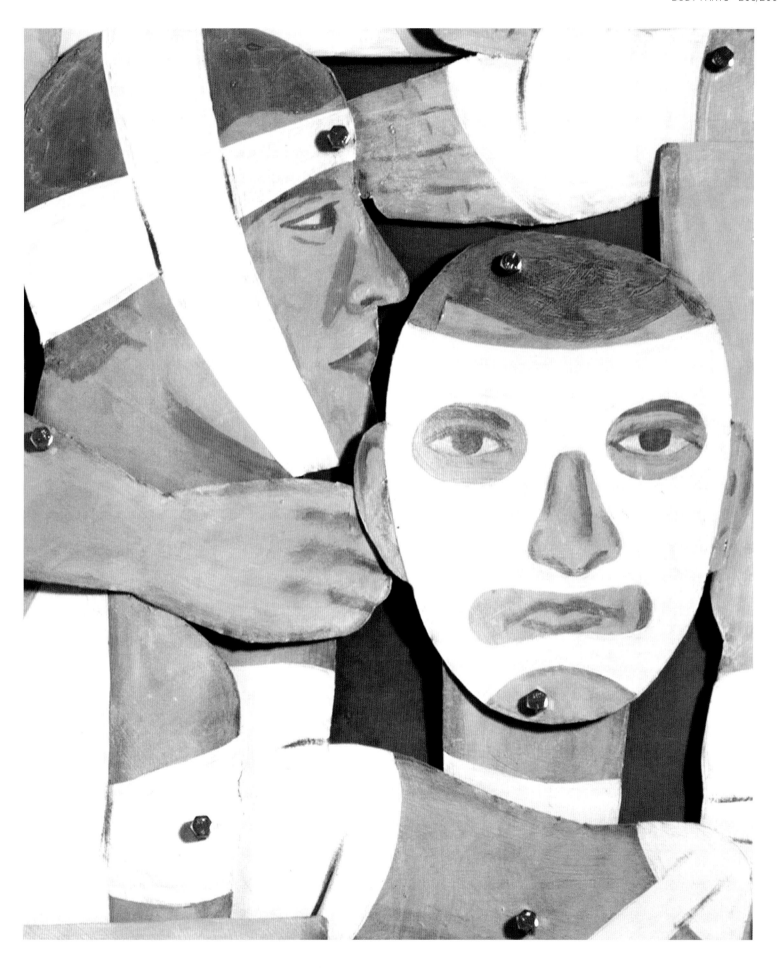

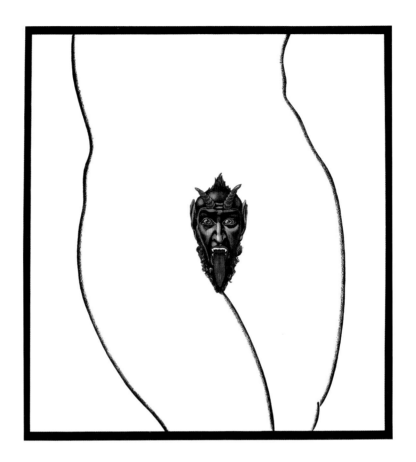

TOP: *ART OR PORNOGRAPHY*, CHINA MARKER AND DECOUPAGE, 1970
ABOVE: TOULOUSE-LAUTREC FOR A POSTER, MARKER AND COLORED PENCIL, 2001
OPPOSITE: *THE PODIATRIST'S DREAM*, PEN AND INK, 2005

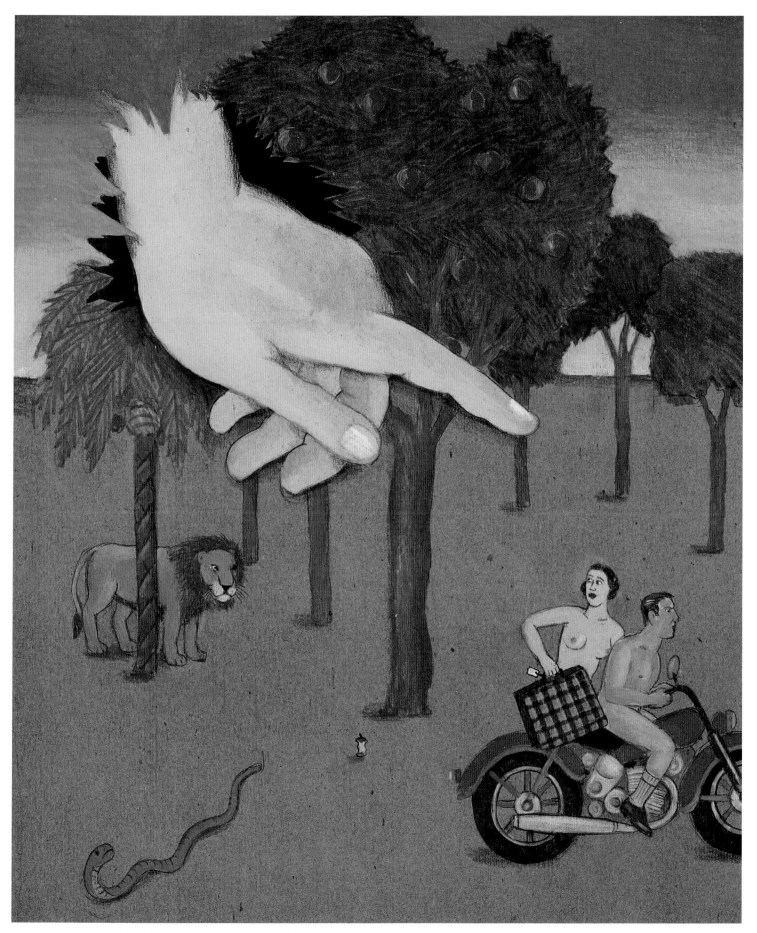

OPPOSITE: DETAIL OF POSTER FOR LECTURE SERIES, MARKER AND DIGITAL COLOR, 2005
LEAVING EDEN, ACRYLIC ON BOARD, 1988

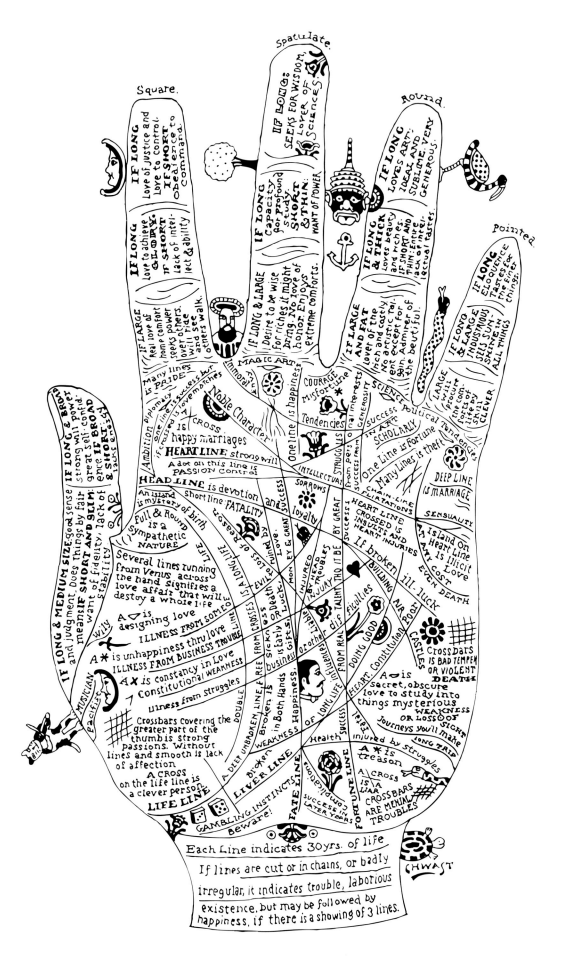

PALMISTRY CHART, PEN AND INK, 2001

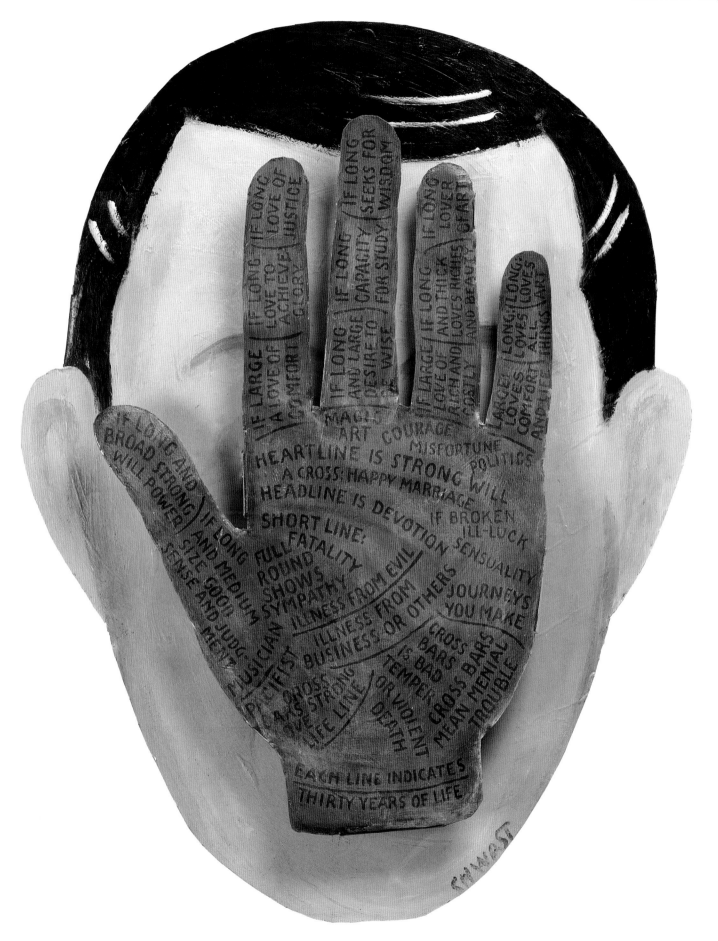

RED HANDED, ACRYLIC ON CUTOUT SHEET METAL, 1995

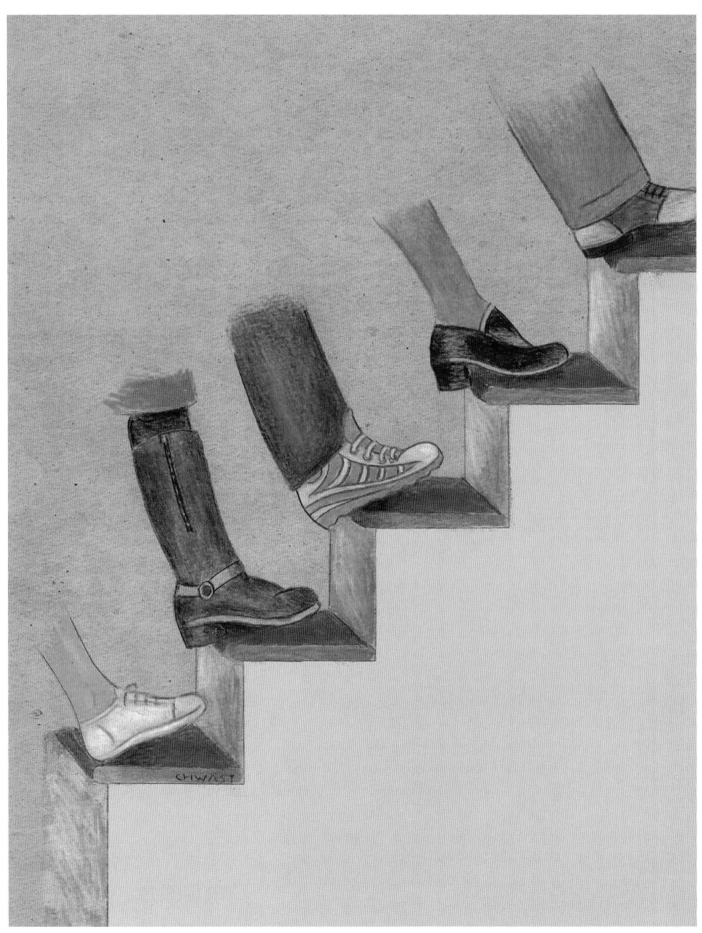

CLIMBING, COLORED PENCIL AND COLLAGE ON WRAPPING PAPER, 1997
OPPOSITE: *TRAVELING SALESMAN*, ACRYLIC ON CUTOUT SHEET METAL, 1994

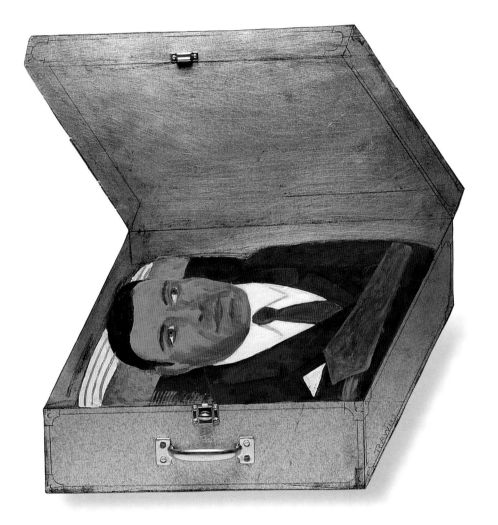

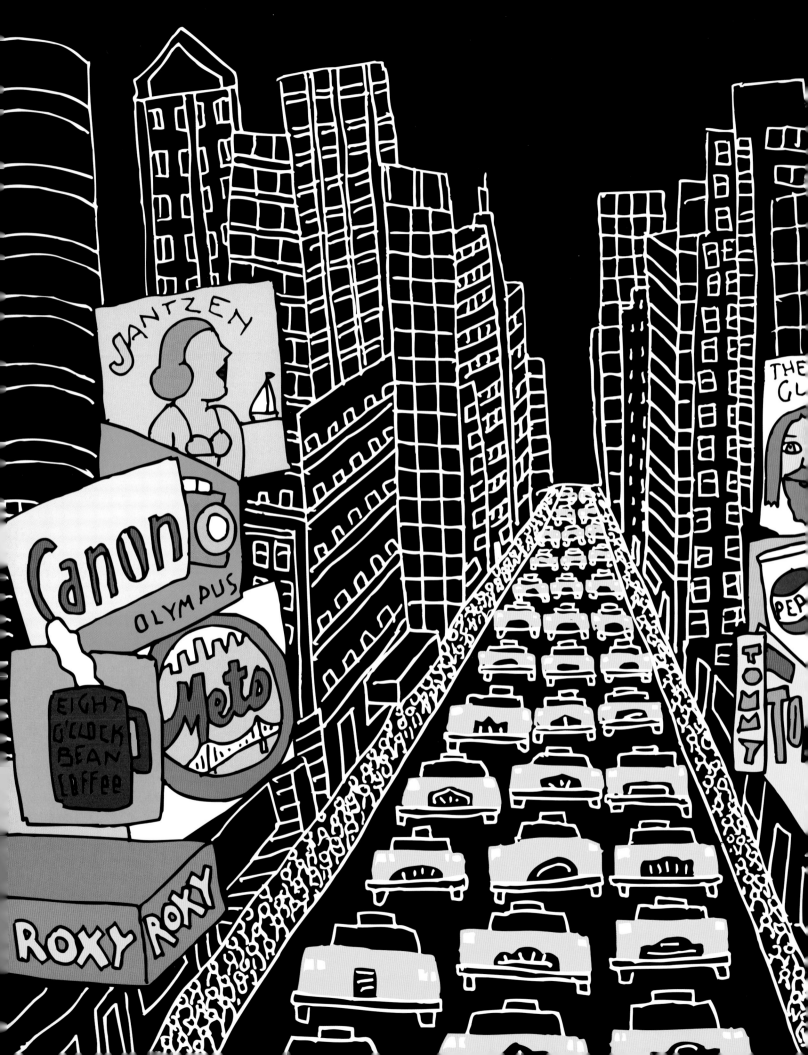

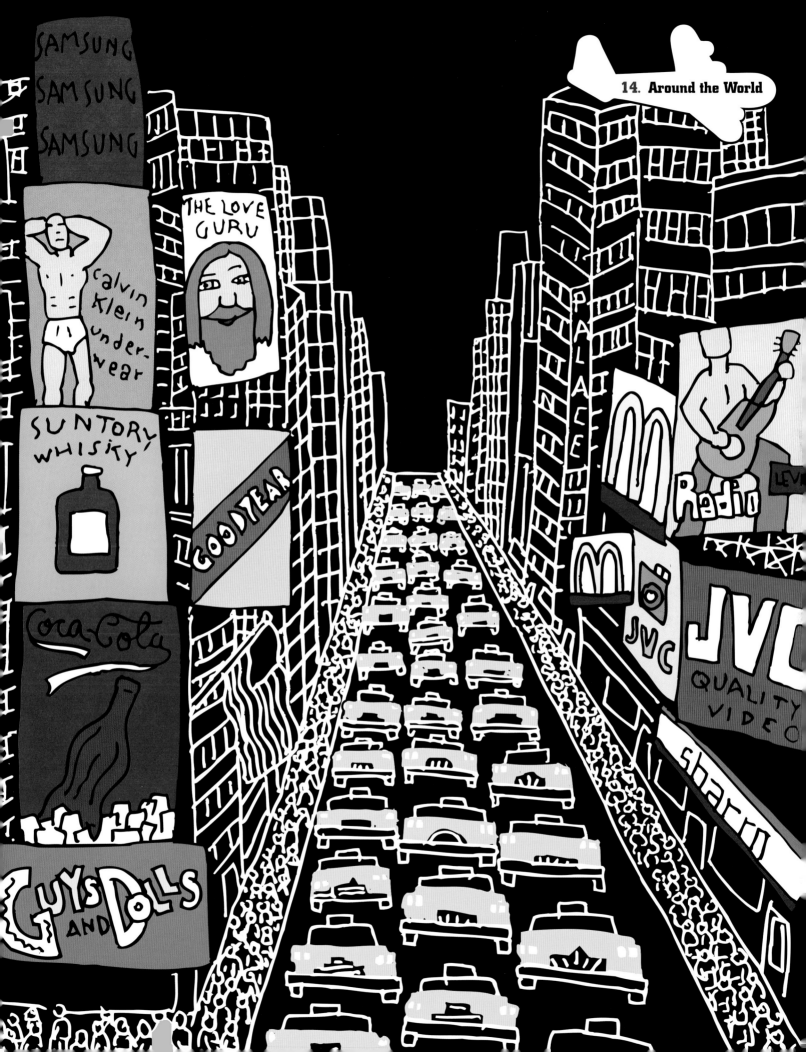

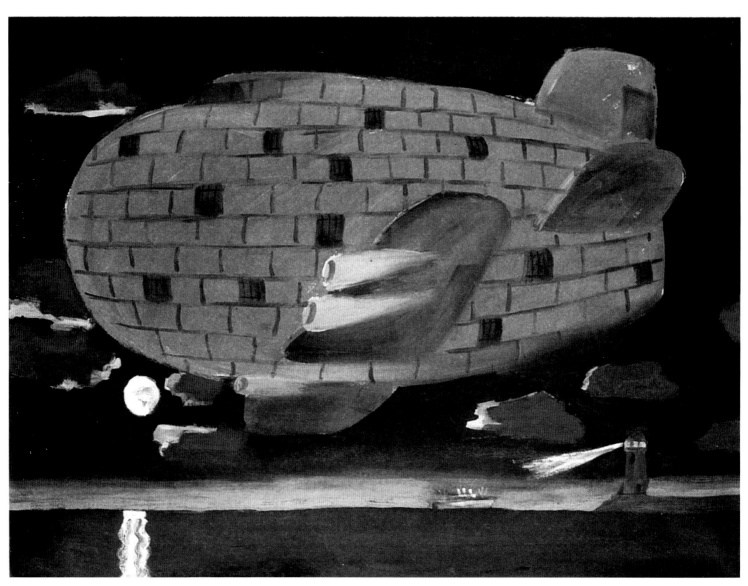

PREVIOUS SPREAD: *TIMES SQUARE*, PEN, INK, AND DIGITAL COLOR, 1994
PRISON CLASS, ACRYLIC ON PAPER, 1990
OPPOSITE: *ADOBE TEAPOT HOME*, ACRYLIC ON PAPER, 1990

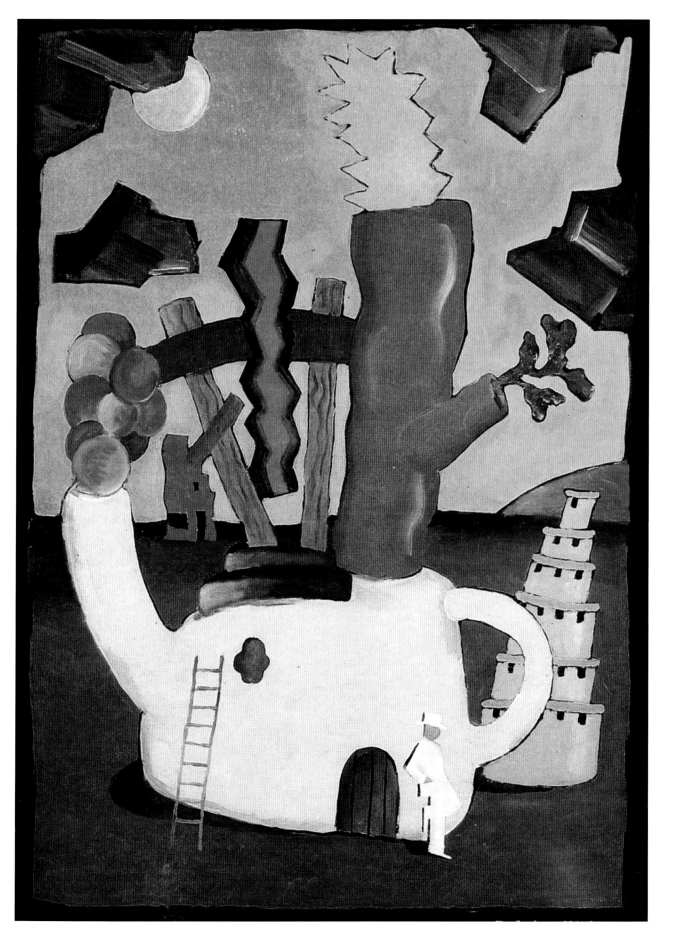

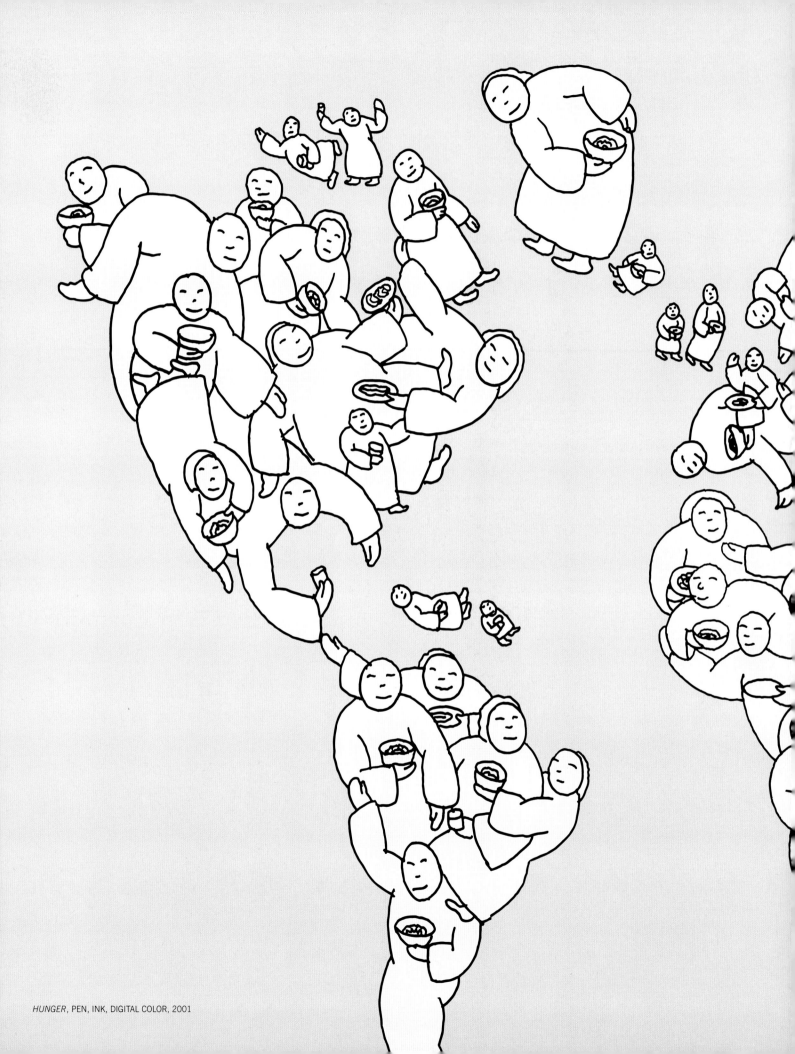

HUNGER, PEN, INK, DIGITAL COLOR, 2001

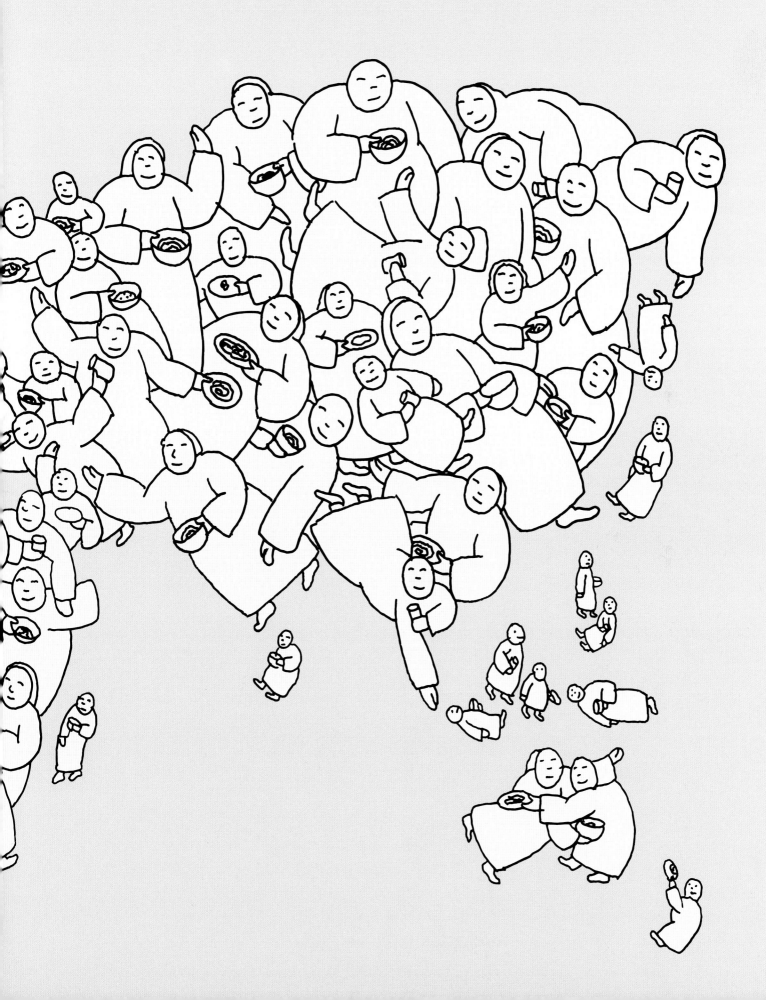

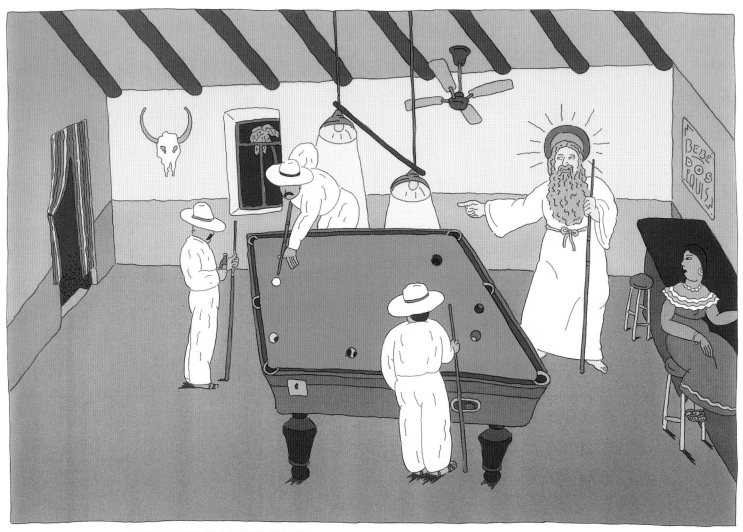

GOD FOUND ALIVE AND WELL IN MEXICO CITY, PEN, INK, AND COLOR FILM, 1988

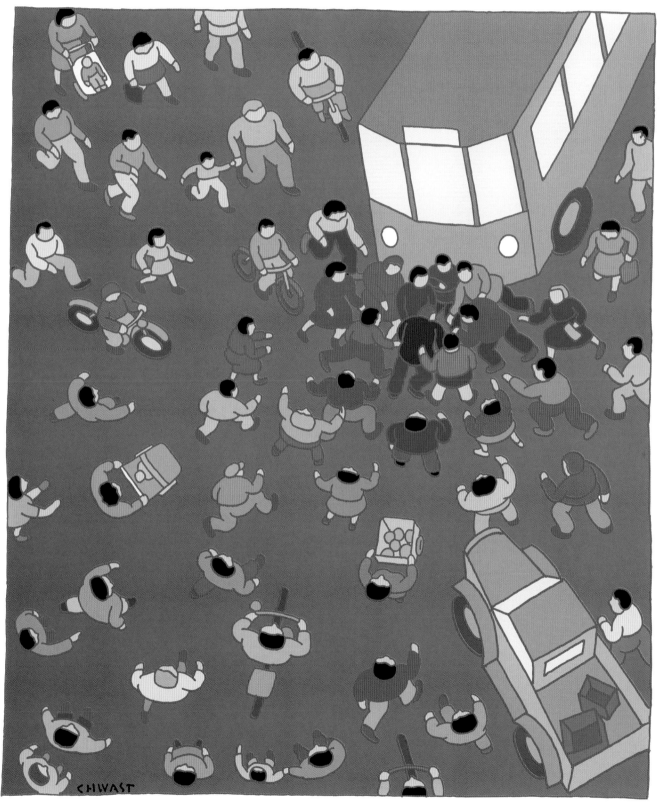

THE ACCIDENT, PEN, INK, AND DIGITAL COLOR, 2005

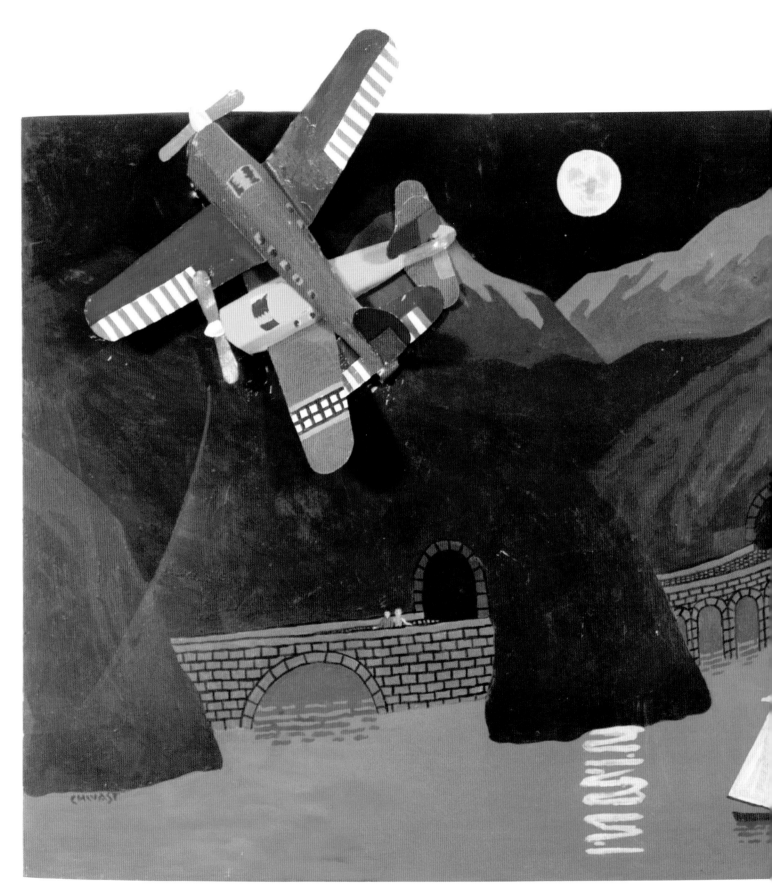

INCIDENT OVER THE LAKE, ACRYLIC ON CUTOUT SHEET METAL, 1998

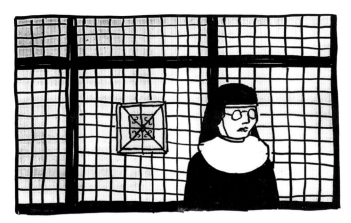

ILLUSTRATIONS FOR A BOOK ABOUT THE CONVENTS OF SEVILLE AND ENVIRONS,
PEN, INK, AND ADDED COLOR ON PAPER, 2006

THREE SCENES: *FRA ANGELICO IN NEW YORK*, ACRYLIC ON BOARD, 1992

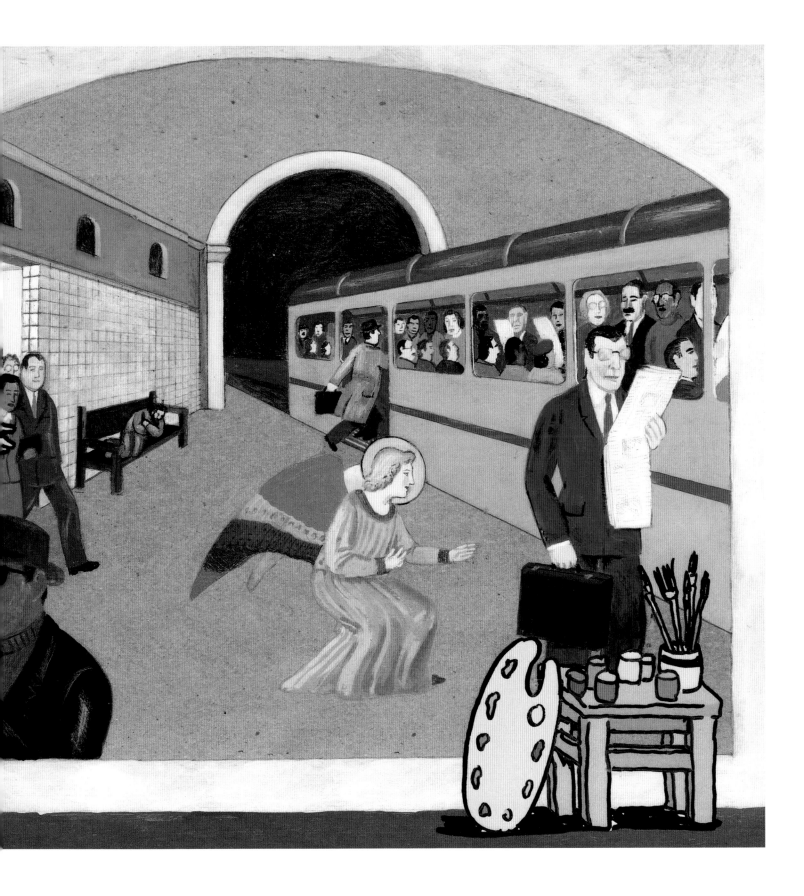

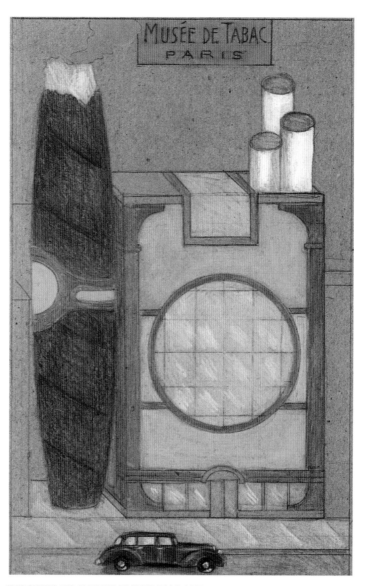

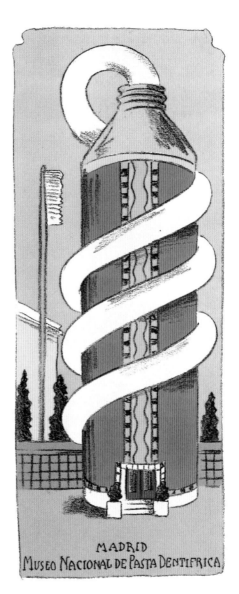

THIS SPREAD AND THE NEXT: MUSEUM STYLE, 1988
ABOVE: ACRYLIC AND COLORED FILM ON BOARD
ABOVE RIGHT: ACRYLIC AND COLORED PENCIL ON WRAPPING PAPER

ACRYLIC AND COLORED PENCIL ON WRAPPING PAPER

WIENER
STADTMUSEUM FÜR
PSYCHOANALYSE

ACRYLIC AND COLORED PENCIL ON BOARD

ACRYLIC AND COLORED PENCIL ON BOARD

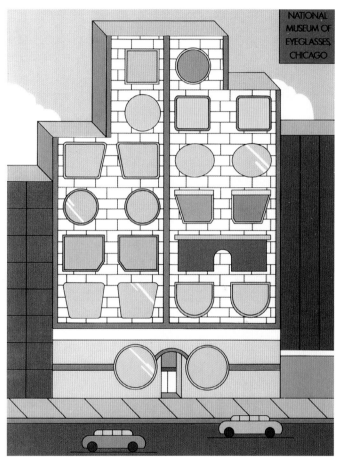

PEN, INK, AND COLORED FILM ON BOARD

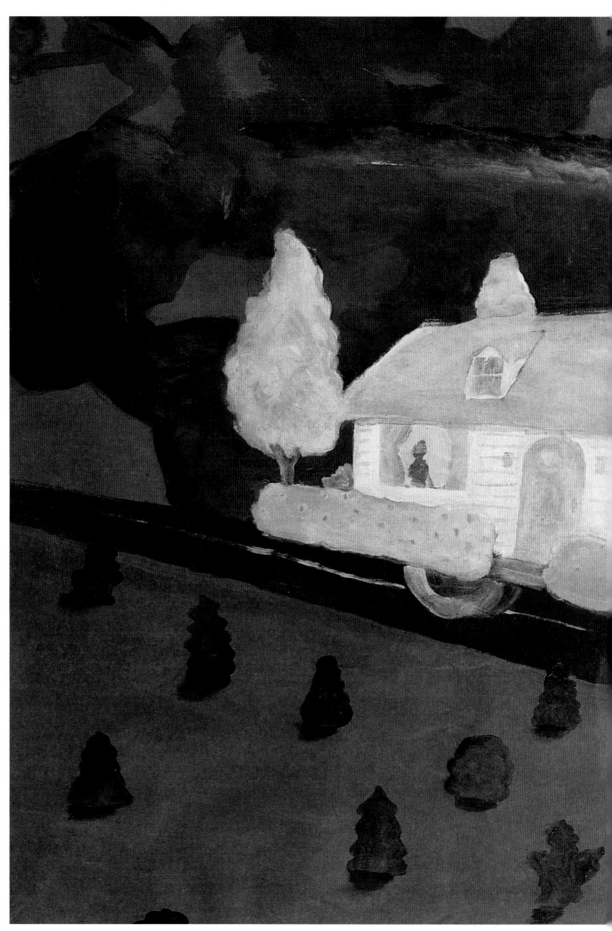

LEAVING NEW ENGLAND, ACRYLIC ON CANVAS, 1990

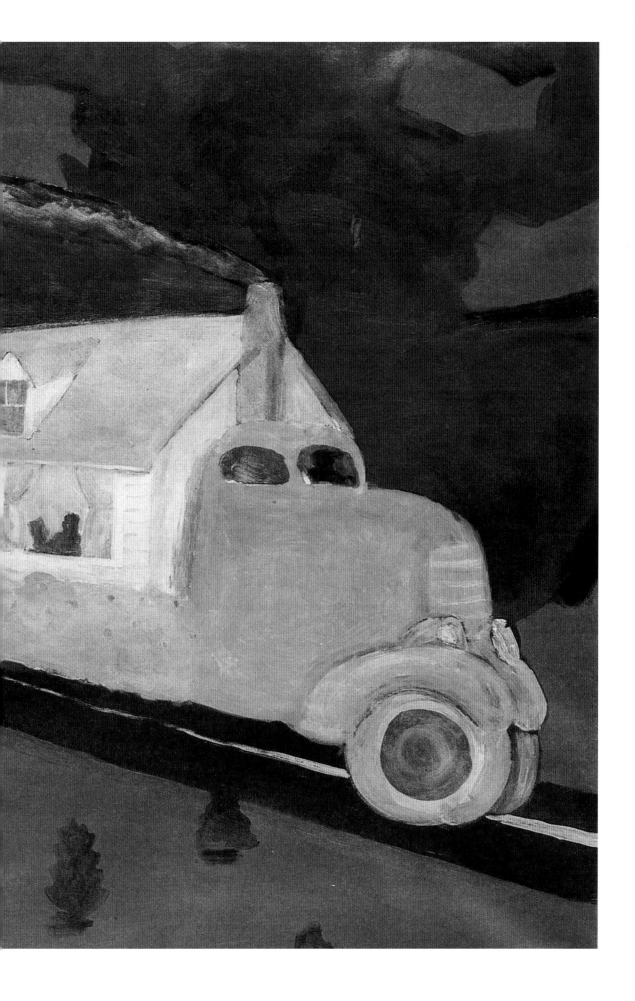

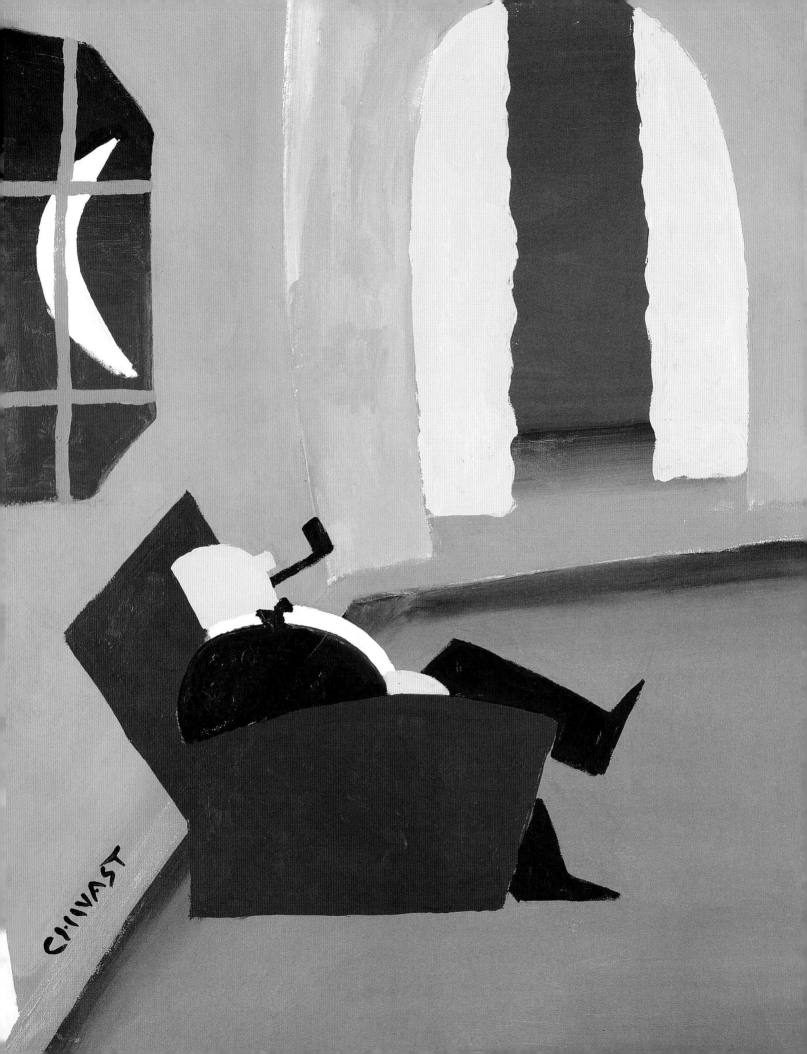

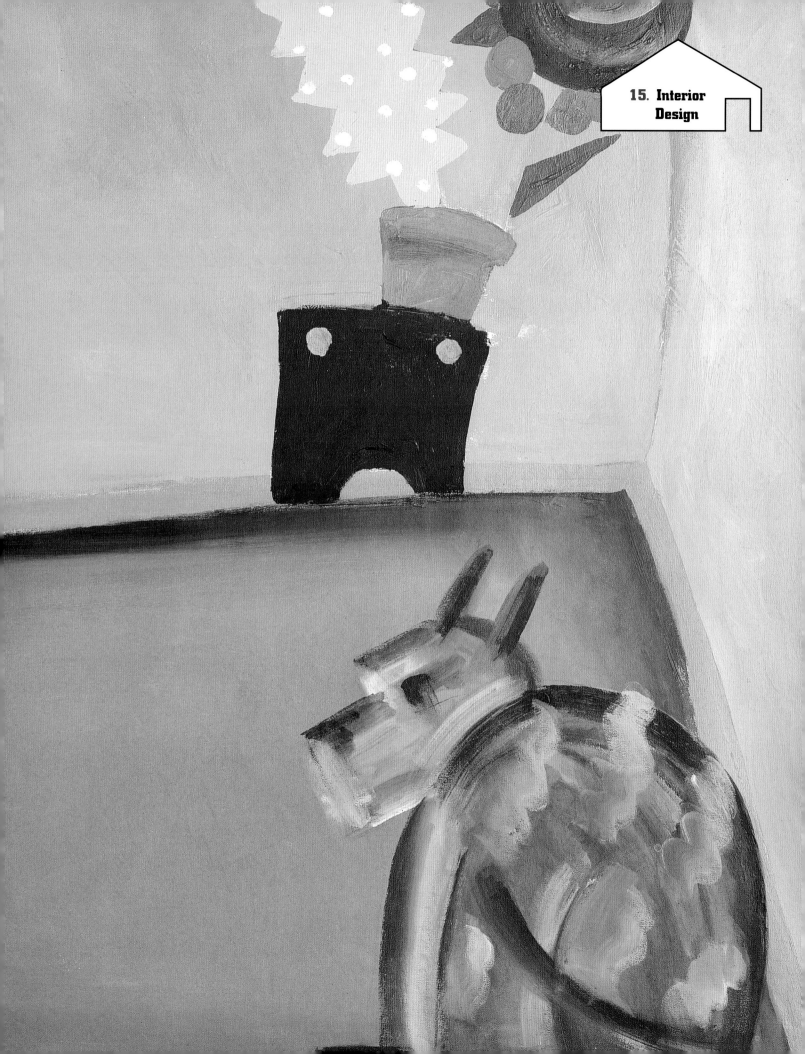

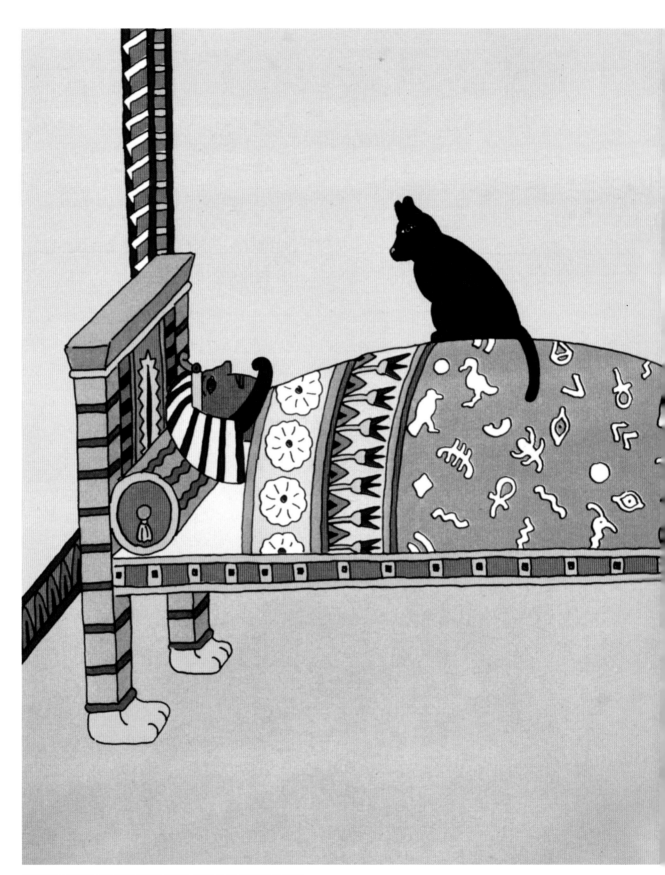

PREVIOUS SPREAD: *CARTOON LIVING ROOM*, ACRYLIC ON CANVAS, C. 1989
PHARAOH'S MORNING, PEN, INK, AND COLOR FILM, 1990
OPPOSITE: *CRIME SCENE*, MIXED MEDIA, 1980

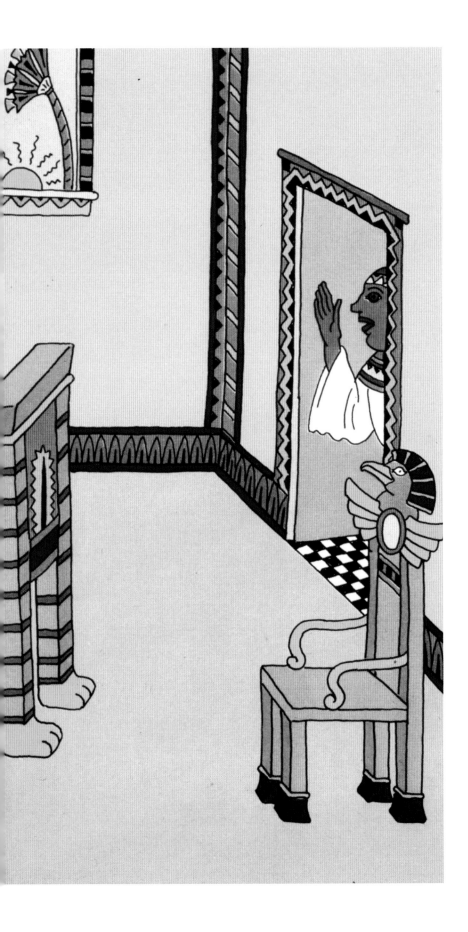

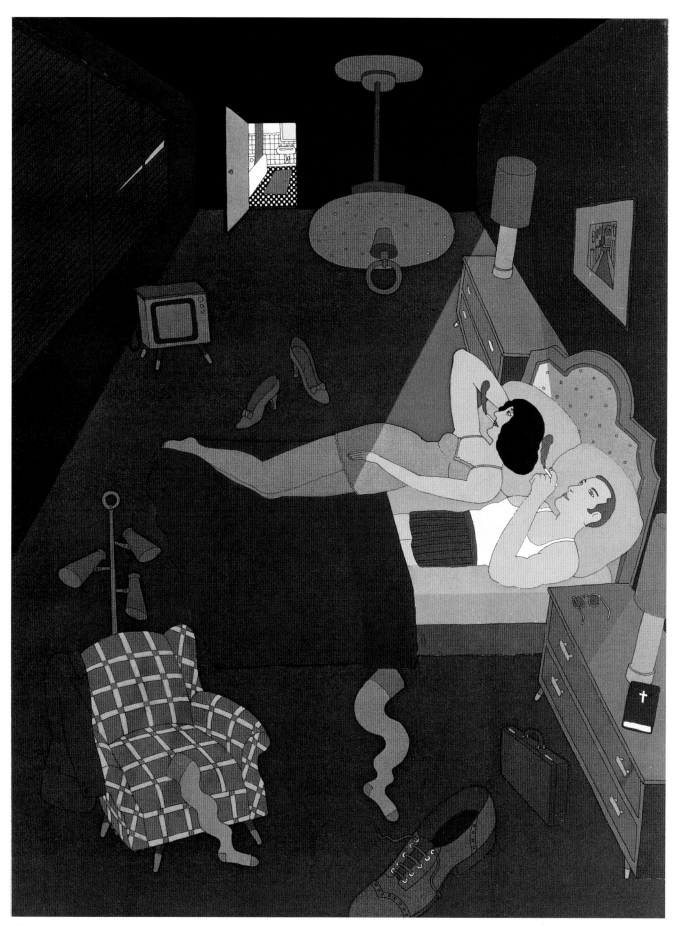

LOOK AT THE WINDOW, PEN, INK, AND COLOR FILM, 1972
OPPOSITE: *OBSERVATION*, PEN, INK, AND DIGITAL COLOR, 2005

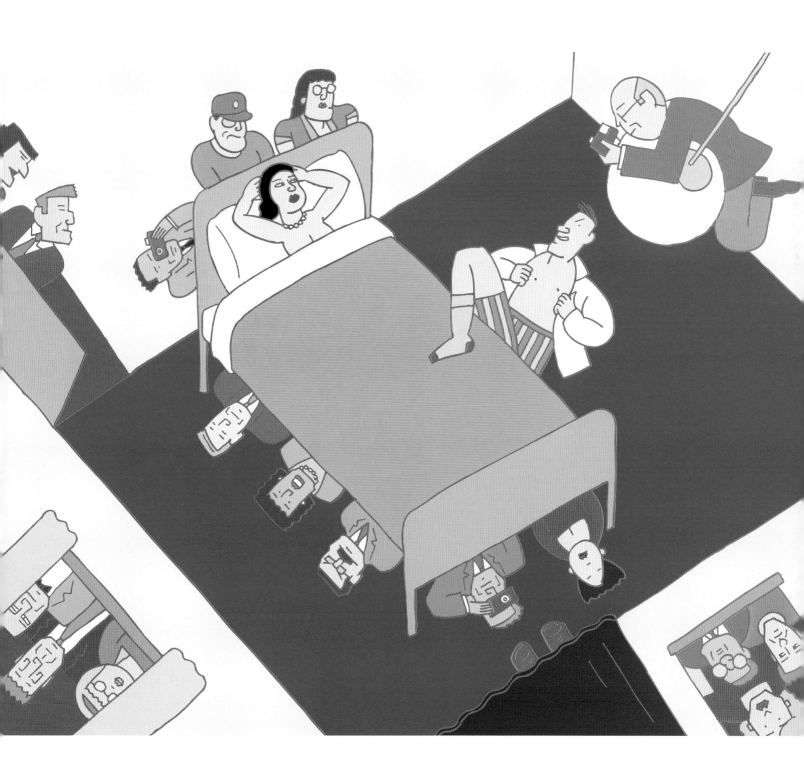

WHERE'S FATHER, SILK SCREEN, 1978

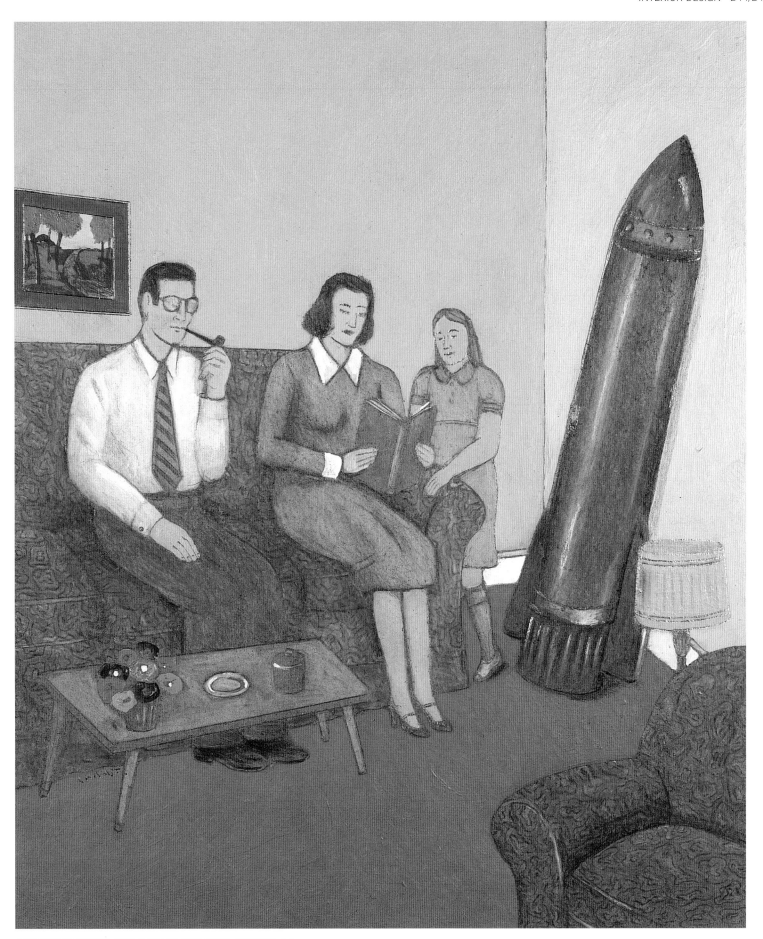

LIVING WITH THE BOMB, ACRYLIC AND COLORED PENCIL ON BOARD, N.D.

MR. CAT'S LOFT, PEN, INK, AND DIGITAL COLOR, N.D.

IN BACH'S LIVING ROOM, PEN AND INK, 1984
OPPOSITE: *1950*, PEN, INK, AND DIGITAL COLOR, 1989

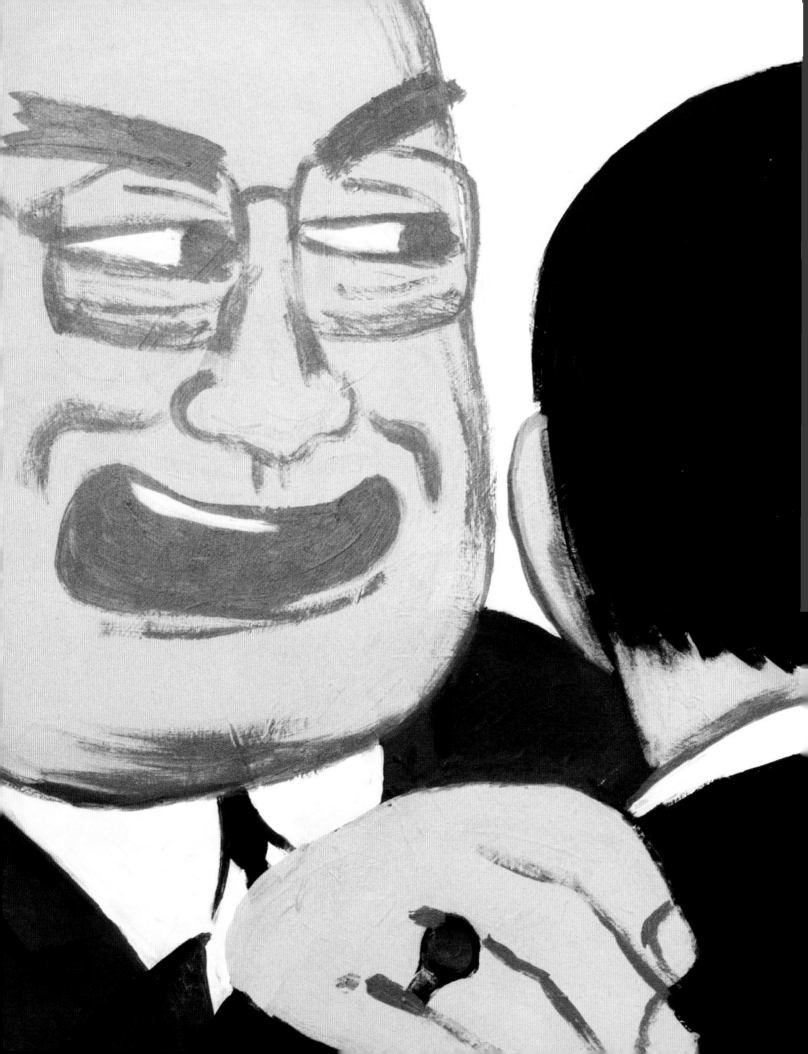

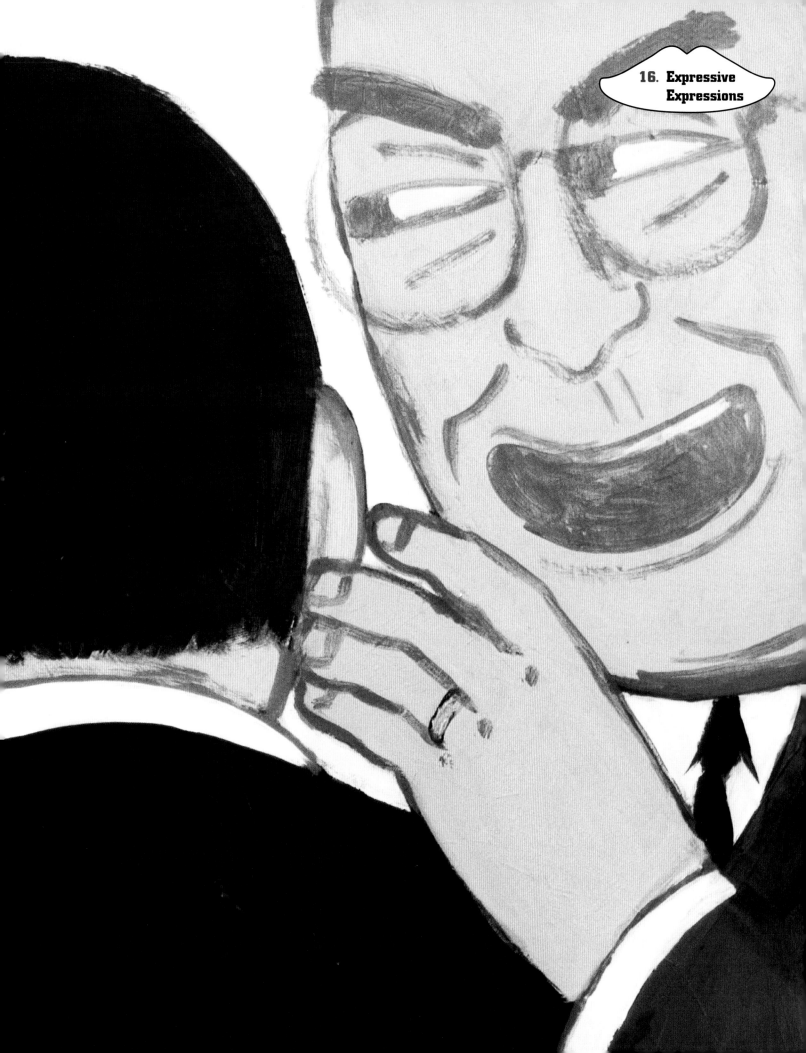

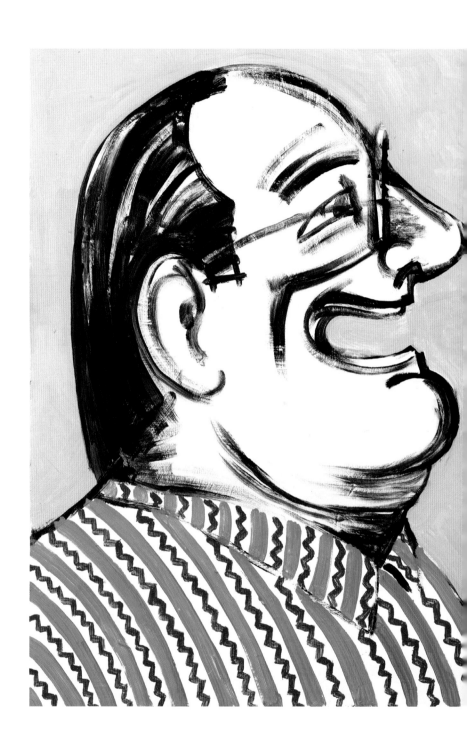

PREVIOUS SPREAD: *LAUGHING WHITE MEN 7*, ACRYLIC ON SHEET METAL, 2004
LAUGHING WHITE MEN 5, ACRYLIC ON CANVAS, 2005

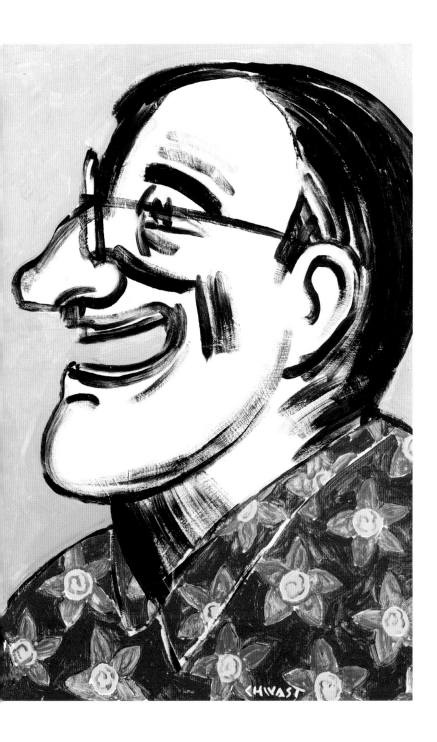

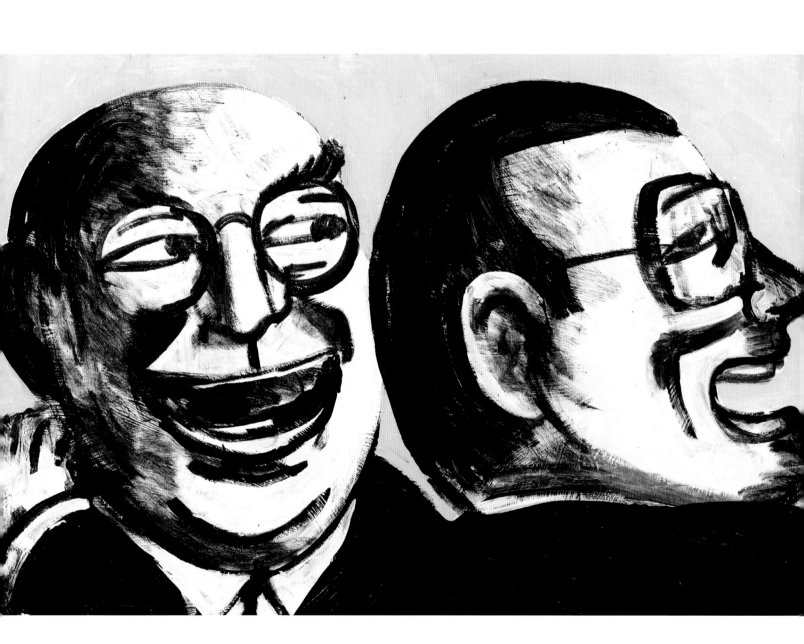

LAUGHING WHITE MEN 4, ACRYLIC ON SHEET METAL, 2004

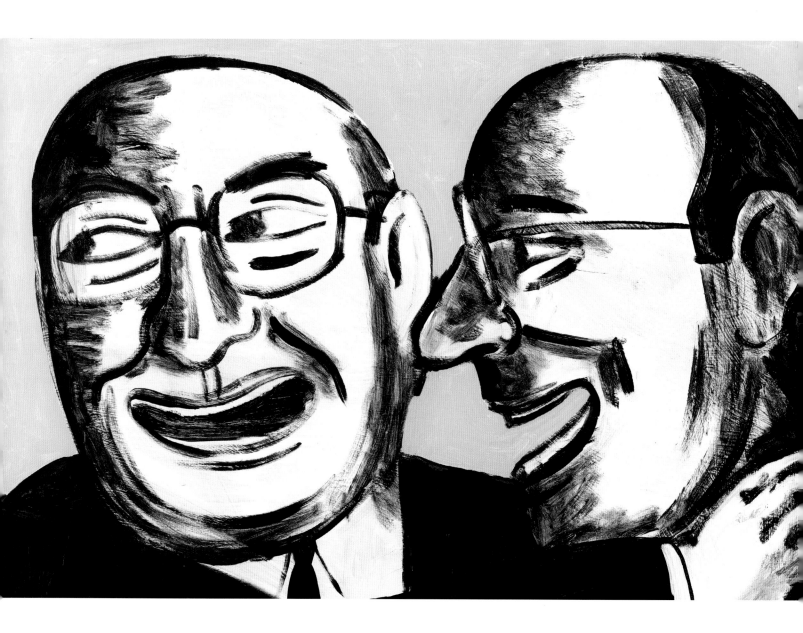

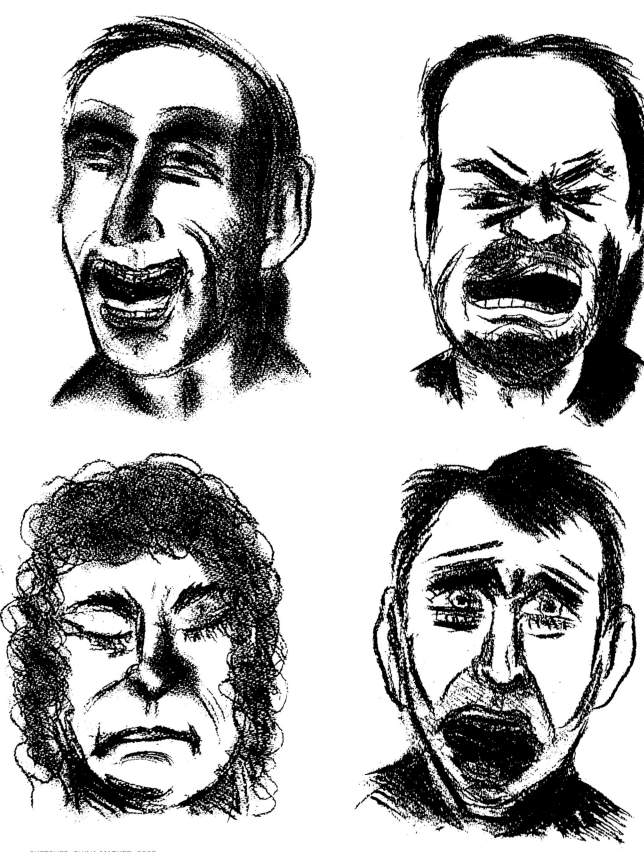

SKETCHES, CHINA MARKER, 2008

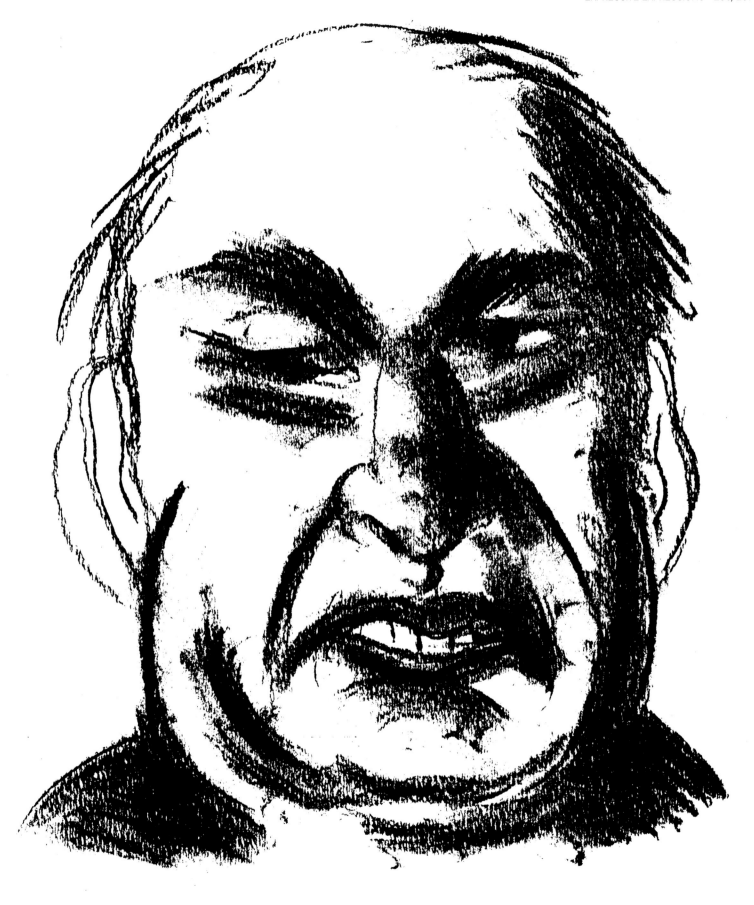

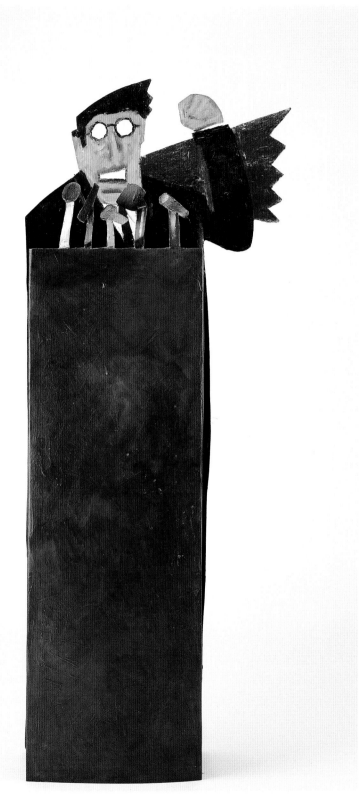

THE CANDIDATE, ACRYLIC ON CUTOUT SHEET METAL, 1992
OPPOSITE: *OBEISANCE*, ACRYLIC ON CUTOUT SHEET METAL, 1991

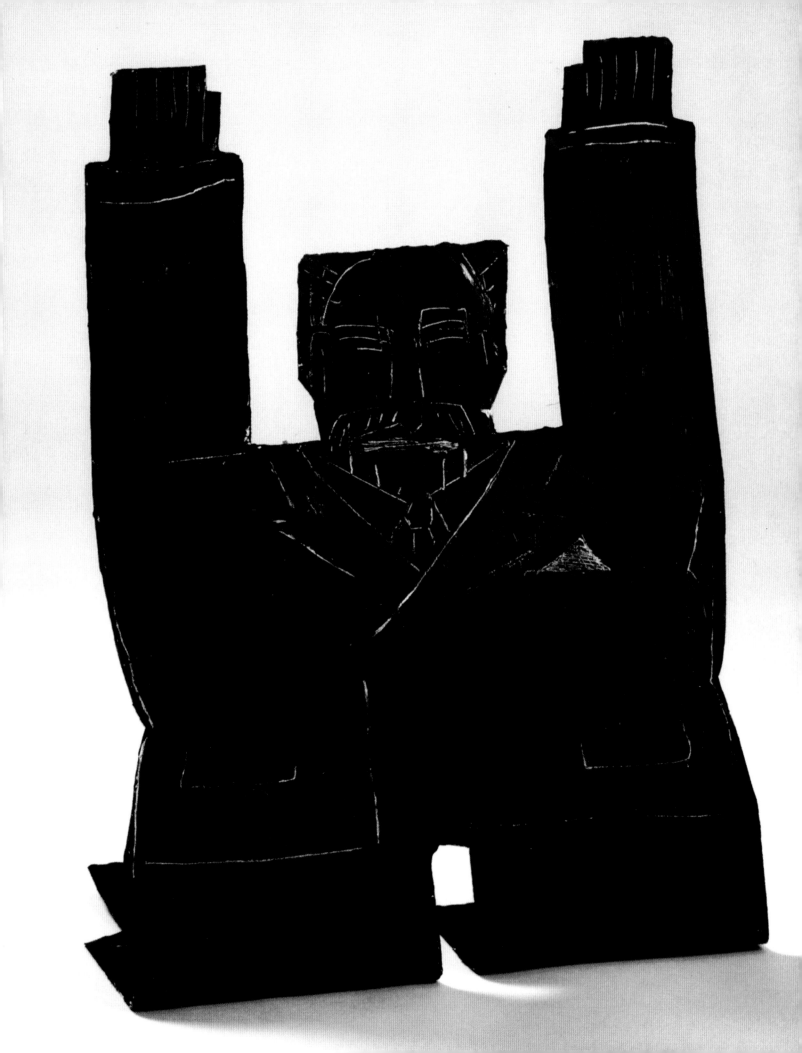

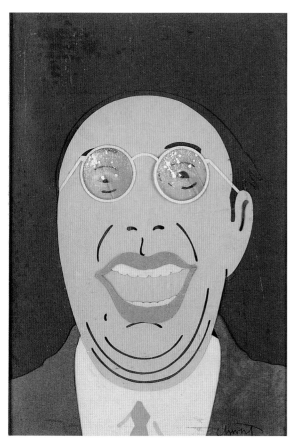

LAUGHING WHITE MAN 3, COLOR FILM ON PAPER, 1970
OPPOSITE: *WHAT'S SO FUNNY*, CHARCOAL ON PAPER, 2006

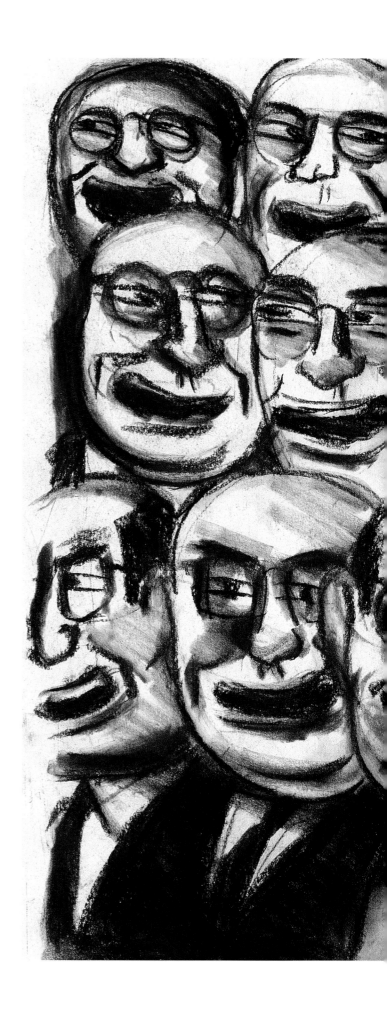

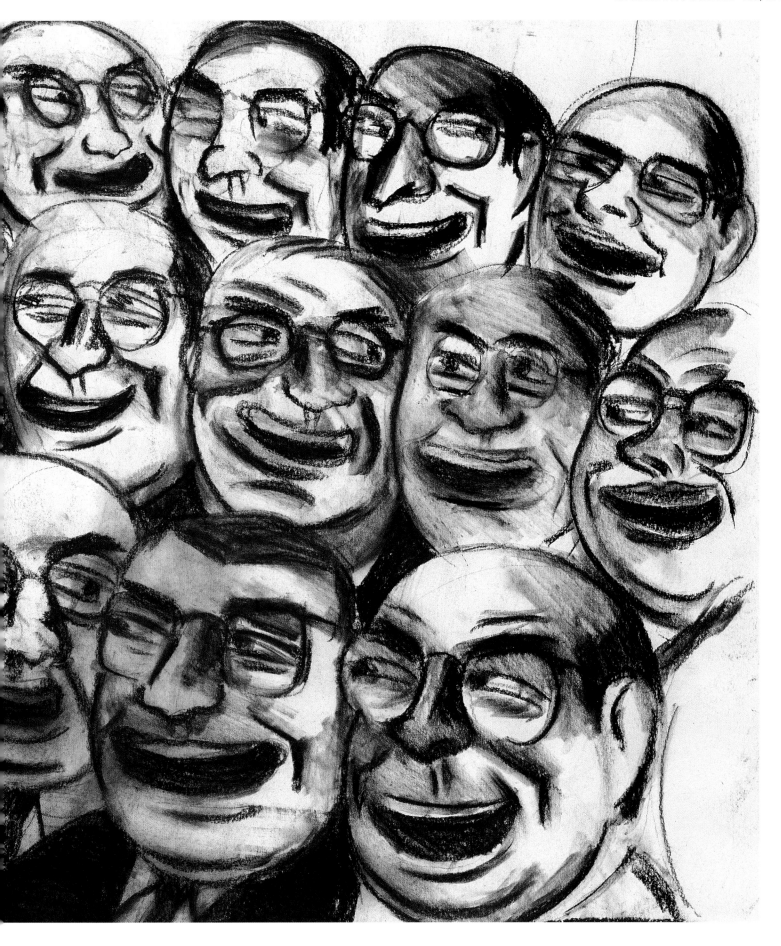

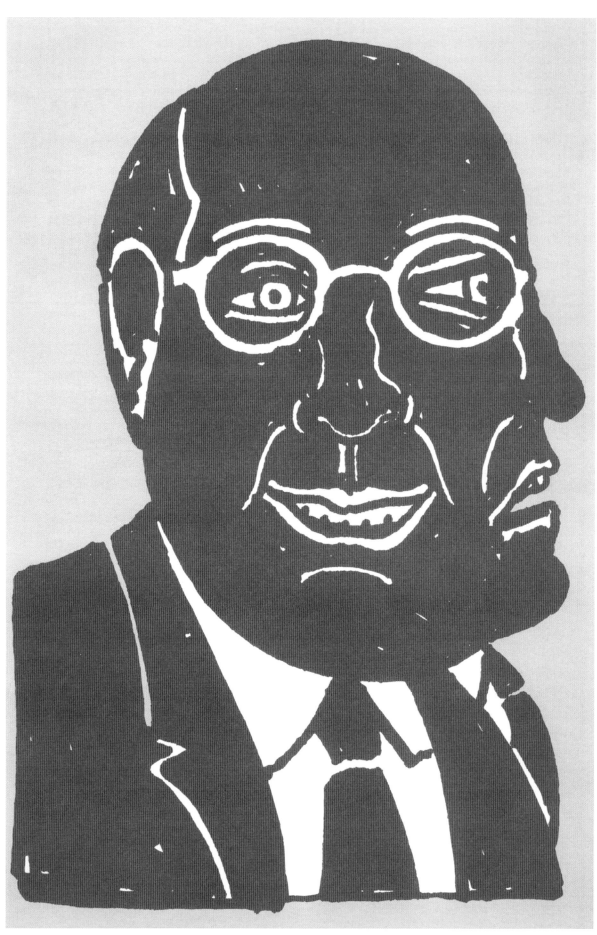

TWO FACED, PEN, INK, AND DIGITAL COLOR, 2004
OPPOSITE: *LIFE*, ACRYLIC ON CUTOUT SHEET METAL, 1991

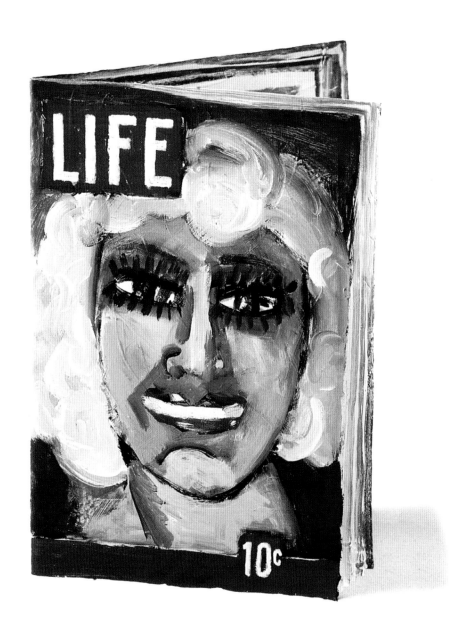

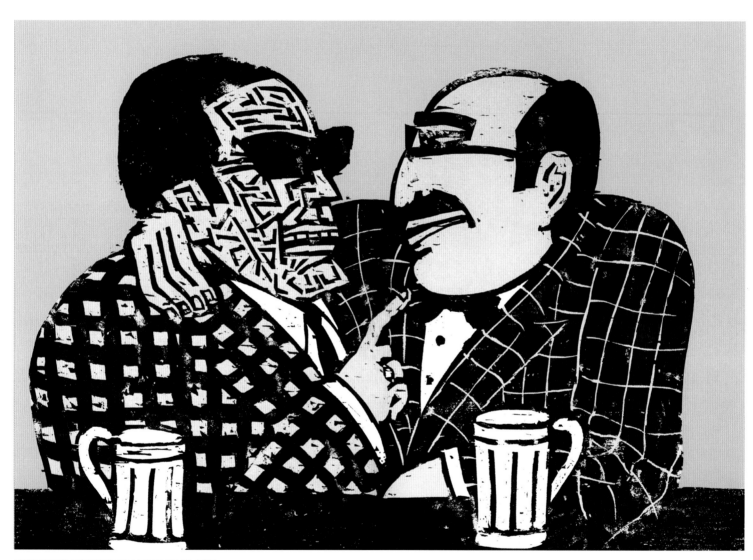

AT SAM'S BAR, WOODCUT WITH ADDED COLOR, 1987
OPPOSITE: *THE FACE OF FEAR*, COLLAGE, 2003

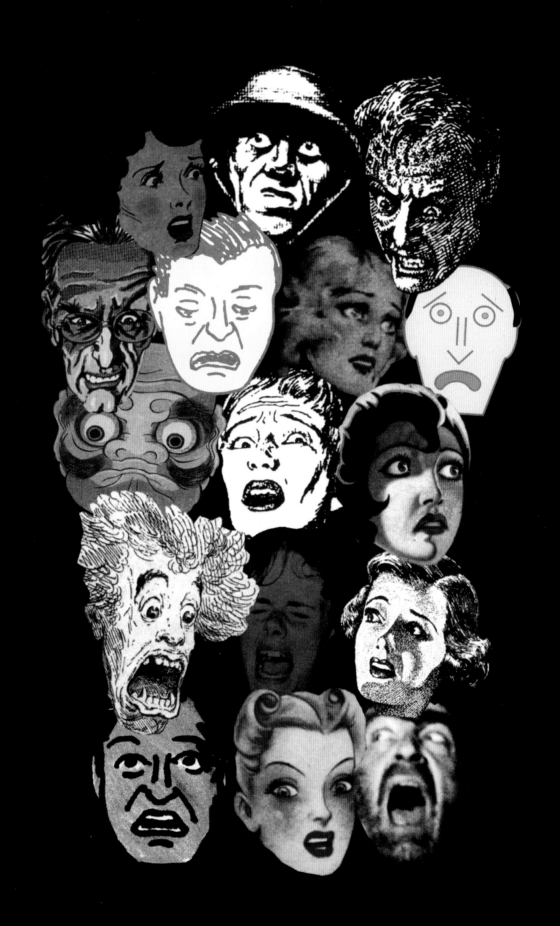

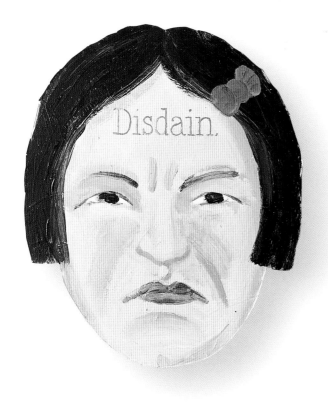
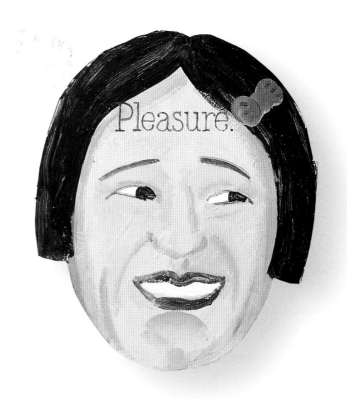
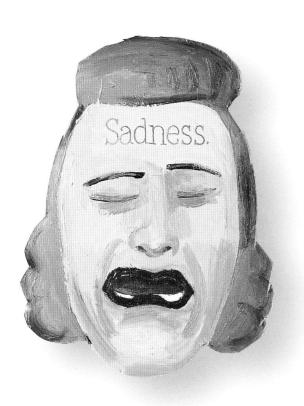
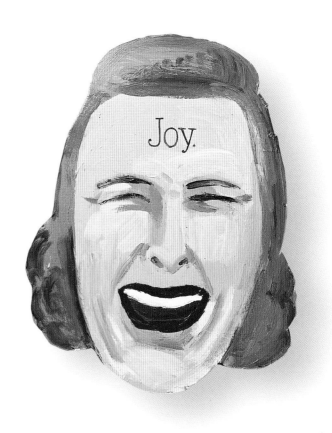

EXPRESSIONS, ACRYLIC ON CUTOUT SHEET METAL, 1993

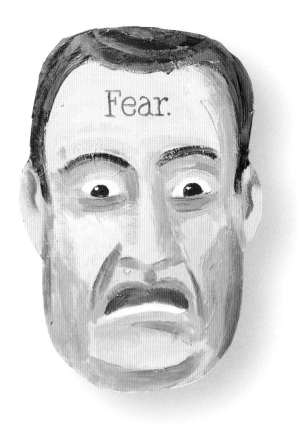

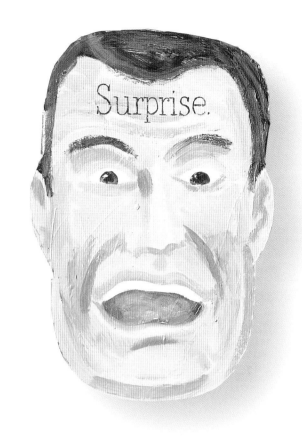

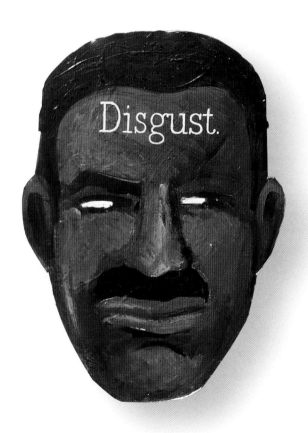

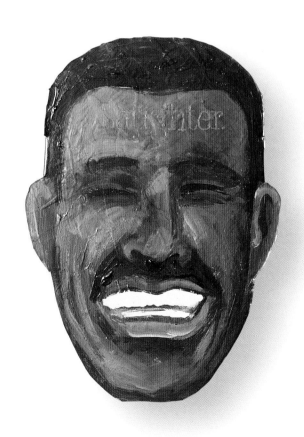

Notes & Credits

The cutout sheet metal pieces are shaped with snips, sanded, and painted with acrylics.
Major photography by Mark Connolly, Lakeville, Connecticut. Other photography by Leo Sorel, New York, and Ian Roberts, New York.
I apologize for not giving credit here to those art directors and editors from the past whose names I've forgotten.

Abbreviations

PPG The *Push Pin Graphic*, Push Pin Studios' bimonthly publication. Produced between 1957 and 1980, it showcased our illustration, design, and (occasionally ironic) ideas. Our political inclinations sometimes surfaced. A visual history titled *The Pushpin Graphic* was published in 2004 by Chronicle Books.

AD Art Director.

AIGA American Institute of Graphic Art.

FAZ Frankfurter Allgemeine Magazin, the supplement to *Frankfurter Allgemeine Zeitung*, the German newspaper. While I was introduced to FAZ by AD Willy Fleckhaus, the master of German editorial design, he was succeeded by Hans-Georg Pospischil, whose great design and use of photography and illustration was innovative and daring. Many of my ideas for picture stories were accepted; the text was written to my images, which is virtually unheard of in this country. My decade-long collaboration with Hans-Georg was the most gratifying of my career.

A Very Short Bio

1931 Born in New York.
1951 Graduated from the Cooper Union School of Art and Architecture.
1954 Cofounded Push Pin Studios.
1970 Push Pin Studios exhibited in Musée des Arts Décoratifs, Louvre, Paris.
1975 Appointed member of Alliance Graphique Internationale.
1984 Inducted into the Art Directors Hall of Fame.
1985 Director of the Pushpin Group.
1985 American Institute of Graphic Arts medalist (lifetime achievement).
1992 Honorary doctor of fine Arts degree from Parsons School of Design.
1997 Master Series Award, School of Visual Arts.
2005 Honorary Royal Designer for Industry, RSA (England).

1. Used Cars

20 This silk screen was originally a *Sports Illustrated* drawing covering the Daytona stock car races. A view of the infield. Bill Cadge, AD.
22 Personal work.
23 For the *Minneapolis Star Tribune*, a front page of a newspaper section.
24 Top: Imagining the cars that prominent artists might drive. See other artists' cars for *FAZ* on pages 36–39. Bottom: Personal work.
25 An abbreviated version of the endpapers for an issue of *PPG* called "Classic Car Catalog."
26 For a calendar produced with Berman Printing and Mohawk Paper Mills on the subject of cars.
28 Personal work.
30 Personal works.
31, 32 See page 26.
34 Personal work.
36–39 See 24.
40, 41 Personal work.

2. Not Quite Human

42 Spread for "The Lighter Side of Hell" issue of the *Nose.*
44 The death of Bach for "Happy Birthday, Bach." The 144-page homage from 1985 featured three hundred likenesses, one for each year since his birth in 1685.
46, 47 Illustrations for *Evergreen Review*. Ken Deardoff, AD.
48 Milton Glaser, Paul Davis, James McMullen, and I presented the golden age of Push Pin Studios in an exhibit at the Suntory Museum in Osaka, Japan, in 1997. Each of us created a robot in his own style for the promotional posters.
49 Cover image for Mohawk Paper Mills' Design and Style series. Steven Heller and I produced brochures featuring work by practitioners of art nouveau, French art deco, Dutch de Stijl, German Bauhaus, American streamline, and surrealism. I was introducing the Italian futurism issue with this robot. Don Povey, editor at Mohawk.
50 For the cover of *New York Magazine* on European terrorism.
51 For the month of December for a Korean calendar.
52, 53 Personal works.

3. Odd Celebs

54 Groucho, Chico, and Harpo Marx for an article in *FAZ.*
56, 57 Two Elvises. I don't recall the purpose of the one on the left. The one on the right was for a calendar on the theme of the '50s.
58 Unpublished.
59 I was asked to paint a portrait of Jackie Robinson on an actual home plate. It was photographed for a paper promotion.
60 Concert poster art. Gary Keys, producer.

61 One of a limited-edition series of silk-screened portraits, printed by Ambassador Arts. Most silk screens are rendered in flat colors. This was produced from full-color art by four-color process.

62 Illustration for the poem "Identity Crisis" by Yip Harburg. I created the drawings for the first book of his poems in 1965. In 1995 the book, titled *Rhymes for the Irreverent*, was reprinted with twenty-three additional illustrated poems.

63–65 Three of a group I thought were among the one hundred most important people of the twentieth century. I couldn't find a publisher for this project.

66 Illustration for a review in the *Los Angeles Times Book Review* of a biography of Walt Disney.

67 For the *New York Times Book Review*. Steven Heller, AD.

4. Brylcreem Man

68–77 A vintage ad for Brylcreem, a hair dressing, suggested this series of fifty-three works. Noblet Serigraphics screen-printed the basic black-and-white head from the ad and added red background.

5. Monkeys All Over

78 This image and those on pages 80, 83, and 85–89 created for Kaz Imaeda for the opening of his shop in Nagoya, Japan. It was the Year of the Monkey.

81 For *Esquire* magazine.

82 Unpublished drawing.

84 For the animal issue of *PPG*.

6. Unreliable Charts and Diagrams

90 For an issue of the *Nose* on the lost art of letter writing. On the left are examples of bad posture for letter writing; examples of good posture are on the right.

92 Poster art for a Swedish silk-screen firm.

93 A freestanding illustration for the *New York Times Book Review*. Steven Heller, AD.

94 Foldout for "The Lighter Side of Hell" issue of the *Nose.*

96 For the *New York Times Book Review*. A freestanding parody. The problem for the editor was picturing the swastika, a word and design poisoned by Hitler, but he finally let it pass. Steven Heller, AD.

97 A page for the couples' issue of *PPG*, inspired by a diagram in a sex manual I was perusing in a used book store in New Jersey.

98 Left: Unpublished sketch. Right: A self-portrait map of the part of Manhattan where I worked (16th St.) and lived (19th St.) and exhibited at the School of Visual Arts (23rd St.). Art for the poster for the Master Series show that Silas Rhodes, the founder and director, generously gave me.

99 Absurd announcement for a lecture. I'm from the Bronx but did visit Texas.

100 Illustration for the *New Yorker*. Christine Curry, AD.

101 Illustration for the *New Yorker*. The annals of graphic art include this traditional form seen in India, China, and Japan. My version was used to illustrate an article in the *New Yorker* magazine on the subject of diapers. Christine Curry, AD.

7. Fine Food

102 Detail of illustration for the *Nose.*

104 Announcement for a Push Pin exhibit in the Kansas City Art Institute. Five Peas: Push Pin Posters, Packages & Publications.

105 Layered pasta, 3' x 6'.

106–109 Prepared dishes series, each 60" wide. Inspired by *Mrs. Beeton's Cookery Book* from the nineteenth century, when kitchen help was cheap.

110–112 Cover and detail illustration for the *Nose*. The theme was "The Food We Love."

113 Illustration for a fiction piece in the *New Yorker*. Owen Phillips, AD.

114 Imaginary housing for *FAZ*. See pages 222 and 223 for work from the same series.

115 Art for a poster promoting chocolate.

8. Mexican Wrestlers

116 Larger-than-life detail of head and mask.

118–124 Drawings of wrestlers in their masks.

125–129 Metal renderings of Mexicans wearing masks, each about 36" x 45", inspired by street graphics of same.

9. Fab Fashion

130 Art for a book *Bra Fashions by Stephanie*, inspired by women that I observed on the beach in Jamaica. (There is no Stephanie.)

132 Fashions for *FAZ*.

134 Art for a cover of *Oxymoron*, a literary and art journal, which I art directed with Steven Brower.

136 Art for a poster announcing my show in Munich.

137 Art illustrating "The Overcoat" by Nikolai Gogol for the *Atlantic Monthly*. Judy Garlan, AD.

138 *PPG* blue issue.

140 Painted for an American Institute of Graphic Arts anniversary event.

141 Personal works.

142 Steel shoes, about 3' x 5'.

144 Even shoes have feelings.

145 The image for the poster announcing that Push Pin was moving.

146 Cover story art about shoes and feet in *FAZ*.

147 Personal work.

148 For an article on dance in *FAZ*.

149, 150, 152, and 153 Art for a survey of hat design appearing in *Persönlich*, a Swiss advertising magazine.

151 Cover art for *Idea*, the Japanese design magazine.

10. War

154 Detail of painting, size 82" x 58".

156 *Tanks I*, *Tanks II*, both 30" x 40".

157 Detail of painting, 96" x 108".

158 This one is closest to my childhood air battle drawings of World War II.

160 Painting. size 36" x 47".
161–165 Paintings, each 96" x 108".
166 Soldiers as workers on an assembly line, 18" x 24".
168 Spread for the "War" issue of the *Nose*. Accounts of Iraqis and Americans killed by car bombs were reported daily.
170 Illustration for the *Nose*.
171 Drawing for an anniversary issue of *PPG* looking back at the past twenty years.

11. Fauna and a Little Flora
172 A drawing for the *Nose* that has been stretched to adapt to a spread in this book. The text was about a chicken that showed up in a front yard in Queens, New York.
174 A personal work, collection of Amie Cooper, who kept a real parrot.
175 Promoting printer's ink.
176 Illustration for an article on spiders in *FAZ*.
177 For a book of artists and their cats.
178 I have no memory of this art. Forgetting clients and purpose is not uncommon for me.
179 For an issue of *PPG* on dogs.
180 Everything about palm trees for *FAZ*. One illustration among several over three spreads.
181 Illustration for a poem by Yip Harburg from his book titled *Rhymes for the Irreverent*, published by Freedom from Religion Foundation Inc. See page 64.
182 Originally designed as a very short animated film, screened at an Alliance Graphique Internationale Conference in Amsterdam.
184 For an early issue of *PPG*.
185 Illustration for a fiction piece for the *New Yorker*. Christine Curry, Owen Phillips, ADs.
186–187 Two from a series of *Femmes Fatales* in *FAZ*, *Sarah Bernhardt* was the cover image.
188 Drawing lesson from *PPG*.
189 Personal work. Height 72".

12. Ordinary Objects
190 Today's bland electronic equipment can't stand up to colorful, eccentric Bakelite beauties of the '40s such as this.
192 This two-part metal piece with rope rearranged to fit on the page. Its rotary dial marks it as retro.
193 For the cover of the "Couples" issue of *PPG*.
194, 195 Small (9" x 9") wall pieces. It was the idea of using steel wool for steam that motivated me.
196 My joke is in the title: Swiss Navy Knife.
198 The hands move with your help. 36" x 49".
199 This wall piece has a catatonic tape measure. 30" x 40".
200 Art for the cover of *Graphis* magazine. Walter Herdeg, editor.
201 The copy promotes a book for New York writers. An homage to Saul Steinberg, my mentor and nemesis.
202 The poster, one of a series by various designers,

promoted Simpson Paper. The title and theme was *Connections*.
203 The metal surface is exposed, with black the only color used.
204–205 Personal works. This dishwasher is grittier than most of my pieces.

13. Body Parts
206 Detail of a 72" x 96" canvas, inspired by the back pages of the *Village Voice*.
208 For the "Looking Good" issue of the *Nose*.
210 Top: This was originally a metal piece with real glasses. It was sold in Germany without being photographed. I redid it as a drawing here. Bottom: Illustrators represented by Push Pin Studios contributed to this issue of *PPG*. The theme was "Uses of the Mouth."
211 Inspired by first aid cards inserted as premiums in cigarette packages, early 1900s.
212 Top: This image was originally created for a college film series called Art or Pornography, produced by Bob Shaye of New Line Cinemas. The version here was from a lithograph. It was printed by Mourlot in Paris. Bottom: The original for this poster was a 2" high black-and-white sketch. I like its spontaneity.
213 These were sketches for a moving announcement that was not produced.
214 For a seminar on teaching design for Cooper Hewitt National Design Museum. Dorothy Dunn, director.
215 Various illustrators interpreted Adam and Eve for *FAZ*. This was mine.
216 For the "Magic" issue of the *Nose*.
217 Another homage to Magritte.
218 Illustration for a forgotten magazine.
219 Personal work.

14. Around the World
220 One of several drawings of city squares of Europe and this one, of Times Square. It appeared in *FAZ*.
222, 223 The theme that I suggested to *FAZ* was imaginary homes.
224 For the *Nose*. The theme was "The food we love."
226 I proposed predictions for the following year in *FAZ*. This one was inspired by the biblical predictions in tabloid newspapers.
227 Illustration for a fiction piece in the *New Yorker*. Most of the fiction illustrations are photographic, but with photos that are more atmospheric than literal. Christine Curry, AD.
228 Everything is flat except for the planes.
229 From one of a series of travel books about the area around Seville. Pedro Tabernero, AD.
230 Imagining Fra Angelico working in the subway. There is something monasterial about the architecture in many of the stations.
232–235 A feature in *FAZ*. I generated this idea of museums that looked like their collections.
236 See 222 and 223.

15. Interior Design

238 Part art deco, part '30s Sunday comics (especially *Krazy Kat*). Self-portrait of the artist, waiting for his wife to finish getting dressed.

240 One of three spreads in *FAZ* about a day in the life of a pharaoh.

241 One of a series of puzzle illustrations entitled *Find the Murder Weapon*. (The knife is in the chandelier.) Most of this art came from an old ad promoting bathroom fixtures.

242 Illustration from *Audience* magazine. Seymour Chwast and Milton Glaser, ADs.

243 A spread from the "Dirty Laundry" issue of the *Nose*.

244 Ruth Ansell, AD of the *New York Times Magazine*, asked me to do a cover for an article on the use and role of fathers. The style comes directly from the German designer Ludwig Hollwein, who used patterns with minimal detail. This is from a limited-edition silk-screen version.

245 The article in the *Atlantic Monthly* concerned "living with the bomb." The deadpan expressions reinforced the banality of the situation. Judy Garlan, AD.

246 Urban life with anthropomorphic cats. For *FAZ*.

248 From "Happy Birthday, Bach." See 44.

249 One entry in my picture essay on imaginary clocks. for *FAZ*.

16. Expressive Expressions

250–255 A series inspired by a photograph of gleeful interior designers from East Hampton. They turned inexplicably into fat cats.

256, 257 Drawings made for this book.

258, 259 Three-dimensional, free-standing pieces.

260 An illustration for an article about comedy for *Audience* magazine. Seymour Chwast and Milton Glaser, ADs.

261 See 250–255.

262 For an article by Hannah Arendt on lying in politics, for the *Nose*.

263 A stand-up three–dimensional homage to the old *Life* magazine.

264 A spread in the book *Sam's Bar*, about characters in a bar one night.

265 Collage for the "Fear" issue of the *Nose*.

266 My take on a treatise of expressions. These heads appeared on the cover of the *Art Director's Annual*.